Art
inSight

Art
inSight

Understanding Art and
Why It Matters

Fanchon Jean
Silberstein

Bristol, UK / Chicago, USA

First published in the UK in 2020 by
Intellect, The Mill, Parnall Road, Fishponds, Bristol, BS16 3JG, UK

First published in the USA in 2020 by
Intellect, The University of Chicago Press, 1427 E. 60th Street,
Chicago, IL 60637, USA

A catalogue record for this book is available from
the British Library.

Copy editor: MPS Technologies
Design: Aleksandra Szumlas
Production manager: Emma Berrill
Typesetting: Contentra Technologies
Frontispiece: *Untitled* by Manuel Silberstein. Photography by Peter Karp.
Epigraph: D. H. Lawrence, *Look! We Have Come Through!*
(New York: B. W. Huebsch, 1917), 125.

Print ISBN: 978-1-78938-117-7
ePDF ISBN: 978-1-78938-119-1
ePub ISBN: 978-1-78938-118-4

Printed and bound by Gomer, UK

To find out about all our publications, please visit
www.intellectbooks.com.
There, you can subscribe to our e-newsletter,
browse or download our current catalogue,
and buy any titles that are in print.

This is a peer-reviewed publication.

My God, but I can only say
I touch, I feel the unknown!
I am the first comer!
Cortes, Pisarro, Columbus, Cabot,
they are nothing, nothing!
I am the first comer!
I am the discoverer!
I have found the other world!

"New Heaven and Earth"
D. H. Lawrence

For Manny

Contents

Creative activity is a type of learning process where the teacher and pupil are located in the same individual.

Arthur Koestler, *Drinkers of Infinity: Essays 1955–1967*
(London: Hutchinson, 1968), 235.

Meet a cave dweller, an African king, an Egyptian pharaoh, a Greek goddess, a Christian saint, and others who let you know who they are and what matters. What would a Roman general and Elvis Presley have to say to one another?

Art is traditional, innovative, noisy, silent, figurative, abstract, pretty, ugly, orderly, or messy. Objects change meaning depending on where they are and what is around them. Chairs, windows, animals, people, and trees may show up in unfamiliar places. Understanding grows through dialogue.

Images from ancient to contemporary art show views of time, nature, human relationships, and more. Artists transform invisible values into visible forms and reveal ways that people and cultures make sense of their worlds.

CHAPTER 4: WHOSE LENS?

Labels and headlines lead you to expect certain ideas. Artists use their perspectives to manage yours. Your tastes, opinions, prejudices, and past experiences affect what you see. When you are alert to the difference between projecting and receiving, you can move from sight to insight.

CHAPTER 5: ART IN DIALOGUE

Paintings from sixteenth-century Iran and twentieth-century America talk to one another. They learn what is important to each by asking questions and modeling open-hearted dialogue. They see how artists in both cultures paint unreal scenes to seek what is real.

CHAPTER 6: THE CAPTURE

Students in communication and mediators in training meet modern art at the Hirshhorn Museum. They ask one another what they see and answer by describing. They discuss each other's perceptions. Successful mediators must be fine observers and excellent listeners.

CHAPTER 7: QUESTION AND PLAY

Practice overhearing yourself through questions and play. Simple observations lead to complex ideas. Circles and lines make up pictures and provide metaphors in art and in life. Narrow categories limit understanding. Questioning art is a form of intercultural communication.

CHAPTER 8: TRAVEL

Go to new places through art without suffering culture shock. A bowl, etched with calligraphy, takes you on a journey to Iran, and a soup can goes with you to America. Both are more than their visual forms. Questioning them carries you from surface to depth.

CHAPTER 9: WHEN ART SPEAKS, LISTEN

Language of all kinds communicates, bewilders, clarifies, and obscures. Become fluent in the language of art and question its colors, materials, and forms—its titles, symbols, archetypes, and frames. "Speaking" the language of art leads to cultural fluency.

CHAPTER 10: FOLLOW YOUR SENSES—SENSE MEANING 145

Body and mind work together. Your senses introduce you to art and to the rest of the world. Notice your first reactions, your thoughts and feelings. Then, return to the art by observing and describing. Open yourself to others' stories.

CHAPTER 11: MAKE SENSE OF THE SENSELESS 153

In the wake of the 9/11 attack on the World Trade Center in New York, artists used small things to confront large ideas. Prayer rugs and cheeseburgers are filled with meaning. Find spiritual beliefs, patriotism, war, sex, and politics, along with fears, loves, desires, and angers.

CHAPTER 12: IN OTHER WORLDS 171

In 2010, the world watched the rescue of trapped Chilean coal miners. Artists take you underground to their dark world. Go more deeply into yourself through detailed questions about what you see in places you may never enter except through art.

WORKS OF ART 180

INDEX 188

Preface

In my sophomore year at the University of Michigan, I got very sick during a flu epidemic and learned what it was to be weak and vulnerable. At the time, I was taking a survey course in art history that touched on Greek art and had introduced me to the famous statue of the Winged Victory, a marvelous marble woman, who, though missing her head, expressed power (and to me, health) through her body. At the end of the semester, the professor asked the students to write about a favorite work, and she was it for me. She soared. She was about being alive. She touched me personally, and later, when I read about her, she taught me about the ancient Greeks.

That was the first time I walked into a work of art and made it my own. It has happened since, though probably without the force I felt as a nineteen-year-old coming back to life. Walking inside a work of art exposed my feelings, and the journey opened another world. It made me curious about the Greeks. The Nike carried me into a culture and its people and led me to understand how "art opens a window into a culture's dreams, drives, and priorities" revealing "aspects of a culture's soul."[1]

I was confronted with many cultures' souls during years abroad as the wife of an American Foreign Service Officer living in Cambodia, Vietnam, Laos, Thailand, Pakistan, and Brazil. Along the way, when we lived in Washington, DC, I earned a master's degree in special education at George Washington University in a program that focused less on disabilities than on learning styles and helping schools meet the needs of children. We studied perception, how beliefs shape the ways we see, and we were cautioned against thinking we understood children's views before letting them talk. We learned the value of asking respectful questions.

My work as a school consultant in Northern Virginia and later in Rio de Janeiro taught me that conversations with children are a form of intercultural communication. Children see and think differently than adults, just as adults see and think differently from one another, and when varying cultures and nationalities get into the mix, those differences can be huge. I ruefully noted that during my earlier years abroad, language issues aside, I thought I understood a lot more than I did.

A decade later, I directed programs for the Overseas Briefing Center at the US State Department's Foreign Service Institute to prepare employees and families for their moves abroad. When I left full-time work there, I became a docent at the Smithsonian's Hirshhorn Museum and received superb training in modern and contemporary art. Worlds opened to me, and I learned that art really is about everything in the world—that art is personal, spiritual, social, and political. The endlessly new forms artists invented captivated me.

During the same period, I worked with Sandra Fowler, a talented intercultural trainer, to design "Training of Trainers" workshops using art, and for several years we taught "Art as Intercultural Communication" for the Summer Institute for Intercultural Communication in Portland, Oregon. I was enthralled to see our participants meet art directly, describe what they saw, and go places they didn't expect to find. They stepped outside their prejudices, and went straight into the images. They probed for meaning. They used vision and intelligence to look before anyone told them what to see. They read and listened to teachers *after* they paid attention to the surface and made a direct connection to works of art through their own observations. Those students inspired this book.

Artists show the rest of us what matters. They often are unsure of what will happen when they enter unknown territory to create landscapes that would otherwise have remained unknown.[2] They are interculturalists who work to live consciously in a complex and uncertain world.

NOTES

1. David Barr, *Nets*, 1988, film and essay produced by Macomb Community College.
2. Marcel Proust, *Remembrance of Things Past*, trans. C. K. Scott Moncrieff and Terence Kilmartin (London: Chatto & Windus, 1981), 932.

Acknowledgments

Many colleagues, students, friends, and family have inspired me with their knowledge, understanding, enthusiasm, and conversation, leaving me a large debt of gratitude. They listened patiently, offered wise counsel, were generous with their time, gave me the benefit of their insight, professionalism, and expertise, and provided unfaltering friendship.

Without Sandra Fowler, a gifted intercultural trainer, I could not have written this book. Sandy and I designed and delivered training programs together for over thirty years, and many of the ideas I write about came from our workshop, "Art as Intercultural Communication." Special thanks to Janet Bennett, director of the Summer Institute for Intercultural Communication, who brought us into its faculty where we offered various forms of this workshop over several years.

Other colleagues in the intercultural training field, the Department of State's Foreign Service Institute, the docent corp at the Hirshhorn Museum, and curators, archivists, and other staff members throughout the Smithsonian Institution opened me to new ways of seeing. Many were beyond generous with their time, including Julian Raby who said the visuals needed to look a lot better. He was right.

Michelle LeBaron had the idea to extend the ways art gives insight into conflict. For many years, she brought her students, who were studying dispute resolution, to sessions with me at the Hirshhorn Museum where they confronted ambiguous images, delved into the mysteries of individual perception, and participated in revealing conversations.

Linda Cashdan, my indefatigable editor, invited me into her home one summer to write in their attic. Five years later, she and her family were still graciously hosting me. Linda's finely tuned edits, her practical advice, and her enthusiasm for this book bolstered my confidence, day after day.

Craig Storti was with me from the start, providing ideas for structuring the book, offering supportive criticism and encouragement, calling me from bird

watching trips, and providing a bit of hilarity. He and his wife Charlotte became close friends, and their firm support during a difficult time has meant the world.

Valerie Lester provided introductions, read an early draft, and brought the full force of her intelligence to her elegant criticism. The same was true for Barbara Frechette, who read with superb critical vision. Ellen Roche read closely and injected clarity, humor, and fresh ideas. Susan Norwitch, Linda Wanner, Ruth Uhlmann, and Craig Mathews also read, encouraged me, and introduced me to others who helped. My thanks to Elizabeth Eder for her close reading and helpful critique.

Tamar Kern, a gifted educator and my dear niece, provided guidance and wisdom for many years while I was writing. Caroline Simon's advice, steady support, and loving friendship have been invaluable.

Dana Weightman, permissions agent par excellence, procured the rights for images and quotes with perseverance and exceptional organizational skills. She was tireless in completing an immensely complex task.

Emma Berrill, the superb and conscientious production editor at Intellect Books, answered questions large and small, provided reassurance, and warmly welcomed Tamar and me to Bristol. My thanks as well to her predecessor, Katie Evans, my first contact at Intellect, whose clear guidance was essential.

Several professional organizations and other groups gave consistent support and belief in the project: the board of the National MultiCultural Institute, and in particular the president and my friend Elizabeth Salett, the Intercultural Communication Institute, the Washington Chapter of Arttable, The Society for Intercultural Education, Training and Research, The Smithsonian Institution, Ye Olde Book Club, the women of the Wisdom Circle, and several trainers at the Georgetown Apple Store.

The list is long of friends, colleagues, and helpers who made inquiries on my behalf, introduced me to knowledgeable people, and advised me in many ways. I keenly hope that I have not left out a single one and beg forgiveness if I have: Ruth Abrahams, Sarah Abruzzese, Spencer Abruzzese, Esthy and Jim Adler, Tina Adler, Martha Ball, David Barr, Jennifer Barrett, Linda Basch, Jean Belitsky, Ruth Bell, Janet Bennett, Rita and Martin Bennett, Karenjot Bhangoo, Elaine Binder, Penny Bonda, Vivian and Marc Brodsky, Adrian Brown, Rhonda Buckley, Jane Cafritz, John Cahill, Leonie Calvert, Carolyn Carr, Soraya Chemaly, Kay

Chernush, Erica Clark, Diane Coburn-Bruning, Shelby Conley, Sally Courtney, Barbara Croissant, Jeff Cunard, Barbara Davis, Diane Dowling, Bill Dunlap, Masumeh Farhad, Claire Frankel, Barbara Franklin, Marianne Freeman, Aneta Georgievska-Shine, Ann Gilbert, Josh Glasstetter, Fred Goodman, Willi and Barry Goodman, Kelly Gordon, Mark Greenberg, Deborah and Bob Groberg, Gay Hanna, Houman Harouni, Jean Harrison, Mary Hewes, Claire Huschle, James Edward Johnson, Carol Kahn, Carolyn Kaplan, Sharmila Kapoor, Wendy Keats, Maria Keehan, Arnold Kessler, Steve Klaidman, Kathy Kretman, Les Kretman, Judy Landau, Marion Lewin, Lynn Lewis, Susan Lieberman, Sue Low, Wendy Luke, Joe Macedo, Judy Marcus, Nancy Micklewright, Wendy Miller, Margaret Mintz, Roberta Mintz, Julia Morgan, Daniyal Mueenuddin, Miriam Nathan, Jill Nevius and Fred Schwartz, Jeanette Noltenius, Marian Osterweis, Mariette Pathy, Ruth Perlin, Anette Polan, Carol Radin, Jane Ramsey, Wanda Rappaport, George Renwick, Barbara Robinson, Dugan Romano, Duke Ryan, Renee Sandell, Mary Kay and Jim Shaw, Marilyn and Don Silberberg, Scott Simon, Elsa Smithgall, Irene Solett, Marilyn Stern, Pat Strongin, Nuzhat Sultan, Margery Thompson, Andre Varchaver, Maria and Luis Vintro, Ellen Wald, Diana Walker, Tracey Weisler, Michaele Weissman, Judy White, Susan Whittlesey, Victoria Wodarcyk, Jeanne Wolfe, Clare Wolfowitz, Judy Zickler.

Not last, but definitely first, and with a full heart, I thank my beloved husband Manuel Silberstein who introduced me to the worlds he inhabited as a Foreign Service Officer and as a painter, a gardener, and a dancer. Manny came to my classes and programs, read for me, and believed this book was necessary.

Introduction

*Through art alone are we able to emerge from ourselves, to know
what another person sees of a universe . . .*

Marcel Proust[1]

You function in the world in at least two ways: directly and indirectly. Your direct
experience makes you active. You observe, watch, inquire, feel, play, and imagine.
You receive sensations and information and give back through comment and
questions. Indirect learning is one-way communication, a lecture, from expert to
learner; you depend on someone to tell you what's what.

To live, you must take in the world both directly and indirectly. *Art inSight*
is about paying attention to your direct experience and using it consciously. It's
about how to observe, find questions, and become an expert at describing. It's
about meeting art as though it were a person and creating a relationship with it
through a conversation that begins when you ask what you see and answer with
a description rather than a judgment.

Questions open conversations with other tastes, perceptions, beliefs, values, and
points of view. Most of us believe we can see the truth about people. We believe
they are what we think they are. We say to ourselves, "This is what you are." But
a question takes us beyond the limits of our vision and judgment. A meeting with
strange art is like meeting other strangers, but we can safely ask questions of art
(and ourselves) we can't or won't ask one another.

Who are you really?
Why am I attracted to you?
What makes me want to turn away?
What do I like about you?
Why do you make me uncomfortable?
What confuses me about you?

This book is about meeting that stranger by first looking and then asking,
describing, talking, and learning. It is about how to talk to art and listen to

1

yourself. It invites you to find the life in seemingly inert objects—to give art, what artist Sigmar Polke called, the capacity to look back, to answer.

The conversation starts with your questions. Questions are direct, from you to it with nothing in between, and they attach you to the thing in front of you. A conversation with a work of art makes you an ally of the artist, a co-creator. The art changes when you ask a question.

I have included art from all over the world, not highlighting one culture over another since one of the purposes of this book is to build respect for diverse world views. I looked for art that reveals cultures and then realized that most does. As I wrote about serendipity, the good luck and coincidence of finding things that fit where you don't expect they will, the book became a journey through many times and places, organized by ideas rather than history, chronology, or cultures. That means that a number of periods, styles, and artists are not here, and when you think of them, I hope you will include them as you read. I write about the visual arts though I am interested in the ways that all art invites us inside and am grateful to poets, playwrights, musicians, and other artists for ideas and inspiration.

"Art in Dialogue" and "The Capture" present two kinds of dialogues. In the first, paintings from the sixteenth and twentieth centuries talk with one another. Each is part of a cultural time and place, and each asks questions that reveal its beliefs and preferences. In "The Capture," students from a class on international peace and conflict resolution meet in the Smithsonian's Hirshhorn Museum to seek ways to become more astute mediators.

A later chapter, "Question and Play," explores the power of questions and the liability of leaving them out in everyday life—or asking and not listening for answers. How do you discover questions? How do you overhear yourself? How do discourse and discovery come together? One section, "Avoid Narrow Categories" is a cautionary note about classifying things—when it helps and when it limits perception and keeps you from noticing the unexpected.

As the book goes on, it questions and explores the roles of body and mind. How do feelings inform us? How do headlines and labels lead us? How do artists use their perspectives to manage ours? How does the first known art reveal the way its makers saw the world, and how do contemporary artists help us see our own world? How do unusual materials make us see differently, and how does a contrast between natural and manufactured objects help us understand cultural attitudes? A Soviet era painting and a French still life are lively travel companions in "Travel." They alert us to the importance of visible and invisible languages to express how things look and what they really are.

How do we become fluent in the language of art? How do we manage the unexpected? How do silence and noise influence the ways we see, think, and feel?

How do tradition and innovation help us understand people who favor one over the other? How does art wake us up to what matters most?

At the Hirshhorn Museum and other places I teach, I am impressed by what I learn through conversation. I am inspired by dialogues that begin by simply asking other people what they see. The writer Eli Wiesel wrote, "every question possessed a power that did not lie in the answer."[2] The power is in the asking. Conclusions are always uncertain and can lead to what Peter Gay called "a perpetual act of revising, of correcting, what we think we know."[3] It's a demanding perpetual act, but I think in order to live peacefully with differences, it's the best we have—to look, ask, revise, correct—and ask the next question.

NOTES

1. Marcel Proust, *Remembrance of Things Past*, trans. C. K. Scott Moncrieff and Terence Kilmartin (London: Chatto & Windus, 1981), 932.
2. Eli Wiesel, *Night* (New York: Avon Books, 1958), 14.
3. Peter Gay, *Modernism: The Lure of Heresy: From Baudelaire to Beckett and Beyond* (New York: W. W. Norton, 2008), 212.

CHAPTER 1

The Original Skype

The Original Skype:
What the Human Form
Can Tell Us

The arts are the generator of dreams (dreams derived from the real, directly-experienced world), a deepening whereby we discover our common humanity. Artists make us transparent.

David Barr[1]

The body always expresses the spirit for which it is the shell.

August Rodin[2]

The human figures that endure throughout history show us what mattered to their creators. For thousands of years, artists have sculpted, drawn, and painted the human form to tell stories and explore where people fit into the cosmos. Faces and bodies memorialize ideals of beauty and heroism and provide snapshots of how individuals and cultures see themselves. They give us clues to attitudes toward nature, roles in family and community, worldly and spiritual concerns, and perceptions of personal strength and vulnerability.

We see the past from a distance and cannot understand the beliefs and practices of ancient peoples exactly as they did. But when we feel their presence through their art and ask it our questions, we go inside that distant other. We wonder why a figure is large or small, decorated or not, made of stone or mud, idealized or imperfect, hastily or carefully made.

Very Early Art

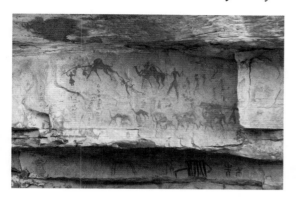

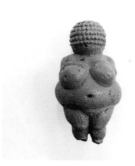

FIGURE 1: Tassili n'Ajjer Rock Painting, Algeria, c.8000 BCE. Dmitry Pichugin/Shutterstock.com.

FIGURE 2: Venus of Willendorf, 30,000–25,000 BCE. 4 3/8". Lefteris Tsouris/Shutterstock.com.

We seldom find human figures in prehistoric art—a message in itself about peoples' views of their stature in nature—but when we do find them, we discover how much they have to say. In an ancient painting from a cave in Algeria, humans are dwarfed by the larger animals that surround them. And the Venus of Willendorf, though only four and three-eighths inches tall (surmised by some to fit perfectly into a closed palm perhaps during childbirth), depicts an undeniably hearty image of a female who gives birth and provides food.

In stark contrast to hidden cave paintings and tiny sculptures, the ancient Egyptians carved giant, rigid figures that represented powerful pharaohs who did not defer to nature but rather dominated their landscapes. Their bodies are archetypal forms, static and predictable, not portraits recording individual features.

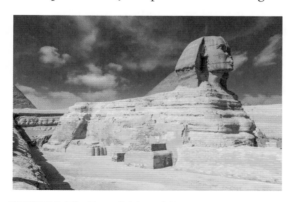

FIGURE 3: The Great Sphinx of Giza, Egypt, 2588–2532 BCE. 66' × 63' × 241'. Anton Belo/Shutterstock.com.

Carvers had to obey a strict formula to satisfy a culture that prized changelessness, even into the afterlife. The strength of these figures was seen to keep the shifting sands of their world in order, and any variation could compromise the well-being of an entire empire.

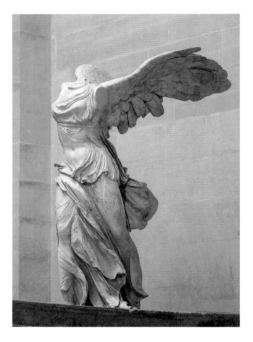

FIGURE 4: Winged Victory: The Nike of Samothrace, Greek, c.190 BCE. 96". muratart/ Shutterstock.com.

The ancient Greeks borrowed sculptural ideas from the Egyptians but radically changed their style, basing their art on a way of life that respected the here and now rather than the afterlife. They too made archetypal figures, but in more naturalistic forms; even an eight-foot tall goddess like the Winged Victory looked like a real woman.

Nike, the goddess of victory, traveled swiftly on her wings. Despite her status as a goddess and a symbol of military conquest, her draped garments reveal her human form. Greek figures such as the Nike often appeared outdoors, not subdued by the forces of nature like the small figures in cave paintings, but enthralled by human accomplishment. Another favorite subject for Greek sculptors was the victorious athlete whose perfect body celebrated human potential. Some Greek sculptures reveal the unique faces of real people, but idealization usually won out. The Greeks worshipped beauty as a god; their figures reflected this devotion.

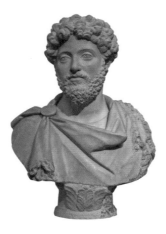

FIGURE 5: Bust of Marcus
Aurelius, Roman, 100s CE. 26 1/4".
Kamira/Shutterstock.com.

The Romans, on the other hand, demanded true portraits in bronze or marble to preserve the distinct appearance of each person. You might recognize the face of Marcus Aurelius but maybe not the rest of him. While Romans believed in accurate portraits, they admired idealized, Greek physiques, and probably gave him a better body than he actually had.

Byzantine and Renaissance Art

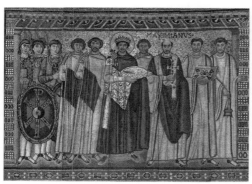
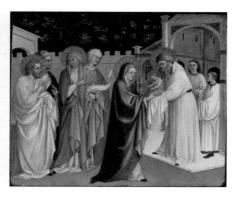

FIGURE 6: Mosaic of Justinian and Retinue, Church of San Vitale, Ravenna, Italy, c.546 CE.

FIGURE 7: Alvaro Pirez, *Presentation at the Temple*, c.1430. 3/8" × 15 7/8".

In Byzantine and Renaissance times, figurative art was closely tied to Christianity. For several hundred years, figures depicting biblical stories were formulaic and

flat, as they appear in a sixth-century Byzantine mosaic from San Vitale in Ravenna, Italy. But during the Renaissance, painters, among them the Portuguese artist Alvaro Pirez, portrayed people as more than symbols, giving them naturalistic forms, closer to what the Greeks had accomplished more than three thousand years earlier. The period nurtured intellectual curiosity, and religious concerns were combined with the study of humanity. Figures in paintings started looking more like real people, though idealized and beautiful. They told us stories from the past, but the present moment became something delectable.

Iranian Miniature Painting

FIGURE 8: *Khusraw at the Castle of Shirin*, early fifteenth century. 10 1/8" × 7 1/4".

In art of the Islamic world, where human representation was often prohibited, artists did include humans to illustrate stories. The figures tended to be stylized rather than naturalistic in paintings that also record a rich history of architectural and garden design. At the same time, some artists painted portraits, particularly of royalty. At no time, however, does the human figure appear in art inside a mosque, and God is never painted in any setting. The Prophet Muhammad, always veiled, appears in a few rare paintings.

West African Mask

The mask is a dramatic form of human representation. In West Africa, it has many roles, among them to connect the wearer (and by extension the rest of the community) to ancestors who represent stories and guide moral behavior. The mask gives us a close look at cultural values that go back a long way and are still very much alive.

This is the mask of mind itself.
Robert Ferris Thompson[3]

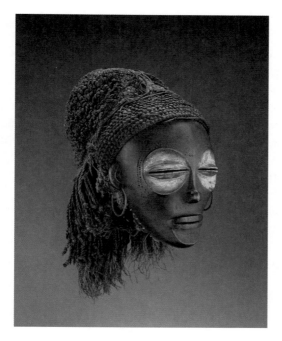

FIGURE 9: Face Mask (*pwo*), Chokwe artist, early twentieth century. 15 3/8" × 8 3/8" × 9 1/4".

What do you see?
○ A wooden mask.
○ Half-closed eyes.
○ Firm flesh.
○ Scarification or tattoo designs.
○ Elaborately braided hair.

What does each visual element possibly refer to?
o Beauty.
o Control.

How do you feel when you look at this mask?
o Cool.

The concept of *cool*, writes art historian, Robert Ferris Thompson, is a "basic West African/Afro-American metaphor of moral aesthetic accomplishment."[4] Cool people show control, composure, and balance. Their communities are more stable because they impart order. Cool connects pleasure and responsibility. It requires humor, charm, and wisdom. If you are cool, you may decide not to reveal emotions, and you carry out difficult tasks with apparent ease.

Cool connects you to your ancestors. If you're not cool, you are disrespectful to them and therefore disrespectful to your present community as well. The cooler you are, the more ancestral you become. "In other words, mastery of self enables a person to transcend time . . . and concentrate on . . . social balance and aesthetic substance, creative matters, full of motion and brilliance."[5] People have "the responsibility to meet the special challenge of their lives with the reserve and beauty of mind characteristic of the finest chiefs or kings."[6] If you are cool, you can restore serenity to another person.

Thompson cites historical and linguistic background for the concept of cool. In the language of the Gola of Liberia, cool is the ability to be nonchalant at the right moment; in other West, East, and South African languages it refers to discretion, healing, rebirth, and newness or purity. "'Cool mouth' (in Yoruba) and 'cool tongue' (in Kikuyu) reflect the intelligent withholding of speech for the purposes of higher deliberation in the metaphor of the cool."[7]

There are more examples coming from Surinam, Benin, and other parts of Nigeria where, as far back as the ninth century, sculpted heads show serenity, a necessary quality in social relations. Yoruba people respect an inner and an outer head. The inner head holds intentions, perceptions, and intuition and is the place of one's essential nature; the outer head displays these qualities. The head is the most important part of the body. It controls the body and its destiny.

Each individual is responsible for respecting the community by behaving in an ancestral way. Everyone is part of a greater community that requires respect, and part of showing it is through attention to the way you look—dress, hair, and facial expression. The visible face displays elegance and composure, but the mask looks inward. It represents self-control. What's within and without come together to make someone cool.

From Past to Present

From prehistory to the present, the human figure in art tells us what is important. In prehistory, when nature overwhelmed them, people were small or hidden. They became large with the Egyptians who sought to control nature and then somewhat smaller with the Greeks who celebrated both nature and the human form by making people look more natural. Then the Romans made them look more like they really did. The early Christians flattened them out in deference to spiritual concerns over realism. And the Renaissance, with its interest in humanism, brought the figure back to life. Throughout time, African masks have been profound renderings of human complexity and the subtleties of relationships.

Who Are We Now?

If human forms in art introduce us to the cultures of prehistory, ancient Egypt, Greece, Rome, Byzantium, the European Renaissance, and West Africa, what do contemporary forms say about the way we live now?

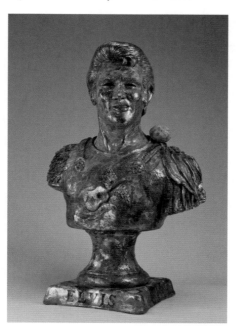

FIGURE 10: Robert Arneson, *Elvis*, 1978.
47 1/2" × 31" × 18 7/8".

13

Many people will recognize the face of Elvis Presley because he was a famous performer, known throughout the world. Here, however, he turns up as a Roman emperor. Like Marcus Aurelius, a broad-shouldered Elvis sits on a pedestal, gazing imperiously over our heads. But while an emperor wears armor as a symbol of his strength and power, Elvis wears a rock on his shoulder and a guitar on his chest. The names of his more famous songs are pressed into the base that holds him up, and at the back, we see the carved-out shape of a heart ("Sing Your Heart Out"). Robert Arneson painted Elvis and his pedestal gold, a nod to the glitter of show business and to how dazzled we are by fame.

FIGURE 11: Tony Cragg, *New Figuration*, 1985. 110" × 169 1/8" × 2 3/4".

Think of a spent plastic cigarette lighter. . . . It is good for nothing now though the story of its function surrounds it. . . . What is the lighter, in fact, made of? Petrochemicals, remnants of ancient life. The chemicals were cooked together by humans rather than spewed from a volcano . . .

Peter Schjeldahl[8]

Using already existing materials . . . brings a real place and time into the aesthetic reality.

Julian Schnabel[9]

Rather than a man on a pedestal, Tony Cragg's contemporary man is a flat figure on a wall, swooping around a corner and made from a mosaic of the plastic he throws away: fragments of plates, cutlery, children's toys, containers of various sorts, and a cigarette lighter. Cragg retrieved these bits and pieces of formerly whole objects from a junkyard, keeping the mud they had picked up after being discarded, and assembling them to make a man.

Tony Cragg is a scientist who likes to make order, and he does that here by carefully positioning the shapes of fragments to suggest organs of the body, altering their original meanings by composing them into another form. The fragments were once whole and had a purpose. Now they're broken and discarded but made useful again as part of a work of art, no longer just junk.

What might you think if you found the same plastic in an archeological dig a thousand years from now? How would you describe the people who made things nature couldn't decompose? Looking at them now, in a new context, you can become an archeologist of the present. What do you think of a man who is made of plastic? How were the objects lost? Would you moralize about waste and the alteration of nature through the cooking of petrochemicals? Or would you consider ways in which plastic has improved modern life? Do the things people use become part of them?

Some people see broken objects as records of time passing and reminders that everything changes. It may be that none of this occurs to you. Maybe this sculpture is merely a record of the objects that are in it.

The man represented in *New Figuration* doesn't make what he needs from natural materials but rather buys and uses plastic things. Would the ancient Greeks have made such a man? Apart from the obvious material difference, what else differs here from classical Greek sculpture? The Greeks give us idealized visions of humanity, and the Nike of Samothrace is an archetype of their mythology. Would they have made a fragmented person out of any material?

We can't be ancient Greeks; we don't see the world the same way, but we can look at their art and ask questions that help us discover how they saw the world. Neither Tony Cragg's figure nor the Nike record reality, but both explore notions of truth.

Art had to become African, African American, if I was going to continue it as a career. It became my mission to further these cultures. This is why I'm an artist. I'm like a warrior.

Marita Dingus[10]

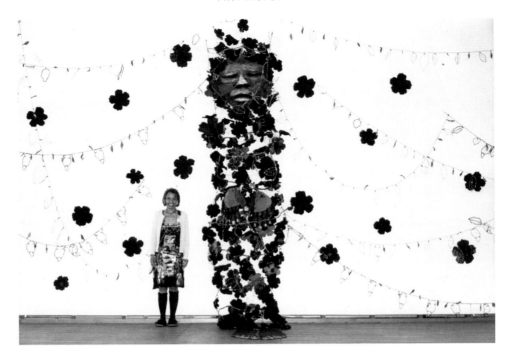

FIGURE 12: Marita Dingus, *Woman as Creator*, 2002. 18' × 5' × 5". Image of artist Marita Dingus standing next to sculpture.

The man in *New Figuration* is anonymous. He is literally and figuratively flat, communicating no interior life as he moves across the wall and around the corner. He is attached to the wall both actually and symbolically; though he appears to curl through space, his body has no volume and needs to be supported. He is nothing more than machine-made plastic. By contrast, in 1984, while artist Marita Dingus was in graduate school at San Jose University, she recalls a mentor remarking that her art looked as if it wanted to come *off* the wall. Her figures do seem alive. They are vulnerable and tough, beaten and surviving, recognizable and unknown. They reveal the dramas of their lives, pull us in, and make us characters in their stories.

Like Tony Cragg, Dingus constructs her figures of scavenged materials, but her choices are more varied: combs, bottles, socks, wire, leather, lids from juice cans, strips of fabric, and other discarded things. In her smaller works, the core to which she adheres these materials is often a bottle—with its ketchup, bleach, or syrup label still attached. These choices may refer to a kitchen, to people relegated to domestic work or enslavement, or to poverty that requires people to reuse discarded objects. At the same time, she is reusing discarded waste and not wasting it. "Dingus is compelled . . . by deep cultural affinities with Third World waste-not

ethics and an over-riding metaphor: creating art out of cast-offs is like giving recognition to previously dishonored peoples, her African American kin in particular."[11]

What are "Third World waste-not ethics"? I lived for many years in Southeast and South Asia where I saw people reinventing cast-off objects into containers, clothing, jewelry, fuel, toys, decorations, and even prosthetic devices. The poor saw the potential in nearly everything. Waste is a form of dishonoring. We throw things away when we consider them unworthy, but Dingus honors so-called discards to give life to the figures she makes.

These figures bear the scars of their existence in her innovative art. She makes something new but refers to traditional West African figures and their decorative scars. She conjures the past, the African diaspora, and the people who lived through it. The figures themselves are reliquaries of objects still vibrating with former life; she restores them to an honorable place and use.

Art made by Robert Arneson, Tony Cragg, and Marita Dingus holds ideas that go beyond the objects themselves. *Elvis* raises questions about our heroes, *New Figuration* about the things we make, use, and waste, and *Woman as Creator* about "previously dishonored peoples." Like all art, these works are meditations on their own times and places and also about every other time and place. What might the Venus of Willendorf say to *Woman as Creator*?

We know we are more complex than our outward appearances, but that doesn't prevent us from reducing and simplifying others. Art wakes us up to our tendency to do that. It guides us toward complexity we can't see at first. When we go back in time and look at older art, we tend to simplify it by fitting things into categories and making comparisons to what we know. It's normal to do that, but watch out for narrow categories. We can't have dinner with cave people and ask how the hunt was, but we can look at their art and ask questions that give life to that time and place. A seventeenth-century Iranian garden and a twentieth-century American diner will do that later in this book when they ask one another why they look the way they do.

People in art lead us, through our questions, to discover what's around them (and to notice what's around us). And then we can ask more questions about their answers.

What guided their lives?
○ Nature?
○ Unseen spirits?
○ Sacred writings?
○ Gods?
○ Ancestors?
○ Religious leaders?
○ Written principles of government?

Who were their leaders?
○ Priests?
○ Healers?
○ Tribal chiefs?
○ Kings?
○ Military generals?
○ Elected officials?
○ Entertainers?

Like art, people are made of surface and depth. We recognize them, but at a first meeting, we only know them a little. They introduce themselves through their faces, bodies, colors, and shapes, but it's just the beginning. What appears obvious or easy to understand, like the tiny stick drawing in an ancient cave, is much more than it seems. In the human figure, artists deliver large ideas through small details and create a certain order we hadn't considered. They make the familiar look strange so that we can rediscover what's around us and search for ideas in what first appears simple, like a figure made of discards. Each of us, now and in the past, has a story to tell.

NOTES

1. David Barr, *Nets*, 1988, film and essay produced by Macomb Community College.
2. August Rodin, quoted in Sylvan Barnet, *A Short Guide to Writing about Art* (New York: Longman, 1997), 162.
3. Robert Ferris Thompson, "An Aesthetic of the Cool," in *Uncontrollable Beauty: Toward a New Aesthetics*, ed. Bill Beckley with David Shapiro (New York: Allworth, 1998), 373.
4. Thompson, 371.
5. Thompson, 372.
6. Thompson, 374.
7. Thompson, 373.
8. Peter Schjeldahl, *Tony Cragg 1975–1990* (Washington, DC: Corcoran Museum of Art, 1991). Exhibition brochure.
9. Julian Schnabel, quoted in James Hall, *The World as Sculpture: Changing Status of Sculpture from the Renaissance to the Present Day* (London: Chatto & Windus, 1999), 106.
10. Marita Dingus, quoted in Vicki Halper, *Marita Dingus: Waste Not* (Seattle: Francine Seders Gallery, 2003), 5.
11. Halper, 5.

CHAPTER 2

Figure Things Out

Figure Things Out

Intelligence is not what you know—it's how you behave or think when you don't know. Intelligence is the independent creative and critical response to an unknown circumstance.

David Barr[1]

What Else Is in the Picture?

Paying Attention to Context

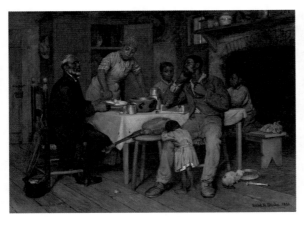 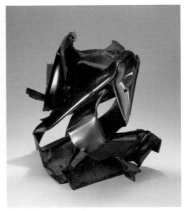

FIGURE 1: Richard Norris Brooke, *A Pastoral Visit*, 1881. 47" × 65 13/16".

FIGURE 2: John Chamberlain, *Untitled*, 1961. 23" × 23 3/4" × 22 1/4".

Two very different works of art here, a painting and a sculpture, different times and places. Where do you start? Start with the forms you *see*.

Forms in art are like words in a play. They have *denotations* and *connotations*.

A door on its own is just a door. That is its denotation. It is what it is.

A door in a painting says something depending on other things in the picture. That is its connotation. It means something in the context of what is around it.

A word on its own is just a word. It has a literal meaning, its denotation.

A word in a play connotes feelings and ideas that vary with the context.

A painting is a kind of play or drama in which forms have meaning in context. Everything in a painting takes meaning from its context.

When you study a new language, you pay more attention to denotation or literal meanings because you must concentrate on the difficult task of learning many new words and phrases. When you have experience with a language, you understand the connotations of words and phrases or how their meanings change in different settings. Behaviors also change meaning depending on their context.

Low Context Communication

If people tend to be direct and explicit when they talk to one another, they are said to use *low context communication*. Germans and North Americans favor low context communication. Low context communication also takes place among politicians drafting legislation or lawyers in a courtroom. They must be careful that each word they use is precise because shortcuts can lead to misunderstandings.

High Context Communication

If people tend to be indirect and use silence and timing as part of their language, they are said to use *high context communication*. Japanese and Native Americans favor high context communication. High context communication also takes place among intimates such as spouses, twins, or close friends and also among people in

professions that use specialized vocabularies, as doctors may in discussions among themselves about a patient's disease. People using high context communication share meanings outsiders tend to miss.

Anthropologist Edward Hall developed the concepts of low and high context communication to explain how context affects meaning when people talk to one another.[2] Objects, too, have different meanings in different places.

Art is very high context.
Everything matters.
If you change the context, you shift the meaning.

The artist Henri Matisse wrote, "The whole arrangement of my painting is expressive. The place occupied by figures or objects, the empty spaces around them, the proportions, everything plays a part."[3] That means he makes every mark for a reason, each is connected to others, and he gives them meaning by arranging them in a particular way. In other words, the context of each mark gives that mark its meaning. And the figures and objects in his art gather meaning from everything else around them.

Richard Norris Brooke would likely have agreed. His people and objects are like actors in a play who invite you into their story. Brooke gives us a title that tells us a little—that this scene takes place in a rural setting. But where exactly? He is an American artist, and the work is dated 1881. That's all we know. We can look him up and learn more. But at the moment we confront this painting, we complete its story and infuse it with our own feelings.

Keep in mind that the artist *decided* which people and objects to paint and how to group them to construct a visual narrative. Everything in the painting takes its meaning from the context.

It may be easier to figure out the connotations in a painting when you recognize people and things. But what about an abstract sculpture like the one by John Chamberlain?

Start with yourself.

What do you see?
○ Bent metal.

Where is it?
○ In a museum.

What does it remind you of?
○ A car wreck.

Why?
○ The metal looks as if it came from cars.

What is it now?
○ A sculpture.

How did the artist make it?
○ By twisting metal, enameling and welding.

What is it about?
○ A shape.
○ An idea.

What shape?
○ Like a twisted plant.
○ Or maybe just a shape.
○ An idea of a car wreck.

What makes you think that?
○ It looks like pieces from a car.

What do those pieces make you think about?
○ Junked cars.
○ Speed kills.
○ Environmental pollution.

What if this shape were made of wood?
○ It would look like a carved shape.

Would that make you think of cars?
○ Of course not.

So . . . pieces of junked cars show up in a museum, a new context. An artist had painted, twisted and formed them into a shape. He chose his pieces carefully and welded them so that we can see how he attached them. He didn't try to hide that process, maybe as a way to refer to the welding used to make cars.

If you saw the same pieces of metal in a junkyard, would you think of a piece of art? Our understanding of most things depends on where they are. In a museum you can appreciate the bright colors and the dynamic shape that makes the sculpture look like it's moving. Actually, we are the ones who move. We do

the thinking—of a car crash? Of speed? At this moment we are not on a highway. We are in a quiet museum. We impose the context.

Of the two works of art you've just seen in this chapter, which is the easier to interpret? Most of us would select *A Pastoral Visit*, a painting within a frame that shows recognizable people and objects in a setting where you might find them. The John Chamberlain sculpture is an abstraction that suggests ideas. Abstract art and ordinary objects out of context challenge and confuse us.

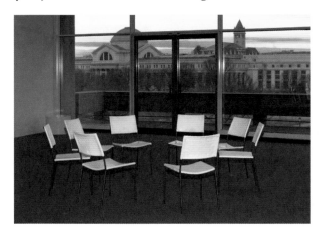

FIGURE 3: Franz West, *Levits*, 2001–06. 34 1/2" × 18" × 22" each.

We assume that there is a proper place for certain things. But when Austrian artist Franz West made chairs and placed them near parked cars in a city, their new context made people think about them differently. Where is it suitable to sit down? What happens when you sit down near a busy street? Are you comfortable? Do passersby question your sanity?

Later, when his chairs were installed in the Hirshhorn Museum, they surprised viewers by being a form of art they could move and sit on. This is not what people usually do with the art in a museum. They could not only go beyond the frame by touching; there wasn't even a frame. West uses context as a device to make us question the use and meanings of ordinary objects when we find them in unexpected places.

What Makes the Familiar Strange?

Hiraki Sawa also raises questions about familiar objects by bringing them into settings where you don't typically find them. Here he manipulates the context to evoke powerful feelings and ask for your understanding and compassion.

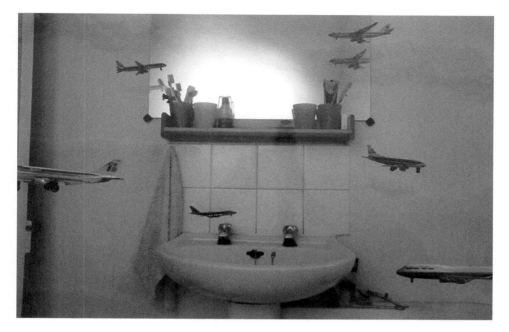

FIGURE 4: Hiraki Sawa, *Dwelling*, 2003. Single-channel video, 09:20 mins.

Hiraki is a contemporary Japanese artist. In 2003, he made a video that expressed his feelings of being uprooted from his home. He shows us the plain London apartment where he lived as a graduate student at the Slade School of Fine Art, but as the camera moves through its rooms, something unexpected happens. Small jet airplanes, marked by logos from different commercial carriers, fly through doorways, rest briefly, and take off again.

Curator Gregory Volk,[4] in a brochure that accompanied the video when it was shown in 2005 at the Hammer Museum in Los Angeles, wrote that airplane travel is likely to be inevitable when living between cultures. Planes drifting randomly through space provide a useful metaphor for feelings of displacement and loneliness. Longings for home can be overwhelming.

Hiraki's apartment is unappealing. He hasn't lived there long enough to give it the personal touches that would make it feel homey. And it is even less welcoming to him as a visitor from a culture where living spaces are designed and arranged differently. In this film, not only is the apartment dull and unfamiliar but it is invaded by airplanes that undo any possibility of it feeling secure. You may never have traveled, but you can understand how wobbly this temporary home feels to the person who lives in it.

The artist does not attempt to simulate reality. His video does not tell a story of an actual event. He uses airplanes metaphorically to convey his sense of being

25

uprooted. But their presence inside his apartment will remind many of a real invasion into different interiors. Since September 11, 2001, Americans and others have lived with the horror that came from watching actual planes fly into the World Trade Center in New York City, seeing benign forms of transportation turned into instruments of terror. When we see planes enter any building, past experience takes us beyond metaphor to a macabre reality, and it is not possible to talk about this video without mentioning that other connection. But Hiraki Sawa has another objective and uses the images to tell a different story.

In *Dwelling*, the planes do not roar, and this makes watching them glide through the artist's apartment an even more bizarre experience. The silence could also refer to feeling closed out by language since as a speaker of Japanese, Hiraki may have lived through a "silent" time among English-speakers before he could understand and communicate easily. Even people who are fluent in a second language miss incidental remarks they would easily comprehend in their first language. Silence, or sound, in a work of art is part of its story.

Silence and Noise

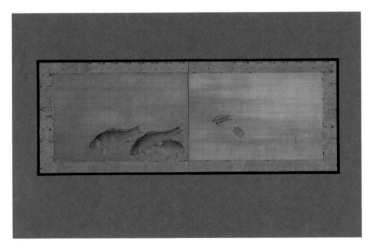

FIGURE 5: Maruyama Ōkyo, *Carp and Turtles*, 1770/1795. 30" × 76".

The creator of *Carp and Turtles* designed a small screen for a particular place, not a museum wall, but as a backdrop for the Japanese tea ceremony. He painted on silk, using subdued colors and placing the carp and turtles of the title near the bottom where kneeling participants could easily see them. Most of the screen is space, perhaps suggesting the depth of a sea that is silent to

most ears. The tea ceremony, formalized and slowly enacted, is a silent ritual. Participants find silence within themselves by concentrating on the exacting motions of preparing and taking the tea. The people and the art communicate eloquently through silence.

Eighteenth-century Japanese people, at the time this screen was made, easily understood why Maruyama Ōkyo emphasized space. To them, space held promise and communicated fullness, not emptiness, and they knew that silence and space live in a close relationship. In open space, you become aware of your own smallness in relation to the greater whole. Openness also suggests accelerated travel through space and time as you will later see in a Chinese scroll. Western art uses the term "negative space" when things are visually open. In Japan, this same open space is considered potential space.

Contemporary Japanese people, whether they practice the tea ceremony or not, use silence in their everyday exchanges more than people in many other cultures. But silence is powerful nonverbal communication everywhere. In conversation, silence can signal profound respect or disrespect; it can encourage or discourage dialogue, provide space for thought and insight, and give deference to another voice. In art as in life, the meaning of silence changes and communicates through context.

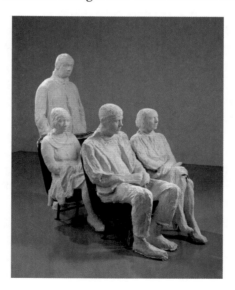

FIGURE 6: George Segal, *Bus Riders*, 1962.
70" × 42 3/8" × 90 3/4".

Four people ride on a bus. Three sit; one stands. George Segal placed his figures on scavenged vinyl and steel seats, but his is no ordinary bus. He made this sculpture at the time of the civil rights movement in the United States.

27

Segal formed his figures of white plaster. Artists typically begin their sculptures with an armature of wood or wire to support clay or other material while they work. But for *Bus Riders*, living people agreed to let Segal wrap them in damp gauze saturated with plaster. When the gauze dried, he removed the molds in pieces and reassembled them into whole sculptures. At the time, doctors used the same material to create casts for broken limbs to keep them rigid so they could heal.

These models were human armatures wearing everyday clothing, so we see the folds of their coats, the outlines of their shoes, and even a woman's purse. The artist shows us people doing something ordinary, riding on a bus. But the final sculpture transforms that activity into an extraordinary drama.

Segal's figures appear ghostly, lending them a deep silence. Their silence separates them though they sit close to one another. Why are they so silent? Is this a typical day, or is something else going on? Why does a single figure stand behind the others, watching over an empty seat instead of sitting in it? Segal may have been referring to a silent protest against segregation when Rosa Parks, an African American woman, sat down on a bus seat to assert her right to do so.

The plaster is a shell or veil that reveals only a small number of personal details. How would it feel to be wrapped in plaster so that others see nothing else of you? What is it like to be seen by skin color or another external characteristic that tells little of a complex personality? The artist does not state his intention in words. He asks that we observe this quiet work, sense the effect of the plaster and silence, and inquire about the details, including the title and the date it was made. The general title, *Bus Riders* could signify any bus riders, but the date is a critical part of the context and deepens the work's meaning.

Bus Riders and *Carp and Turtles* were made in different places for very different reasons. *Bus* carries you into an everyday activity, and *Carp* exists in a special place, separated from ordinary life. Both, through an intentional use of silence, take you beyond appearances to meanings within you and within the larger context of their cultures.

Noise and silence, like presence and absence, have been part of art's language for a very long time. *Carp and Turtles*, inspired by spiritual practice and religious texts, communicates silence through traditional materials used for making Japanese screens. Artists often use paper but this particular piece is made by painting with ink and watercolor on silk, an elegant and valuable material. Viewers seek the silence within the screen to quiet themselves by participating in a well-established ritual. By contrast *Bus Riders* communicates a different, noisier kind of silence through nontraditional materials and methods. Rather than explicitly referring to known texts, it suggests an open-ended story. The viewer must participate to continue the story.

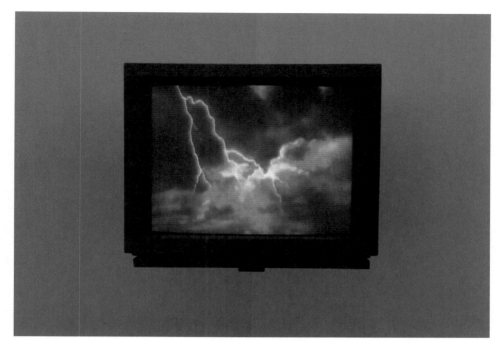

FIGURE 7: Christoph Girardet, *Enlighten*, 2000. Single-channel video loop, 05:10 mins.

In 2007, Washington, DC's Hirshhorn Museum showed a film with no particular beginning or ending. The artist, Christoph Girardet, made it by piecing together clips from commercial movies in which thunder and lightning had been used to add drama and heighten emotional responses to stories. The storms were not natural but produced by studio sound effects.

You've probably watched films that used the ominous sounds of thunder to make you feel uneasy. These special effects told you what to feel about the action in a story, but in this installation, Girardet's intention is different. He gives viewers a noisy storm with loud thunder and bright lightening and then stops it all to leave them in darkness. His film reaches for people's separate reactions to first being bombarded with light and sound and then suddenly left with silence and night. Because the special effects are separated from the original stories, people watch them as isolated light and sound and react as they wish rather than taking instructions from a film director. He places viewers at the center of the action, and that makes each story different. Silence and noise, light and dark, are only devices, not resolutions to a story. The story is in you, and you come to your own conclusions. The title, *Enlighten*, may be a metaphor for self-revelation and insight.

What Time Is It?
What Do Tradition and Innovation Tell Us?

Art's traditional goal, until sometime in the nineteenth century, was to teach history, mythology, or religion through a one-way communication from the work to the viewer. But much changed when artists recognized that the viewer's perception and intelligence also shaped the meaning of a work. That introduced an element of uncertainty in any intended message. Argentine author Jorge Luis Borges validated the reader's or viewer's participation in a work of art by identifying it as "commerce," another word for back-and-forth communication. In 1972, he wrote, "Poetry is in the commerce of the poem with the reader, not in the series of symbols registered on the pages of a book."[5] You've seen turtles and lightening as symbols, but it turns out their meanings are not fixed.

Artists responded to their own perceptions by inventing new modes of expression. And then things got complicated. They didn't completely abandon traditional art but moved toward new modes of communication.

Tradition and Innovation: The Collective and the Individual

Every great painting carries within itself the history of other great paintings.
John Russell[6]

Honor what they bring; it will bear poetry later.

Rika Burnham[7]

Tradition

In Art
Artists use established theories, styles, and materials.
They repeat familiar themes.
Meanings tend to be clear.

In Life
Values and customs are transmitted from one generation to another.
Communities and collectives share traditions.

Innovation

In Art
Artists experiment with new theories, styles, and materials.
Themes vary.
Meanings tend to be ambiguous.

In Life
Invention leads to alterations in values and changes in customs.
Individuals experiment with varying lifestyles.

Past, Present, Future

Preferences for tradition or innovation hook up to people's attitudes toward time. Anthropologists Florence and Clyde Kluckhohn examined values by questioning whether particular cultures looked more to the past, present, or future. They found that cultures oriented toward the past look to their histories to support their values. Those oriented toward the present tend to make the most of what happens now with less regard for the past or for planning ahead. And cultures that are future oriented think of innovation as progress.

The Kluckhohns recognized the limitations of their categories since people hold varying beliefs within a single cultural group. Some people reject or question what they consider outmoded values or behaviors yet continue to respect the traditions of their childhoods. They may thrive on new ideas but rely on the past to guide them. Lines blur between established practices and new ways of doing things. But it is useful to examine tradition and innovation to search for values that lie beneath these concepts.

Traditional Art

Traditional art conforms to practiced ways of making things. It tends to reflect cultural values by giving a visual form to people's pride in their inheritance and creating an embodied sense of identity among those who share a heritage. Traditional art communicates respect for history and for ancestors. In difficult times, it may provide hope to a community and the possibility of healing. It can be a guide through passages from childhood to adulthood and from birth to death and remind people of right ways to live.

People within a culture feel at home with the arts of their traditions and believe they represent correct ways of making things. Correct or not, both insiders and outsiders identify certain styles with specific cultures. That means you might connect African masks, Hindu statues, Chinese landscapes, Japanese screens, and Native American sand paintings to the places they came from.

Architects and city planners sometimes use traditional art for special reasons. In the West, the Greek classical style implies respect for the past and a continuation of certain cherished principles. Several buildings on the National Mall in Washington, DC have Greek columns and friezes, and this "neoclassicism" adds a sense of grandeur and stability to a city committed to democratic principles. You will also find a Norman castle and an Egyptian obelisk. Forms from the past can stand for values in the present that are meant to encourage the right kind of future.

The Figure in Traditional Religious Art

Most traditional art has a function. It teaches, evokes feelings, presents ideas, or connects the mortal to the immortal. Tradition is particularly important in the making of religious objects so that believers easily recognize forms or figures that repeat known themes. Innovation or change might divert attention from their purpose as objects of meditation or reminders of communal values. Adherents sense something profound in them that goes beyond the figures themselves—perhaps a cosmic sense of connection to deep spiritual values and a sense of inner peace and solace. When certain religious objects are designated as art, it is often because of their refinement. Experienced artists have made them as perfectly as possible to imbue them with great feeling.

Artists who make traditional art are not expected to innovate or invent but rather to perfect themselves through knowledge and the practice of repeating certain forms over and over. Rather than seeking individual recognition, they are instruments of the process. Mythologist Joseph Campbell wrote, "Indian art is a yoga and its master a kind of yogi,"[8] working under the guidance of a recognized master who ensures that the tradition moves from the one who has practiced to the one who must learn to practice. Novices go through long apprenticeships before they are eligible for commissions to make sacred objects. By then, they have studied texts of postures, symbols, and proportions and prepared themselves by meditating and envisioning the result. Works become revelations, not of supernatural beings but of powers of nature latent in the artist who can pass on an understanding of immortality to ordinary people.

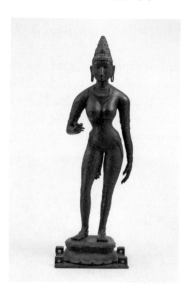

FIGURE 8: Queen Sembiyan
Mahadevi as the Goddess Parvati,
Chola Dynasty, tenth century.
42 1/4" × 13 1/8" × 10 1/8".

The Hindu statue has an important function because, after the priest performs proper rites, the deity temporarily dwells in it. Humans caught in the cycle of birth and rebirth can only detect parts of the whole, but through contemplation, they come to grasp their connection to a larger creation. The priest helps devotees perceive a divine essence and cosmic order they otherwise could not grasp.

Hindu worshippers recognize that their understanding of life is fragmentary. To see more fully, they contemplate traditional figures that embody many aspects of the whole. Devi, for example, embodies the benevolent mother, bringer of fertility, insurer of success, and protector of individuals and towns. As the female aspect of the godhead, she personifies love, gentleness, the continuation of family and community, and the power to destroy evil.[9]

In the manifestation you see here, she looks down because *seeing* is a significant activity. Only when a visitor to the temple participates in the ritual of "darsan," or the act of seeing the image of the deity, does the god symbolically return the gaze. They make contact through their eyes, an act of great intimacy. Seeing, among observant Hindus, is like touching; therefore eye contact in public, even among intimates, may be inappropriate.[10] In some cultures, people who don't look directly at others may seem devious or untrustworthy or to suffer from low self-esteem. But among Hindus, who apply other meanings to eye contact, this judgment would not be appropriate.

The Horse and Rider in Traditional and Innovative Art

Cultures use particular forms or figures to signify ideas and communicate values. Similar types of figures appear all over the world but look vastly different depending on when, where, and why they were made. Throughout history and in many cultures, the horse and rider show up as symbols of status, power, or wealth, and, in some cases, less desirable qualities.

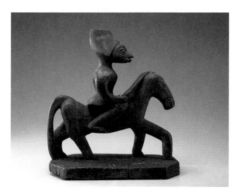

FIGURE 9: Horse and Rider, Yoruba Peoples,
early twentieth century. 17 3/4" × 15 /8" × 7".

In Yoruba culture, the mounted Shango, god of thunder and lightning, rides "fire like a horse." As Ogun, god of iron and warfare, he symbolizes political and social mobility and represents conquest in actual battles as well as supernatural engagement.[11] The Yoruba rider sits firmly on his horse, as tradition dictates. His knees grasp the animal, his back is straight, and he looks ahead with clear eyes. If he were riding to battle as a member of a cavalry, he would see clearly what he needs to do. As an individual rider, he is in control. He has tamed the animal, and its power enhances him. The horse does not overwhelm him; he commands and manages its power.

Innovative Art

Italian sculptor Marino Marini reverses this traditional depiction of a man dominating an animal. His rider does not control a horse that throws its head upward and spreads its four legs to remain stationary. The rider has small eyes and is not looking toward the glories of battle but sits awkwardly with his arms up and his legs angling out. He is also not a figure of high status or nobility but an anonymous person who struggles not to fall. Here Marini invents a form to express his personal reaction to the horrors of war. Artists who innovate assert their individuality.

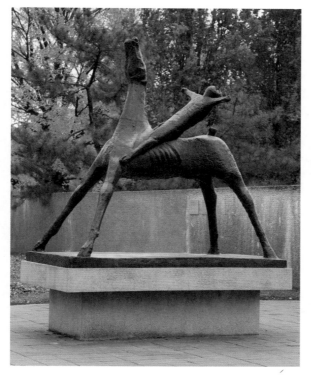

FIGURE 10: Marino Marini, *Horse and Rider*, 1952–53.
81 1/2" × 47 × 77 3/4".

Both the Yoruba sculpture and the one by Marino Marini look to the tradition of saying something important through the horse and rider. But the artists made them for different reasons. The Yoruba piece from West Africa comes out of an established spiritual and *collective* heritage that uses the horse and rider to express power and control. It teaches the value of self-control. By contrast, Marini engages in an act of *individual* creativity, and he uses the horse and rider to express human vulnerability. Artists of his time and place tell personal stories and share emotions through innovative methods. His art doesn't instruct but rather confronts us with new ways of looking at the world. It raises questions rather than presenting certainties.

Innovation may also show up in small changes. The great Italian painter Giotto was innovative in the thirteenth and fourteenth centuries when he did not supply inscriptions for some of his frescoes.[12] He used themes from biblical texts for which inscriptions were expected, but he wanted visual images to speak for themselves, and people judged this seemingly small change as revolutionary. It was surprising because many years earlier, in the Middle Ages,

Pope Gregory the Great had justified such a practice by stating that the unlettered could "read" pictures by looking at them—without written descriptions. Still, seven hundred years later people saw Giotto as innovative. Tradition is very durable.

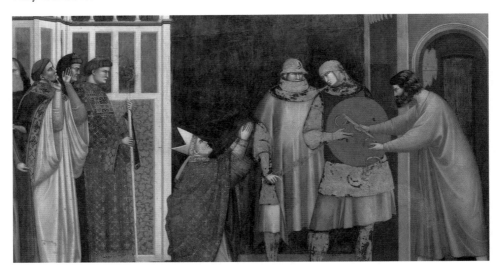

FIGURE 11: Giotto di Bondone (1266–1336), Scenes from the Life of Saint Francis: Liberation of the Heretic Pietro, detail.

Giotto's painting *Scenes from the Life of Saint Francis* does have a title but no other inscriptions. He probably expected his viewers to know enough about the life of Saint Francis to understand the narrative.

Styles of making things and choices of subjects often take root in the past and change in the present. When you recognize Michelangelo's work, it is because he invented forms. They seem to carry his signature whether his name appears or not. But he, along with many other artists of the Italian Renaissance, looked back to Greek classical figures. In Chapter 9, you will meet Leon Golub, a twentieth-century artist who, when he painted *Four Black Men*, also linked tradition and innovation by referring to ancient Roman friezes but refashioning that form to tell another story. In the same spirit, when Picasso made a Cubist head, it was still a head and often a portrait. But its form was inventive and new, as you will see in the next chapter.

Traditional art tilts toward the past, and people who share similar experiences or religious beliefs understand its shared meanings. Innovation, arising from an artist's poetic intelligence, shakes things up. It is unpredictable, and fewer people share its meanings. Nearly everyone finds innovative art difficult to understand because its meanings are not fixed. But both traditional and innovative art search

for essential truths and try to make sense of the world by telling stories, referring to history, and giving visual form to thoughts and feelings. All art reveals values, anxieties, and desires we share with others everywhere.

Tradition Joined to Innovation

An engagement with a work of art is a beginning, not an end.

Rika Burnham[13]

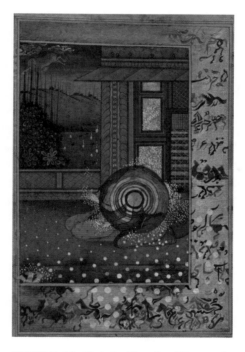

FIGURE 12: Shahzia Sikander, *Writing the Written*, 2000. 8" × 5 1/2".

Pakistani-born Shahzia Sikander began studying miniature painting as a student at the National College of Arts in Lahore, where she was trained under miniaturist Bashir Ahmad. She learned to finish paintings by meticulously applying as many as ten to twenty layers of watercolor and gouache and rubbing the surfaces with a stone to make them shine. In 1993 she moved to the United States to pursue a master of fine arts at the Rhode Island School of Design, and she later helped bring international recognition to miniature painting in contemporary artistic practice.

In her work, we find the original thinking of a contemporary artist who is also a master of traditional painting. Art historian Wendy Steiner might say that she performs as a free individual while investing in collectivities. Her images are layered, and details emerge slowly. Through the act of looking, *you*, the observer, bring together views and insights into tradition and innovation, past times and present moments, her story and yours. You share moments of consciousness and understanding with the artist.

Some of Sikander's works, such as the one pictured here, resemble the appearance of traditional miniature paintings. Those compositions are in the small scale suitable for the pages of a book, but she displays them as separate, framed works, and the subjects are her own. Respecting the geometry of architecture, *Writing the Written* presents an elaborate border covered with calligraphy, animals, and dots meant to enhance the meaning within the picture. The painting includes a circular form at the lower right, behind which you can see two pairs of folded legs. She paints a stylized landscape on the upper left and, on the right, what appear to be windows. There are sprays of dots in several places.

Sikander gives us an imaginative rendering of contemporary subjects using a traditional form. Her work questions patriarchal traditions, and she obscures the conventional representation of male and female iconography by applying an overlaying circular form. She means to expand our thinking about the meanings we apply to gender and sexuality. We recognize objects but find them presented in new ways with references to spiritual beliefs, religious teachings, myths, history, childhood stories, and the importance of community.[14]

In summary, she:
o relates traditional miniature painting to contemporary life;
o presents contrasts between past and present, the ideal and the real, acceptance and disbelief;
o refers to gender, feminism, race, class, ethnicity;
o uses a personal vocabulary of symbols;
o tells underrepresented stories of women;
o reminds viewers of their own stories;
o brings a sense of mystery and discovery to all our experiences.

In recent years, Sikander has expanded her practice to include large-scale floor-and-wall drawings, installations, and multimedia works. She also collaborates with other artists.[15]

We live inside our personal boundaries, our usual ways of seeing. But art takes us to the other side and gives us a chance to enter a different sensibility. It urges us to

confront confusion, try to unravel it, and also to know there will be some things we cannot understand. At the same time, by entering another sensibility, we can form new connections.

Art strives for an essence, and its truths are in its details. But those details don't build to a bigger meaning without your noticing and questioning what is in front of you. The art of figuring things out starts small. Looking and questioning can move you from being a mere traveler to a sojourner, from one who glances at something and moves on, to one who lingers and participates in others' experiences.

NOTES

1. David Barr, *Nets*, 1988, film and essay produced by Macomb Community College.
2. Edward Hall, "The Power of Hidden Differences," in *Basic Concepts of Intercultural Communication*, ed. Milton J. Bennett (Yarmouth, ME: Intercultural Press, 1998), 61.
3. Henri Matisse, quoted in Sylvan Barnet, *A Short Guide to Writing about Art* (New York: Longman, 1997), 28.
4. Gregory Volk, exhibition brochure accompanying *Dwelling* by Hiraki Sawa, Hammer Museum, Los Angeles, California, February 22–June 19, 2005.
5. Jorge Luis Borges, quoted in Alberto Manguel, "The Muse of Impossibility," *The Three Penny Review* 123 (Fall 2010): 8.
6. John Russell, *The Meanings of Modern Art* (New York: Museum of Modern Art, 1974).
7. Rika Burnham, personal communication, Hirshhorn Museum, 1990s.
8. Joseph Campbell, *Myths to Live By* (San Anselmo: The Joseph Campbell Foundation, 1972).
9. Anon., exhibition brochure accompanying *Devi: The Great Goddess*, Freer Gallery of Art and Arthur M. Sackler Gallery, Smithsonian Institution, Washington, DC, 1999.
10. Daniel J. Boorstin, "The Dazzled Vision of the Hindus," in *The Creators: A History of Heroes of the Imagination* (New York: Random House, 1992), 4–8.
11. Mary Nooter Roberts, *Facing Africa: The African Art Collection of the Toledo Museum of Art* (Toledo: Toledo Museum of Art, 1998).
12. James Hall, "Sculpture and Language," in *The World as Sculpture: The Changing Status of Sculpture from the Renaissance to the Present Day* (London: Chatto & Windus, 1999).
13. Rika Burnham, personal communication, Hirshhorn Museum, 1990s.
14. See Shahzia Sikander, *Directions*, November 18, 1999–February 21, 2000, Valerie Fletcher, curator, Hirshhorn Museum and Sculpture Garden, Smithsonian Institution, Washington, DC.
15. See Paul Richard, "Lifting the Veils of Mystery," *Washington Post*, November 21, 1999.

CHAPTER 3

Step Back to Go Forward

Step Back to Go Forward:
Where Art Started and Some
of the Places It Goes

The past is a foreign country . . .

L. P. Hartley[1]

*By focusing on the peculiarly human niche in the continuum, we can
if we wish . . . inhabit the productions of art with the same sense of
beauty and mystery that seized us at the beginning.*

Edward O. Wilson[2]

Since prehistory, it has been necessary to make art to say what was important.
Mysterious as cave painting and prehistoric sculpture are, they send an emotional
charge, and we get that. We sense the passion and experience of ancient peoples, and
because we participate through their art, we recognize our mutual humanity. Their
art belongs to them, and it also belongs to us. We can inhabit their times in our time.

How do you go back to go forward?
○ Look first. Let art grab you.
○ Be quiet and receptive.
○ Be humble. As T. S. Eliot wrote, "The only wisdom we can hope to acquire is
the wisdom of humililty: humility is endless."[3]

How would it feel to make this thing?
Why was it made?
Was it made as art?
For what other reason was it made?

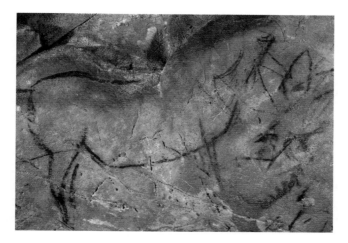

FIGURE 1: A Horse, prehistoric cave painting, Spain, c.15,000 BC.

Humans seem always to have created art. Prehistoric paintings in caves go back about 30,000 years, and there is much we can never know about why ancient peoples made them. It appears they recorded a strong impression of what they saw and of the mysteries of nature that were part of their lives. Long before the rules of perspective were discovered, they strove for accuracy by selecting the bulge in a wall to express the volume of an animal's belly. They responded to a world that was awe inspiring, unknown, and threatening. Thousands of years later, through their art, we sense that world. Art was the language to say what was present.

Things We Can't See and Things We Think We See

Instead of recording the presence of animals, contemporary artists Ann Hamilton and Kathryn Clark paid attention to their absence by using wax, an ancient and traditional material, to make us see what has been lost. In 1991, using about one ton of beeswax, they prepared hundreds of hand-cut, amber-colored panels to adhere to the windows of the Hirshhorn Museum in Washington, DC. On each, they pressed the name of an extinct species of animal, 107 in all.

The open letters, like stained glass in a church, depended on light flowing through the windows to be read. The artists removed tiny amounts of wax as they imprinted the names, and in doing that, used emptiness to confront us with the extinction of animals, a loss we cannot see unfolding as it takes place. They began their project on the day of the vernal equinox in order to contrast

clock-time to the biological time that was the subject of their work, thereby selecting methods and materials to make visible an invisible process of loss.

The smell of the wax and its rich color attracted people to the panels, but when they absorbed what they were seeing, when they *saw,* they received a sobering message about change. The piece was called *View*.

Wax

Bees, working together, created the wax in the first place. That communal work was continued through the collaboration of the two artists and, later, through the essential help of museum staff to transport and install the squares. Because wax is fragile, easily bending and melting, the panels occasionally slipped from the Hirshhorn windows, and someone needed to reattach them with a heat gun. That led to additional hours of cooperative, daily labor to keep the panels in place so that they would not be lost like the animals they recorded.

The very use of wax in a museum carries a subtle, silent message. Many artists use the lost wax process, a long-practiced and complicated way of making sculpture in which the original form melts away during the heating of a mold. The final piece, a bronze figure, lasts longer than wax, but something has been lost in the process of its making. The original sculpture, the one the artist formed and touched, exists only in memory.

Memory is often recorded on paper (a relatively more durable material than wax), and compiled into books where you might find lists of extinct animals. But you may not feel the emotional impact of loss by reading lists assembled from research. Hamilton and Clark decided to make us pay attention to the fragility of life and its impermanence by using an impermanent material, one that can melt away like the existence of the animals they recorded.

Books

Artist Anselm Kiefer also records the unseen and changing universe but rather than using fragile materials, he introduces a paradox by working with lead, a very durable material that will last a long time. He is fascinated with books that transport us to other realms, and in 2001 he composed charts of stars and placed them in his own eight-foot-high lead book that sits on the floor. He numbered the stars in the way that scientists at the National Aeronautics and Space Administration catalog what they see. But Kiefer uses his charts to question what observers are doing because they may be recording radiant energy from stars that burned out

FIGURE 2: Anselm Kiefer, *The Secret Life of Plants (La Vie secrète des plantes)*, 2002. Lead, oil, chalk, pigment. 76 3/4" × 118 1/8", 700 kg. National Gallery of Australia, Canberra.

a long time ago, leaving only their light. Because it takes a long time, light years, for that light to reach their instruments, astronomers may see only traces, not the stars themselves.

An eight-foot lead construction is an odd sort of book. You can't hold or read it in the usual ways. But Kiefer has his reasons. Like many artists, he uses irony to carry us into mystery. On lead that will last a long time, he records stars that may have disappeared. Light is ephemeral. You can't hold it, but you can see it. It moves. Lead is steady, and you can touch it, but you need to be careful because it can be poisonous. If Kiefer's book were made of paper, he may have written on it using a lead pencil.

Hamilton and Clark transferred to wax tablets what they learned from books. Their wax tells the story of disappearing animal life and will, itself, disappear. Cave paintings, which came before writing, are, in a sense, the books of 30,000 years ago. Stone caves last a long time, but the paintings on their walls are fading. Any book that records things from the past to be read in the future can disappear.

Anselm Kiefer wants us to see that many things contain their opposites. Lead is durable but bendable, useful though poisonous. Astronomers see the stars they record, but their records may be of something already gone. They see the universe

through their telescopes, and then they realize how much they can't see. They, like all of us, believe what they see is true, and then they confront the limits of their perception.

Consider

What is wax?
What is lead?
Where does each come from?
How do you usually use wax and lead?
Why did Hamilton and Clark name their piece View?
Why did Anselm Kiefer name his piece The Secret Life of Plants?
What do Kiefer, Hamilton and Clark, and prehistoric artists believe is true?
Do you agree with them?

Time

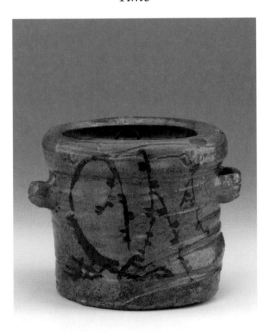

FIGURE 3: Japanese Water Jar for Tea Ceremony, Momoyama period, 1568–1614. 7 1/2" × 9 1/4" × 9 1/4".

Cultures have different attitudes toward time. Some are more oriented toward the past; others look more toward the future. Some cultures believe they should live in harmony with nature; others try to control it.

Attitudes toward time and nature are related. Where people strive to control nature, they tend to look more to the future than the past. Where people believe they should live in harmony with nature, they tend to look back toward ancestral ideas of how to live in the present.

These orientations are inclinations, not absolutes. Behaviors shift depending on circumstances, and everyone lives with contradictions. People who find meaning in a harmonious relationship to nature also use air conditioners. Cultures that prize innovation and change also support established spiritual traditions to guide their behavior. In cultures where people believe that events are fated to happen, they may try to change things through individual initiative.

Some humble objects signify deeply felt beliefs and hold pervasive and enduring concepts. The jar pictured here intends to make time visible. The artist shaped it, glazed it with precision, and then handed it over to a kiln knowing that heat would change it. When a less than perfectly round bowl emerged from the fire, its shape reminded people of nature's power over their lives. Japanese people participating in the ritual of the tea ceremony find the pot beautiful and satisfying because it embodies wabi-sabi. It evokes the mysteries of nature and the effects of time.

Wabi-Sabi

Wabi
refers to humble things and to understatement.

Sabi
refers to things that show the results of time,
of having been handled through long and loving use.

A water jar made by a human being holds respect for nature and submission to what cannot be controlled. A seemingly simple ceramic pot communicates complex, layered cultural ideals. The open bowl is a metaphor for an ideal human relationship to nature. In his book about wabi-sabi, writer Leonard Koren contrasts the bowl to factory-produced commodities.[4] The bowl is a one-of-a-kind object, subject both to the hand of an individual maker and to fire; the commodity is stamped out of a machine. He links cultural appreciation for one or the other to varying perceptions of time and nature and also

to respect for intuition over logic. One orientation is not more worthy than the other.

Cultures and people, all of us, appreciate certain qualities depending on where we are and what we are doing. I include Koren's list here because contrasts help us understand differences between traditional and modernist ways of thinking about the world.

Modernism tends to emphasize the	*Wabi-sabi* tends to emphasize the
public	private
logical	intuitive
universal	personal
belief in progress	belief in no progress
present	past and present
control of nature	uncontrollability of nature
romance of technology	romance of nature
adaptation to machine	adaptation to nature
geometry, precision	organic, softness
box	bowl
manmade	natural
purity	contamination
clarity	ambiguity
light and bright	dark and dim
material	immaterial
everlasting	ephemeral

Both wabi-sabi and modernism reacted to art from the past. Wabi-sabi moved away from elaborately decorated Chinese art from the sixteenth century and earlier, and modernist artists resisted existing academic, impersonal rules for making art that didn't allow them to express what they wanted to say. The two results are quite different. Wabi-sabi is earthy and imperfect while early modernism was often seamless and polished.

Does this mean that Japanese artists do not make sleek, highly finished art? It does not. And does contemporary art from the West, or anywhere else, always look machine-like? No. In fact, some evokes wabi-sabi.

This wall sculpture by Leonardo Drew is composed of boxes along a grid. It is not humble in size, but its message is as personal as the one embodied in the Japanese water jar. Despite its size and severe lines, it too is a meditation on time, nature, and change. In *Untitled (No. 49)* Drew exposed wood and fabric to natural elements that rusted them, making rust a metaphor for time passing. The boxes remind us how the things we collect corrode, deteriorate, and change with time.

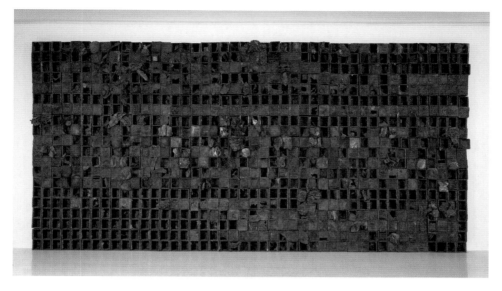

FIGURE 4: Leonardo Drew, *Untitled (No. 49)*, 1995. 137 1/2" × 287 1/2" × 8". Artwork © Leonardo Drew, courtesy of Sikkema Jenkins & Co., New York.

Each box holds memories, like the ones we fill with old photographs and letters or the shoeboxes children use to store the odd things they collect.

Art started with nature.
Cultures perceive nature in different ways.
Some emphasize living in harmony with nature.
Some believe they should control nature.
What you find beautiful and valuable is rooted in
cultural concepts and ideals.
Art is about
what you see
and
what you try to understand when you can't see.
When you see, you travel.

NOTES

1. L. P. Hartley, *The Go-Between* (London: Penguin Random House, 1953). Hartley, 1895–1973, was a British writer, and the book was made into film in 1970. The book's opening sentence is: "The past is a foreign country: they do things differently there."

2. Edward O. Wilson, *Consilience: The Unity of Knowledge* (New York: Vintage Books, 1999), 258–59.

3. T. S. Eliot, "East Coker", *Four Quartets* (New York: Harcourt, 1943).

4. Leonard Koren, *Wabi-Sabi for Artists, Designers, Poets, and Philosophers* (Berkeley: Stone Bridge Press, 1994).

CHAPTER 4

Whose Lens?

Whose Lens?

What do you see?
Wait. . . . Let the picture do its work—But work with it. . . . Engage
with it! . . .
Now, what do you see?—Wait, wait, wait.

John Logan[1]

Body and Mind

What do you see and what do you think?

You see through your body and your mind. Both are necessary. One is not more important than the other. Your body notices by looking, and looking connects you to a person or an object. If you find that a landscape painting is gorgeous, that's your body telling you. Your mind will quickly explain just what is beautiful. But your body knows what you like without that explanation. Feeling beauty is an experience, a happening, and a completely personal moment that doesn't need words. When you describe the color of autumn leaves and where you saw the trees, you are not talking about how you felt when you saw them. It's your mind talking.

The relationship between your mind and body shifts with each new experience. When you pay attention to what each does and to the ways they work together, you see more clearly. Looking at art is a superb way to practice this skill.

To understand "ways he comprehended reality," artist Jasper Johns talked about his "watchman" and his "spy."[2] Everyone has them.

Your watchman looks and connects you to what you see. Watching is a direct experience with nothing standing in the way of your gaze. When you look at a painting of a flower, you know it first through your eyes, which of course are parts of your body. They carry you into the space of the painting and connect the flower to you before your mind says its name or reminds you of the last time you saw one like it or prompts you to prefer roses to daisies.

Your mind is a spy. It notices your watchman or eye taking in visual information. It encourages you to read a label or look up an artist's resumé. If you see something in a painting that's irritating, your spy will say so. That may cause you to belittle or ignore it. If it is unusual, you may disregard it or act as though it doesn't even exist. Artist Paul Gauguin wrote, "we tend to recognize as true and normal only what is customary."[3] When an experience doesn't fit our idea of the way the world should be, we resist taking it in.

Every human being is subject to this censorship. You can't avoid it, but you can watch the interference it causes. Notice your watchman and your spy, the play of your senses and intelligence, and take charge of them. Your body and mind work together. You can respect your immediate sensations, and you can watch yourself interpreting.

Art historian John Yau says that your look makes you part of the object and *makes you a factor in the object*. Because you are present, something modifies, changes, enlarges, or diminishes. Yau says this is a form of reciprocity between you and the work of art and creates a link between you and the artist. You participate, preserve, and change the object.[4]

How is an object changed by your presence? When you picked up this book, it changed. The book no longer lay still and closed. As you began to read, marks of ink on a page were transformed into words in your mind. Those led to thoughts and ideas. You reacted and interpreted. Your mind was altered by this activity. Through your memory, you preserved what was written.

Your Body and Your Mind Connect You to Things

Your body *looks*	Your mind *sees*
notices with your senses	asks why
connects you (to art)	removes you while you figure something out
makes you stop	moves you toward understanding
judges immediately	examines that judgment
is present at the moment	is aware of past and present
is inspired	brings in facts and reasons
responds to beauty	seeks to understand emotions
has an inner experience	interprets the experience

Your body and your mind can make things clear and interesting and also bring in fog and judgmental thinking. One way to understand that is to contrast projection and reception.

Projecting and Receiving

All things change according to the state we are in.

Robert Henri[5]

Projection . . . *happens when you move your beliefs and ideas into others' experiences and believe they think and feel as you do.*

When Sigmund Freud introduced the concept of projection, he was referring to our tendencies to attribute our own thoughts, emotions, and ideas to another person or object. It happens so often we scarcely notice. The result is that other people, events, and objects seem to take on characteristics they didn't have before we arrived. Autumn leaves take on meaning: *how can death be so beautiful?* Before we projected, they were pieces of a tree.

Projection both adds qualities and subtracts them. It's a form of filtering. Filters purify water and get rid of what we don't want to drink. They're useful for getting rid of pollutants, but overactive mental filters can remove particles of experience. When that happens, our perception and understanding may be impaired so that we fail to see people and objects as they are. We can get stuck in automatic responses and can't see with fresh eyes. The richness and complexity of an experience gets filtered out, and the world becomes a place of our own invention, endlessly repeating itself.

Reception . . . *happens when you are open to new information and recognize that words, behaviors, and objects change their meanings depending on their contexts.*

When a radio dial is set precisely on a station, the reception is clear. If not, you receive static or indistinct messages. We design our own filters by relying on comfortable ways of looking and thinking. Receptive people are aware of muddled messages and filtered information. They, like most of us, prefer their own points of view and would rather not bother with ideas that conflict with their beliefs. But, unlike most of us, they notice their resistance and try to see the bigger picture where new information lives.

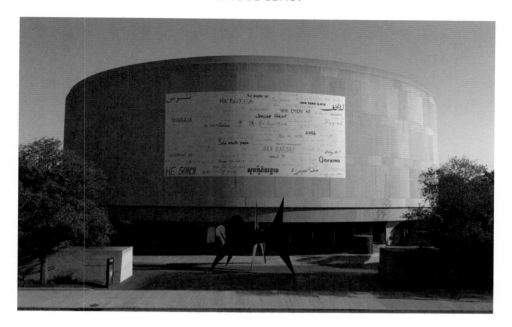

FIGURE 1: Jim Hodges, *don't be afraid*, 2004. 35' × 75'.

In the year 2000, Jim Hodges, an American artist, started working with the phrase, "don't be afraid." In 2004, he asked over ninety United Nations delegates to write it in their own languages, and he then created a banner, using their handwriting, to repeat the phrase over and over.

In 2005, it appeared outside the Hirshhorn Museum in Washington, DC where each person who saw it responded in his or her own way. Many associated the command with the terrorist attacks of September 11, 2001 while others found different connections to both public and private events. A student studying conflict resolution at American University noted that the banner faced Independence Avenue, and that made her consider personal meanings of independence and freedom. Hodges intends viewers to react in such diverse ways and to project feelings about fear onto his work. Each projection affects the meaning of the phrase.

But what about the work itself, apart from the meanings we give it? Since we are always in connection to the thing we see, we can't separate ourselves entirely. But we can become more receptive by asking questions. Here are some possible questions with answers I've taken from people who have seen the work; you may have others. How would you answer the questions at the end? What else might you ask?

What do you see?
○ A large banner with writing.

Where is the banner?
○ On an outside wall of a museum.

What does the writing say?
○ I can't understand most of it.
○ It seems to say "don't be afraid" in several languages.

What makes you think that?
○ I can read a couple of the languages.

Where does your eye go in this work of art?
○ To the languages I know.

How does the location (context) of this banner affect its meaning?
○ It's on a museum, so it isn't about a real event.
○ A museum is telling us not to be afraid of art.
○ Don't be afraid to be in Washington, DC.

What is this artist trying to convey?
○ Ways people around the world say don't be afraid.
○ The appearance of different handwritings.
○ Similar emotions felt by different people.
○ Respect for individual experiences, thoughts, and emotions.

What might UN delegates have thought when asked to write, "don't be afraid"?
What is the role of a UN delegate in keeping the world safe?
What happens when someone tells you not to be afraid?
How do you feel when you see words you can't understand?
Why is the title written in lowercase letters?

Language has no meaning when you can't understand it. When you look at this banner, your eye travels to find the languages you understand. We all need to make sense of what is around us and be understood when we speak.

In a place where you don't know the language, fear is a likely response to signs you cannot read, particularly when you're lost or need the police. Your body longs for meaning. You project your frustration outward onto people who don't speak your language. You know it's not rational to blame

someone for what you can't understand, but your body registers anxiety or frustration.

Fear is a universal emotion. Hodges wants us to notice many things: the actual phrase, where it is written, and where his banner is installed. He also wants viewers to make a connection to the words, the languages, and the many forms of writing. The process matters. Do we project ourselves onto the idea of fear? Do we receive new information through questions? If so, answers will vary, and we find that some questions cannot be answered. In the languages we can't read, does the poster say, "don't be afraid"?

Jim Hodges uses "don't be afraid" as a type of headline. But in contrast to a newspaper headline, it means to get your attention without leading you toward a single story or one conclusion. He wants you to be provoked by words that are suggestive and open ended.

Headlines and Labels

A newspaper story leads you into its subject through a headline. A headline is efficient. It tells you what the story is about, and you can go into it quickly. But art delivers slowly, and unlike a newspaper article, where it would be difficult to ignore a headline, you can choose whether to read a wall label first or start by looking at the work.

A newspaper story is often about an event. A work of art may also be about an event, but rather than explicitly telling a story, it may provide an artist's meditation or opinion. The newspaper uses print lined up on a page to tell you a story in a straightforward way. A painting enfolds its story in an array of techniques, and it takes time to figure things out. Art invites you to both discover its story and come up with your own. You could argue that a title for a work of art is a type of headline. But a title on a work of art (or the lack of one) is part of the art and does not intend to tell you the whole story. It may even be ironic or misleading. In *don't be afraid*, a headline is actually the *subject* and the content is your reaction to the command.

Art may seem like a fast message, but it's slow. To read slow messages, you need to both receive and project. Receive by describing what you see. Project by providing your own title.

Ask

What exactly do you see?
What sorts of colors?

57

What's big?
What's little?
What is the thing made of?
When and where did the artist work?
o (Here, the museum label will help.)
What was going on in the world?
What attracts me?
What puts me off?
What does it remind me of?
How does it make me feel?

Labels put things (and people) into categories and are sometimes useful. But they can falsely simplify something complex. You avoid lazy labels when you ask questions. Prejudice and quick judgments often attach themselves to labels that limit insight.

Cultures don't offer headlines and labels to explain people's behaviors. But we tend to apply them. If people avoid eye contact, we may label them impolite but then learn that looking away is a form of courtesy in places where the direct gaze is considered intimate or intrusive.

Positive and negative stereotypes actually make things happen. They are self-fulfilling prophecies, sometimes known as the Pygmalion effect, where our expectations are met by what we believe to be true. A label encourages us to construct a story to go with it or act in a way that can encourage people to behave as we thought they might. If we believe people are rude or polite, we may unconsciously do things that cause them to behave as we thought they would.

Practice

Make up a label for two deaf people using sign language.
Tell yourself a short story to go with the label.
Would the two people label themselves the same way and tell the same story?
Make up one-word labels for Hindus, Jews, Christians, and Muslims.
How would they label themselves?

A Peaceable Kingdom?

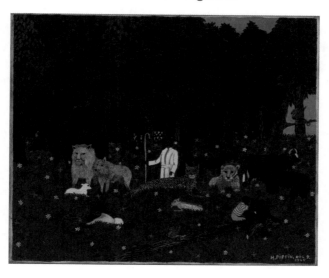

FIGURE 2: Horace Pippin, *Holy Mountain III*, 1945. 25 1/4" × 30 1/4".

Between 1820 and 1849, Quaker minister Edward Hicks painted sixty versions of a work he titled *The Peaceable Kingdom*. His viewers recognized the biblical reference to peace based on a prophecy (Isaiah 11:6–9) that the lion and the lamb will lie down together and a child will lead all creatures. For Quakers, the "peaceable kingdom" is a spiritual landscape in which animals symbolize human vices and virtues.

In Horace Pippin's reference to the works of Hicks, he places a man holding a shepherd's staff at the center of a flowered field in which children play among animals that are normally not found peacefully together. Behind the shepherd, he painted a dark forest and a bit of sky. The title of this painting appears to refer to the harmonious scene in the foreground.

But the label misleads us, and only the viewer who stops to look more profoundly will locate the real subject of the painting. Military tanks and a lynched African American man are in the depths of the woods, and these are difficult to see, particularly here in the reproduction. The central figure in the foreground, the shepherd, is also African American. He is a shepherd of peace but stands against a violent backdrop that refers to the action in two world wars and the prejudice in the United States that led to the lynching of African American people who were not protected by law. Grave markers in the forest commemorate both those who died as a result of racial violence and of war.

The title, *Holy Mountain,* can be read as ironic. If this is a depiction of a holy place, it is not a peaceful one. At the same time, the foreground image is based on the venerated idea that diverse beings can coexist peacefully. The children playing in the field could grow up in a diverse world without the threat of unjust violence, but that world doesn't exist here.

Pippin wants you to be soothed by an appealing scene and then look behind the pretty image to deeper truths—to wake up. As a soldier in World War I, he faced segregation that separated troops by race and prevented valorous soldiers from being recognized for their accomplishments. He puts large ideas in a small painting. You can miss a great deal by accepting easy messages from the label and the surface without looking more deeply.

Happy were
the poets of old
beneath the oak
they sang like a child

But our tree
creaked in the night
with the weight
of a corpse despised

Tadeusz Różewicz, stanzas from "A Tree"[6]

Perceiving Perspective

I consider art to be a means of perception, a means of cognition. Perception makes it possible to structure reality and thus to attain knowledge. Art reveals to us the heart of things, the essence of our existence. That is its function.
Rudolf Arnheim[7]

Perspective controls how you look and see. Your perspective is the view you have from where you stand, both literally and figuratively. Your view of a street changes when you leave the sidewalk to look down at it from the top of a high building. When you are hungry an apple looks delicious; when you're ill, it doesn't look good. Perspective is a point of view and an opinion; it includes attitudes and interpretations. The word comes from the same Latin verb as respect: *specere*, to look or regard. So, built into the notion of personal perspective is respect—for your point of view and another's.

Perspective is also a device artists use to make you see space a particular way. Sometimes, they use it to give the effect of distance or to make a picture look like walk-in space. A choice of perspective reveals what an artist (and others) believes is important and valuable.

Perspective through the Centuries

FIGURE 3: *A Day on the Grand Canal with the Emperor of China, or Surface Is Illusion but So Is Depth* DVD cover, David Hockney, directed by Philip Haas, 1989.

In this film, artist David Hockney invites you to join him "on a magical journey down a seventy-two-foot long legendary seventeenth-century Chinese scroll, which traces the Emperor Kangxi's grand tour of his southern domains." Comparing the scroll to a painting by Canaletto, Hockney "spins a dazzling discourse on Eastern and Western perspectives and their relationships to his own artistic vision."[8]

The film travels into two kinds of artistic space:
the multipoint perspective of seventeenth-century China
and the one-point perspective of eighteenth-century Italy.

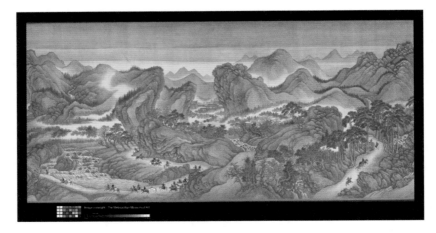

FIGURE 4: Wang Hui, Kangxi Emperor's Southern Inspection Tour, Scroll Three: Jinan to Mount Tai, c.1698. 26 3/4" × 45' 8 3/4".

Going first to China, Hockney moves you through the painted scroll by rolling it on its wooden poles. Your eyes move through a landscape and along streets into the homes and workplaces of people who are making dumplings, taking care of children, and tending gardens. If you were turning the edges yourself, you would move at your own pace to linger in a teashop, visit the workshop of a hat maker, and pause to look up to the sky or across to mountains before returning to the progression of buildings and people. Finally, you would reach the emperor and his elaborate entourage at the far edge of the scroll.

FIGURE 5: Canaletto, *Piazza San Marco*, late 1720s. 27" × 44 1/4".

In the film, an eighteenth-century painting of Venice by Canaletto hangs behind David Hockney. The camera moves closer to show you people gathered in a busy city square surrounded by exuberant buildings that mix architectural styles from Europe and Byzantium. You remain still; you do not touch or move the painting. Canaletto, like the Chinese scroll-painters, gives you a glimpse of daily life, but he defines sight lines to direct your vision. The story in the painting takes place at a single moment rather than unfolding through your own visual journey.

What happens?
o The Chinese scroll invites you *in* so that you follow the emperor's journey and tour part of Southern China.
o The Venetian painting invites you to look *at* it from the outside.
o *In* and *at* comprise a notable difference in the thinking of these artists. Both understand what is called perspective as the term is used in painting, but they manipulate your point of view by using it in different ways.

What does each artist make you do?
o Wang Hui makes you *tour*.
o Canaletto makes you *stand still*.
Where do your eyes go?
o All over in the scroll.
o Toward the back, at about the center, in the painting.

Why do artists create particular illusions at certain times and in particular places?
Why did a Chinese artist of the seventeenth century use multipoint perspective?
Why did an Italian artist of the eighteenth century use one-point perspective?
What do these choices tell us about the cultures (religious, social, and historical) of Asia and Europe at the time?

The subtitle of the film is "surface is illusion but so is depth."
What is the illusion in the scroll?
What is the illusion in the painting?

When eighteenth-century Europeans painted city scenes, they intended to answer certain questions: How do things look? How do they sit in space? How does their position on a two-dimensional canvas make us see them as large or small? Using mathematics and geometry, artists created a pleasurable illusion of three-dimensional space, a kind of window through which you could look to

observe a moment in time, a frozen moment. In such paintings, your eye goes back into painted space toward a single point often referred to as a horizon line.

This technique is called triangulation because the space is organized like a triangle with the farthest point in the distance and lines of sight slanting out toward you on the right and left. Triangulation allowed a militia to position a canon and hit a target quite accurately. In paintings, it gives the illusion of deep space. Art critic John Berger said in *Ways of Seeing* that Renaissance perspective is unique to European art in its centering everything on the eye of the beholder.[9] The visual world, he says, was thus arranged for the spectator, for *you*.

The concept of linear perspective emerged from a revolution in mass communication at about the same time as Gutenberg's invention of movable type in the fifteenth century. Writer Samuel Y. Edgerton Jr. says that,

> without this conjunction of perspective and printing in the Renaissance, the whole subsequent development of modern science and technology would have been unthinkable. . . . Surely in some future century, when artists are among those journeying through the universe, they will be encountering and endeavoring to depict experiences impossible to understand, let alone render, by the application of a suddenly obsolete linear perspective. It, too, will become "naive," as they discover new dimensions of visual perception in the eternal, never ultimate, quest to show truth through the art of making pictures.[10]

We are living in that time now. Many artists give us "all-over" art, with no discernible beginning or end, a kind of endless space.

The Venetian painting has a fixed horizon line that divides the ground from the sky, and you see that as you look into painted space. In the Chinese painting, to see the sky you must move your eyes up to it, while you are turning the scroll. In other words, you decide where to go in the scroll; it doesn't decide for you. Many things are happening all at the same time, and you must look around to find them.

At all times, the space you occupy limits what you see. On a street, you observe some things and not others, or you may see only what is in your mind. Artists use space creatively to direct your attention to visual data and at the same time send you beyond the edge into ideas and action outside the picture. It's something like reading this book. You look at the print, but your mind goes beyond its pages.

The scroll suggests a bigger picture of space and time than the Venetian painting. It shows you several events taking place simultaneously. It gives you many sight lines so that you participate visually. The scene of Venice looks like walk-in space, but you are outside that space, looking in and not participating.

Writer George Rowley says that "Chinese painting is an art of time as well as space" and "a scroll must be experienced in time like music or literature."[11] You

wander through it. It implies that there is more space beyond the edges and that there is a mystery in the universe that can "only be suggested," not explained.[12]

Your Perspective—Your Reality

English physicist David Bohm says that he is concerned about what happens when humans see the world as though it were made of unrelated, separate parts:

> The widespread and pervasive distinctions between people (race, nation, family, profession, etc.), which are now preventing mankind from working together for the common good . . . have one of the key factors of their origin in a kind of thought that treats things as inherently divided. . . . Each part is considered to be essentially independent and self-existent.[13]

When we regard people and the natural environment as separate from ourselves, we treat them differently than we would if we felt connected to them.

Hockney says Canaletto painted the world as existing separately from the person who looks at it. You can see the farthest point, sometimes called the point of infinity, but you can't get there because you observe from a fixed position. He contrasts that with Chinese scrolls that break borders and show the interconnectedness of things. Infinity is everywhere and includes you. You look behind walls and over buildings because you are not in a fixed position. Your hands move the scroll, and your eyes and mind travel through time.

Hockney diagrams the two perspectives this way:

VIEWER
Multipoint
Perspective

VIEWER
One-point
Perspective

Illustration by the author.

Everything that we know about ourselves and our world is shaped by our histories. . . . When we see, feel, touch, think, remember, invent, create, and dream, we must use our cultural symbols and languages. Among these "languages," Art [her capitalization] holds a particularly visible and privileged place.

Mary Anne Staniszewski[14]

The contrasts David Hockney presents don't fully explain the views that everyone, East and West, had of the world when Wang Hui and Canaletto worked. But they do make us think. Is any work of art a valid picture of an idea, a time, or a place? Does the artist have a bias? What is the purpose of that bias?

Since the nineteenth century, Western art has not depended on the rigid use of linear perspective. There are many reasons for this, among them the responses of artists to the inventions of new machines and psychology. The microscope and the telescope sent human vision to worlds far beyond a fixed point in time and space, and Sigmund Freud opened an understanding of the complexity of human perception.

When people see the universe as immense, art enlarges, not in size but in ideas and techniques. Artists reach into spiritual practices, science, the environment, social issues, and domestic life, and they seek ways to go beyond the mere depiction of things and into the vastness of human experience. Impressionists, Cubists, Surrealists, and others have crashed through art's conventional frames, breaking up the surfaces of things in order to give impressions of objects from different points of view and from the interior of the mind. The artists that Samuel Edgerton says will endeavor to depict experiences impossible to understand are working now, and some use one-point perspective in inclusive ways. Rather than excluding chunks of the world, their one-point perspective includes more than you may imagine.

Hiroshi Sugimoto photographs the interiors of elaborately decorated old movie theaters, positioning his camera up high and at the back. Your eye goes first to the screen in the center of his photograph and then to the details of the theater as the space moves out to the right and left. This is once again triangulation, the same geometric idea that permitted Renaissance cannons to be fired accurately, but Sugimoto's image suggests peace rather than warfare, and he brings viewers into the picture rather than excluding them. How?

FIGURE 6: Hiroshi Sugimoto, *Ohio Theater, Ohio*, 1980. 16 5/8" × 21 7/16". © Hiroshi Sugimoto, courtesy Fraenkel Gallery, San Francisco.

He leaves his camera lens open during the entire showing of a feature-length film, and that process dissolves its details into light. What you see is a brilliant white rectangle that appears empty but is actually filled with the scenes of a motion picture. It is a void that is full, a Zen Buddhist concept of the fullness of space that is never empty.

Your Sight and Insight

FIGURE 7: William Ely Hill, *My Wife and Mother-in-Law*, 1915.

Your perceptions are part of who you are. In this famous picture of an old woman/young woman some people see the old; some see the young. But both images are present at the same time. Each of us sees one or the other because our perception is selective. Into the mix go our personal histories, ages, sexes, and cultural backgrounds.

Your beliefs create perceptions. In the title of her book *Believing Is Seeing*, art historian Mary Anne Staniszewski reverses a common aphorism to make the point that our personal backgrounds directly affect the ways we read works of art because "our reality is always *mediated* [her italics] by cultural institutions. . . . To know oneself . . . one must enter culture. . . . In this sense, your identity is founded upon that which is exterior to yourself."[15] Perspective—from where you are—and perception—what you see—are linked. Who you are makes you *choose* what to see.

We all unconsciously apply our own cultural codes to other peoples' behaviors, and we judge them. A cross-cultural perspective is vision through the eyes of people who see the world through other cultural learnings. It validates the co-existence of many points of view, a tolerance for multiple perspectives.

Cubism's Multiple Perspectives

About 1907, an influential movement began in modern art when artists Pablo Picasso and George Braque experimented with breaking objects into planes and assembling them so that they represented things from several points of view all at once. In their paintings and sculptures, you can look at a face or an apple or a house from different sides; you can stand in one place but still see the front and back or top and bottom of something. It is like traveling through space and time while sitting in an armchair or flying through three dimensions simultaneously.

FIGURE 8: Pablo Picasso, *Head of a Woman (Fernande Olivier)*, 1909 (cast 1960). 16 3/8" × 9 3/4" × 10 1/2".

In the sculpture pictured here, Pablo Picasso added the name of Fernande Olivier to the title, which would seem to imply a portrait. But do we really believe this is the recognizable Fernande? The hair is pulled up into peaks, her neck is twisted, her exceptionally large eyes look in different directions. This is not everyday reality but a vision of anatomy that flickers in the light and seems to move in space. We get many points of view and a certain amount of pure invention through triangles, curves, and twists.

Physician Leonard Shlain writes that biography resembles a Cubist work of art because the writer gives you the public, private, and personal lives of a person all at once.[16] We can't see these parts all together in the people we know. Cubism is like reading the story of someone's life, not day by day from birth to death, but from the multiple points of view of the biographer. In a Cubist sculpture, we see multiple views from the artist's perspective.

In Cubism no single perspective is more important than another. In a 1988 catalog of his work, *David Hockney: A Retrospective*, at the Los Angeles County Museum of Art, Hockney says, "Cubism . . . points the way to greater tolerance and interdependence of perspectives where failure to learn such lessons can have dire consequences."[17] One perspective is not the whole truth. When we are confronted with information that tells us there are other ways to see, holding a single point of view can be destructive to human relationships.

Some art historians question whether Cubism succeeds in truly presenting multiple viewpoints simultaneously, but this does not do away with an important message about the interdependence of perspectives in a complex world. It is a metaphor for many points of view existing simultaneously and an appeal for open-mindedness when you meet something strange. When theoretical physics came along in 1908, it taught that things have an independent existence outside of any relationship to human beings and that we can't apprehend everything in the universe through our senses. All sides of an apple or a person exist even when you can't see them.

People see differently. If you enlarge your vision and understand another's point of view, you may still continue to believe that your own ideas are right or best. You don't need to believe or accept or like or care the slightest for what you see. You may wish you were somewhere else. But at precisely that moment of distress, your appraisals become part of the picture. That is when asking at least one question, "What do I see?" and answering yourself with a description may stop you from rushing into a poorly considered judgment. It calls you to account for what you believe is true.

Artists give us mirrors that reflect what we might not otherwise see. "In every work of genius we recognize our own rejected thoughts. They come back to us with a certain alienated mystery."[18] When we recognize ourselves in someone else's

story, we develop empathy, a powerful form of understanding that can arise even when you don't share a set of beliefs.

New Ways to Look and See

We may learn from . . . artists something about how to conceive of our own ordinary existence—about how to live, and die, more constructively or at least alertly.

Michael Kimmelman[19]

Museum administrator Stephen Weil wrote that art of all kinds is shown today in ways that demand a new "aesthetic way of seeing in order to be appreciated."[20] What does it mean to develop a new aesthetic way of seeing?

For many years, people could walk into art museums and find portraits, landscapes, still lifes, history paintings, religious art, and mythological characters they recognized. Painting and sculpture often resembled something in the real world. It told stories and instructed. Now, many of us can't figure out the art we find. What does it have to do with us? Does it have any connection to the world in which we live?

Indeed it does, but where do you begin to see those connections? In the United States, as Weil points out, art is protected as a form of speech, and the culture encourages the individual expression of artists, no matter how controversial their work may be. Contrast that with the Soviet Socialist requirement that art support and promote the state. The result was not individual expression but a depiction of official values, often in paintings of smiling, immaculate people working in fields. If life wasn't like the paintings, it should be.

Art that comes out of individual thinking also follows rules. The most abstract art holds the past in its debt along with time-honored ways of making things. Rules of aesthetics endure through centuries. Richard Estes, Anish Kapoor, Hiroshi Sugimoto, and Jim Hodges use materials, methods, and ideas that existed before they did. At the same time, they make art in a world of telescopes, microscopes, computers, airplanes, and space travel that make people see differently than they did when Wang Hui and Canaletto painted. When vision changes, so does art.

Looking at Art with a New Way of Seeing:
A Short Lesson in Modern Art
Thanks to Kirk Varnedoe and Others[21]

Modern art is about everything.
It speaks a language you can learn.
The language is made of details.
Small details make a big difference.
What do you *see*?

The details add up to a language that makes sense in context.
You read "red" one way or another, depending on where it is.

Materials are part of art's language.
Some materials are so new, they confuse us.
Some materials are old but used in new ways.
Their meaning depends on where they are and how they're used.

Abstraction is not a code with hidden meanings.
It too is a language that makes sense in context.

Modern art doesn't intend to teach you lessons.
Messages move back and forth, from the art to you and from you to the art.

Art that teaches wants to tell you about itself.
Modern art often wants to tell you about yourself.
It asks what you think and feel.
Get to know your "watchman" and your "spy," your body and your mind.
How do you react to horror, lust, envy, hilarity?
It's not usually with polite appreciation.

Ask what a piece of art would say to you if it could speak.

Ask what is missing.
What is not present may be just as important as what is.
Ask, "What if . . ."
What if something were: bigger, smaller, pink, upside down, plastic, mud?

Modern art tells you about life, and the mixed blessings of modern life keep chang-
ing.[22] Artists make us notice.

NOTES

1. John Logan, *Red* (London: Oberon Books, 2009), 9.

2. John Yau, "The Mind and Body of the Dreamer," in *Uncontrollable Beauty: Toward a New Aesthetic*, ed. Bill Beckley with David Shapiro (New York: Allworth Press, 1998), 298.

3. Paul Gauguin, quoted in Jodi Hauptman, *Beyond the Visible: The Art of Odilon Redon* (New York: Museum of Modern Art, 2005). Exhibition brochure.

4. Yau, "The Mind and Body of the Dreamer," 300.

5. Robert Henri, *The Art Spirit* (Philadelphia: J. B. Lippincott, 1960), 40.

6. Tadeusz Różewicz, stanzas from "A Tree," in *The Burning Forest*, trans. Adam Czerniawski (Northumberland: Bloodaxe Books, 1988). Reprinted by permission of the author. Used with permission from the Estate of Tadeusz Różewicz.

7. Rudolf Arnheim, quoted in Adam Bernstein, "Rudolph Arnheim: Studied Art-Perception Links," *Washington Post*, June 13, 2007, http://www.washingtonpost.com/wp-dyn/content/article/2007/06/12/AR2007061201957.html.

8. David Hockney, *A Journey on the Grand Canal with the Emperor of China, or Surface Is Illusion but So Is Depth*, dir. Philip Haas (Milestone Film and Video, 1989), DVD.

9. John Berger, *Ways of Seeing* (London: Penguin Books, 1972).

10. Samuel Y. Edgerton Jr., *The Renaissance Rediscovery of Linear Perspective* (New York: Basic Books, 2008), quoted in David Hockney, *David Hockney: A Retrospective* (Los Angeles: Los Angeles County Museum of Art Exhibition, Museum Associates, 1988), 89.

11. George Rowley, *Principles of Chinese Painting* (Princeton: Princeton University Press, 1974), quoted in *David Hockney: A Retrospective*, 91.

12. Rowley, quoted in *David Hockney: A Retrospective*, 91.

13. David Bohm, *Wholeness and the Implicate Order* (London: Routledge & Kegan Paul, 1980), quoted in *David Hockney: A Retrospective*, 88.

14. Mary Anne Staniszewski, *Believing Is Seeing: Creating the Culture of Art* (New York: Penguin Books, 1995), 1.

15. Staniszewski, *Believing Is Seeing*, 35.

16. Leonard Shlain, *Art and Physics: Parallel Visions in Space, Time and Light* (New York: Quill William Morrow, 1991).

17. David Hockney, *David Hockney: A Retrospective*, 90.

18. Ralph Waldo Emerson, "Self-Reliance" (1841), quoted in Alexander Eliot, *The Timeless Myths: How Ancient Legends Influence the Modern World* (New York: Truman Taley Books, Meridian, 1996), 137.

19. Michael Kimmelman, *The Accidental Masterpiece: On the Art of Life and Vice Versa* (New York: Penguin Press, 2005), 72.

20. Stephen Weil, *Making Museums Matter* (Washington, DC and London: Smithsonian Institution Press, 2002), 178.

21. Kirk Varnedoe, *A Fine Disregard: What Makes Modern Art Modern* (New York: Harry N. Abrams, 1990).

22. Lucy Lippard, *Mixed Blessings: Art in a Multicultural America* (New York: Pantheon Books, 1990).

CHAPTER 5

Art in Dialogue

Art in Dialogue

Painting should call out to the viewer . . . and the surprised viewer should go to it as if entering a conversation.

Roger de Piles[1]

One day a painting from the year 1971 said to a painting from 1520, "Come visit." The painting from 1520 was Iranian and the one from 1971 was American. The Iranian painting favored gardens, and the American preferred cities. The Iranian looked at the American city, and the American looked at the Iranian garden, and both felt confused. They wanted to leave and go home, but each decided to first ask a question. A question led to an answer, and an answer led to another question. Their questions were about what they saw in the paintings, but pretty soon they were talking about more than cities and gardens. They heard each other say things that were new and strange. They listened, and as time went on, they told each other

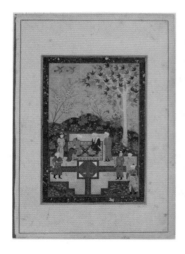 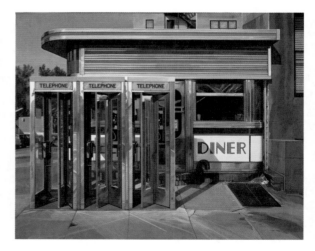

FIGURE 1: *An Old Woman and Sages in a Garden*, Iran, c.1520–40. 13 13/16" × 26 5/16".

FIGURE 2: Richard Estes, *Diner*, 1971. 40 1/8" × 50".

what they thought. They didn't like everything they saw. But that didn't stop them from asking questions, and they didn't walk away. Instead, they risked stepping out of the worlds they already knew. They didn't say, "I don't know much about art, but I know what I like," which would have expressed contempt for strangeness.

If they could speak, what might these two paintings, made more than four hundred years apart, ask one another? What would each find odd or familiar, appealing or disturbing?

From Diner *to* Garden

Diner: What's going on here?
Garden: People are talking to one another.
D: About what?
G: They are probably telling stories, discussing philosophy, reciting poetry.
D: About what?
G: Many things—about how to live the right way.
D: Is there a reason why they're in a garden?
G: Yes, a garden stands for paradise.
D: So it's an imaginary garden?
G: Yes, but it's also a real garden.
D: Did the idea come from the artist's imagination?
G: Not really. It came from scholars who knew more than artists about how paintings should look. Sometimes several artists worked on one painting. They all painted what they were good at, and they followed rules to make sure it was done correctly.
D: What kinds of rules?
G: Well, if they paint gardens, they need to show the four directions of the world, north, south, east, and west, and they have to put in water.
D: I can't find any water.
G: See that gray square at the bottom? It's a pond. The artists used real silver to show how precious water is. Now the silver is tarnished, but you can still see the swans and the fountain. Iran is two-thirds desert so Iranians appreciate water. I could say something else about water if you're interested.
D: I am.
G: Everyone should be because water is important no matter where you are. You can't live without it. It's a symbol for all things coming alive. It's a gift from heaven really.
D: So most things in this painting mean something. What about the birds?
G: Birds have spiritual significance. They fly, and that means they can get closer to heaven than humans who have to stay on the ground. That's one reason people need to improve themselves—so they can get closer to heaven.

D: Does the tree mean something too? It's very tall.

G: That's a good thing to notice. Trees mean a lot to us. Their roots are below the ground, their trunks are on the ground, and their branches reach toward heaven. Those are the three realms of existence. And trees are beautiful and give shade. Do you mind if I recite three lines of poetry to show you what I mean?

D: That would be nice.

G: It's a poem from Mesopotamia that was written over four thousand years ago. It's called *The Epic of Gilgamesh*.[2]

> With crystal branches in the golden sands,
> In this immortal garden stands the Tree,
> With trunks of gold and beautiful to see.

D: It seems you respect wisdom from the past.

G: We certainly do. It guides us in the present.

D: Well, this is a pretty painting, but I still wonder about some things. Why would people sit on a carpet in a garden?

G: The carpet is made to look like a garden. You can put a carpet like this anywhere, and it will remind you of a garden. Here it's like one garden inside another.

D: That's an interesting idea, but neither looks like a real garden.

G: The painting isn't supposed to look like the everyday world because it's about more important things.

D: Such as?

G: That people should come together to improve themselves by admiring nature and reciting holy verses.

D: What about that yellow sky? Skies aren't usually yellow.

G: Maybe not, but it looks pretty; yellow is a happy color.

From Garden *to* Diner

Garden: What's in your painting?

Diner: Things from a city.

G: Is this a painting of a real city?

D: In a way it is but not as it would look if you were there. The artist chose different scenes and put them together the way he wanted.

G: Did he decide everything about his painting?

D: Yes, he worked alone.

G: I'm curious about what he decided to paint—a worn-out wall and a broken sidewalk and trash. And I also noticed that he covered up the windows in the building.

D: People need shades on their windows to give them privacy when they live so close to one another. He also shows the way life is. When things wear out, people throw them away.

G: Why would anyone want to make a painting about things breaking or wearing out?

D: The artist was interested in how a city looks.

G: Like the phone booths I guess. Why are the doors open?

D: He liked the way they looked. And if people wanted to use the phones, they could.

G: So why aren't there any people in the painting?

D: The artist may have left them out in order to say something about them.

G: Really! If he wanted to say something about them, why didn't he just put them in? I was also looking for trees, and I noticed there are some, but they are very far away.

D: You have a good eye. Those trees are hard to find. Cities often don't have many trees because they've been taken away to build buildings.

G: Doesn't Richard Estes think trees are important?

D: Yes. I think he does; otherwise why would he have painted them at all?

Their Conversation Becomes More Revealing

Diner: What sort of poetry are people in your garden reciting?

Garden: The poems are most likely about the presence of God in everything. Things are beautiful because they reflect God's perfection. We become better people when we talk about God. Our poets use elegant language that uplifts us when we hear it. Our paintings are often about poetry and stories.

D: It must be pleasant to talk about these things in a beautiful garden.

G: Yes, because a garden makes people think of a kind of paradise on earth. The word paradise may come from the Persian term for park or enclosed garden, *pairi-daeza*.[3] Earthly gardens are hard to make. They require work and care so they always look beautiful. It's a way to respect God who made the first garden. People treasure real gardens and paintings of gardens.

D: Couldn't one artist have painted this and received credit for such fine work?

G: Artists aren't used to working alone. They learn to do things the right way so when it's time to make a painting, each one does what he knows best. One paints trees; another paints people. They work together. If they don't follow the rules, paintings won't carry the right messages.

D: What kinds of messages?

G: One message is about gratitude and appreciation. When you paint a garden, it must be beautiful to show how much we admire the gifts God has given us.

D: So the purpose of your painting is to carry messages.

G: Yes, you would find those messages if you read our poetry.

D: I may be starting to understand what I didn't understand. But I'm puzzled about something I learned from art history. Renaissance artists in Europe used geometry to make paintings look like places you could walk into. Even though your painting was made around the same time, it doesn't look like real space, and that makes the people look as if they could slide out of the picture. You said before that the painting is about things that are more important than the everyday world. But couldn't the artists have used rules of perspective to make space look real?

G: I appreciate your going back to that question. The reason the artists didn't strive to imitate the real world is because they would be wrong to act as though they could make things the way God does. Only God can make the world. Artists can illustrate stories and make beautiful paintings, but they must not copy God by trying to make things look as real as He does.

D: So your garden is more about ideas than things.

G: Yes, that's right. People could learn a lot from knowing more about trees and water and birds and what they stand for.

D: One more question: You said that wisdom from the past guides you in the present. Don't you respect new learning?

G: Yes, we certainly do. But we also know that our ancestors have a lot to teach to help us make sense of the present.

They Get Curious about How Paintings Are Made

Garden: I want to know why one artist would work alone. We even learn his name. Doesn't that make people pay more attention to him than to the painting?

Diner: Americans value individual creativity so they pay attention to artists like Richard Estes who do unusual and remarkable work.

G: I agree it's unusual. Why did he put together different scenes instead of making a painting of one place?

D: I'm not sure exactly, but I do know that he uses a camera to take pictures of places in cities. He photographs streets and things made out of glass and steel because they reflect light, and he likes reflections. I think he also likes modern technology, and actually a camera is a form of technology.

G: So, does he take pictures and copy them?

D: No, he composes paintings with the scenes he collects, and then he draws and paints. He was really interested in light and reflections, and he studied the way they look in cities.

G: His painting looks kind of frozen, like nothing is happening.

D: It looks that way because he painted so precisely. He wanted the painting to look like a photograph or like something mass-produced—as though it came out of a factory. Machines in factories can make things that look perfect and exactly the same—like the phone booths.

G: Those phone booths may look perfect, but no one wants to be inside them. Everyone wants to sit in a garden. Why paint things people don't use?

D: He had his reasons I'm sure. What do you think?

G: I only know that in my painting, people are talking to one another. In your painting, there are telephones, but no one is there to make a call. The windows of the building are covered so people can't look in or out. And the diner is closed so no one can go there to eat and talk. Why did he leave people out of his painting?

D: We don't really know. Maybe he wanted to say that people are so busy in cities, they don't have time for conversations. Or maybe he was more interested in painting phone booths and buildings than the people who use them. Remember you said that the reason the sky is yellow in your painting is because it's a pretty color. Maybe Richard Estes painted phone booths because he liked the ways the light looks on metal.

G: Are you saying you don't know what this painting means?

D: Well, yes and no. Your painting has meanings built into it. My painting waits for people to put in their own meanings. That doesn't mean that Richard Estes didn't have reasons for making the painting. He was interested in cities and helping us see them through his carefully painted works of art.

G: So he wants people to admire his painting.

D: Probably, but he also cares about his work. Richard Estes works hard to be a good painter. He paints things so carefully and with such attention that they look real, but he's not making a map of a city. He's painting things the way they look to him. Maybe he wants viewers to pay attention to the places they live, but he is not telling them what to think. What do you think?

They Talk about What They Like and Don't Like

Garden: I think this is a lonely place, and there are no people in the painting because no one wants to live there. I think people want gardens and poetry. Didn't he care about those things?

Diner: Maybe he left those things out because he did care about them and wants us to pay attention to what may be missing in cities. Maybe that's why he put trees in the distance. Maybe he likes buildings but wishes they hadn't replaced trees. And he may think that people don't talk enough or if they do, they use

telephones instead of seeing one another. Maybe that's why he closed the diner in this painting. We really don't know, but we do know that he was a good painter.

G: Then he probably could have painted anything he wanted. Why did he put in broken and worn out things? Did he put them in to say he wishes they weren't that way?

D: Maybe. But he also was truthful about what he saw.

G: Aren't there enough ugly things around? Shouldn't we have paintings about beautiful things?

D: Artists show their versions of the truth. They believe there is beauty in doing that. It's honest.

G: I think he could be honest about beautiful things.

D: Many people would agree. But they also admire the artist and the painting.

Garden and *Diner* met as strangers. They were polite, and at first their conversation was a bit stiff, but they gave one another a chance to describe themselves. They listened without telling the other what they already knew or liked. Both avoided giving many opinions, though what they noticed and asked showed they certainly had them. They talked to one another without referring to labels, books, art historians, or critics. They could do that later to extend their learning. But at their first meeting, they stayed in the present moment and allowed visual details to guide their questions. Those questions carried them beyond the frame, from surface to depth, from sight to insight, and from looking to seeing.

What Is Important in Each Painting?

An Old Woman and Sages in a Garden
Gardens.
Poetry.
Nature.
Symbols.
Past wisdom.
Respect for God.
Bringing meaning to viewers.
Several artists painting the right way, the way that has been practiced.
Story and metaphor.
How things should be.

Diner
Cities.
Technology.
Mass production or "machine aesthetics."
What you can't find in nature.
The present.
No built-in moral or message.
Accepting meaning from viewers.
The inventiveness and skill of a single artist.
Visual reality.
How things are.

Does this contrast suggest that people in twentieth-century America believed conversation, poetry, the past, and respect for God were unimportant? It does not. Does it say that people in sixteenth-century Iran did not invent new things or that they didn't have broken things in their towns? Certainly not. It simply shows how each painting emphasizes what is meaningful at a certain time and place.

Art Makes Things Unreal to Make Them Real

Art deliberately makes things both familiar and strange. It gives visual form to our worldly, emotional, or spiritual experience and invites us to explore what that is. We recognize the garden and the city, though neither appears as we would find them in the everyday world. When you find the unreal in a piece of art, question it. What exactly do you see? What could be the reasons for things appearing a certain way? Art reveals values. Some are cultural, and some are personal. Artists mentally frame ideas and objects and present them by using artistic conventions or methods of making things.

Classical Forms and Modern Forms

Both classicism and modernism strive for meaning. Classical conventions typically come from the past. They dictate what artists need to do to make acceptable works of art. The *Garden*'s classical form is a way to provide an ideal model of the cosmos and illustrate treasured stories or myths that inspire awe and humility. The *Diner* comes from a modern society that values scientific inquiry, certainty, and straightforward depiction. Richard Estes does not propose to idealize the city in his painting or illustrate a collective myth.

The *Garden* and the *Diner* ask us to pay attention to
the real and the ideal,
eternity and the present,
nature and the machine.

We Like the Familiar

A culture's special history shapes beliefs, tastes, and desires. Until we confront other ways of doing things, we don't usually question our assumptions of what is correct. In a later chapter, you will read about houses and how people feel about right ways to live in them. Human belief systems and artistic conventions are not part of an unchanging, natural order as Mary Anne Staniszewski points out,[4] but we tend to feel they are. When we meet strangers, we quite naturally judge them by our personal meanings, which they may not share.

Artistic Decisions

Artists decide how to make things, and their decisions come out of cultural and individual practice and learning. The *Garden*, with its birds, suggests air and shows a lot of sky. The *Diner*, with its stainless steel and concrete is earthbound. The light is uniform in the *Garden*, and there are both shadow and light in the *Diner*. The edges are curved in the *Garden* and, for the most part, straight in the *Diner*. In the *Garden*, people's robes only suggest the shapes of their bodies. In the *Diner*, you see the details of most things. Its strong lines make things feel very still while birds, people, and plants in the *Garden* suggest motion. If these paintings are about communication, then you might say the garden is about specific people talking to one another directly while the *Diner* refers to nonspecific, mass communication.

Space

The *Garden* closes the space at the bottom with strong lines, but the top is open to the world outside its walls. The artists make sure you can see the important things. Where would you enter the painting?

Richard Estes controls space tightly in the *Diner* by placing the three phone booths close to the edge of the painting and putting the diner and the building behind them. You can't see things in the background. On one side, he gives us a little bit of open space but not much. Where would you walk into the painting?

Time

The *Garden* suggests eternity through the endless cycle of changing seasons. It comes out of a culture that respects wisdom from the past. Its ideal is a nature-bound form of paradise. The *Garden* shows us how things should be.

The *Diner* shows the present where the seasons don't change. It comes out of a future-looking culture that defines itself through technological accomplishment. The city's ideal is efficiency. The *Diner* comments on how the world is.

Cultural Values

There are silent cultural issues in these paintings, and both the *Garden* and the *Diner* are about ideas more than things.

Both value human contact and nature, but they are clearly depicted in one and merely suggested in the other. It's not surprising that the *Garden* is dismayed over the lack of people and beautiful things in the *Diner*. The scene feels lonely. Even if people were present, it isn't likely they would be reciting poetry over the telephone. Didn't the artist care about beauty? Yes, but a different kind of beauty. Doesn't he think people and trees are important? Probably, but he says so by leaving them out. Doesn't this painting mean anything? Yes, but the artist doesn't tell us; the viewer creates meaning. We long for meaning and beauty. We learn our own culture's ideals of beauty, and then we judge things everywhere by those ideals.

Who Are the People?

A Story about the *Diner*

One question above asks about the people who live in these paintings. A few years ago, I taught a class at a university in Washington, DC for students in the school of communications. They contrasted the *Garden* and the *Diner*, first describing what they saw, then offering interpretations, and finally giving their personal reactions.

One of them, Joanne, told her own story about the *Diner*. She said it made her think of her mother who had grown up in the 1950s in an American city where high school students gathered in diners. She imagined her mother sitting in a booth talking about the future with other girls her age. Who would they marry? What kinds of homes would they have?

Joanne's mother grew up at a time in America when most women had few professional aspirations outside their roles as wives and mothers. Joanne said she thought of her mother and her friends idealizing a future in which their lives would unfold exactly as they were raised to believe they would. In fact her mother is divorced from her father and working outside the home. Joanne understood the *Diner* as a symbol of a perfect world that never existed but which, even now, gives Americans a nostalgic sense of a simpler time when everyone seemed to share a set of values.

Because Joanne lives in a culture where there are diners, she can imagine the life surrounding them, and when she imaginatively walked into the painting, she found a personal meaning. At the same time, she took part in a classroom activity designed to focus on the difference between placing herself in a painting and seeing the same painting on its own terms. First she described visual details, then she interpreted, and then she shared her emotional response. She understood that her reaction to the work was separate from the artist's intention, yet both were a form of truth.

Imagine that *Garden* and *Diner* are the names of two women who meet one day. *Garden* dresses in loose clothing and wears a headscarf, and *Diner* dresses in tight jeans and a tee shirt. At first glance, what might they think of one another? They would no doubt make immediate judgments as nearly everyone does. But in the dialogue you just read, in the make-believe world of two paintings talking to one another, that immediate judgment didn't prevent each asking the other who they were. They asked one another for an interpretation from the inside, through the eyes of the individual living within the culture. The story from within is different from a story a visitor is likely to tell.

This is a book about noticing your judgments, since they inevitably will be there. It then proposes ways to ask questions when you approach works of art. Questions also open conversations with people. You needn't agree with an artist's or any other person's point of view, but a question puts you on pause and opens a middle ground, a space, to begin a conversation. Art never tires of sincere questions and long conversations.

What Is True Conversation?

The cup has to be empty to hold something.

Jiddu Krishnamurti[5]

Physicist David Bohm has been my guide into the riches of conversation. In his book, *On Dialogue,* he quotes philosopher Jiddu Krishnamurti to remind us to

avoid allowing our thoughts and opinions to overwhelm the voice of another person. In the spaciousness of true dialogue, you simply listen without an obligation to do anything or come to conclusions. He says that when you "communicate in truth," you avoid making data fit previously held assumptions.

What happens in a true dialogue?
○ You participate in a flow of meaning from all sides.
○ You reach for shared meanings.
○ Shared meanings are a glue that holds people and societies together.
○ You discover shared meanings by observing and inquiring, noticing and asking.
○ You realize that ideas are related to one another or are part of a larger system.
○ You do not regard important topics as untouchable.
○ You notice assumptions from self-interest, religion, and national identity.
○ You notice when opinions come from past thought rather than present conditions.
○ Opinions are like computer programs in our minds.
○ Opinions come from different views of the truth.
○ You explore views of the truth.
○ You allow multiple points of view to exist.
○ You search for points of contact where meanings can be shared.
○ You favor coherence over incoherence.

Some definitions:
Coherence: like a laser, a light that is very intense and focused.
Incoherence: like ordinary light that goes in many directions.
Dialogue: the word flowing through,
> from the Greek *diagolos: dia,* through and *logos,* the word.
> Bohm says that a dialogue can take place among any number of people. It can also exist silently within any one of us, alone.

Conversation: an exchange of ideas in a familiar or intimate way.
Communion: conversation at a profound level.

What works against true dialogue?
○ Fragmenting the world into separate, unrelated parts.
○ Attacking, slandering, and polarizing.
○ Believing everything is inherently right or wrong.
○ Taking ideas and information out of their intended contexts.
○ Avoiding conversation about important topics.
○ Not recognizing your underlying assumptions and opinions.

○ Failing to examine your process of thinking—how one thought leads
 to another.

What works for true dialogue?
○ Describing.
○ Observing and asking.
○ Noticing and respecting different ways of seeing the world.
○ Remembering that a dialogue does not require you to give up your beliefs.

What might An Old Woman and Sages in a Garden *(c.1520–40) and* Diner
(1971) have meant to their first audiences?
Have those meanings shifted?

NOTES

1. Roger de Piles, *Cours de peinture par principes*, quoted in Alberto Manguel, *Reading Pictures: What We Think about When We Look at Art* (New York: Random House, 2002), viii.

2. "The Epic of Gilgamesh," in *The Epic of Babylon; or, The Babylonian Goddess of Love and The Hero and Warrior King*, vol. 1, restored in modern verse by Leonidas Le Cenci Hamilton, trans. Ishtar and Izdubar (New York: W.H. Allen & Co., 1884), 170.

3. Richard Harris, *Paradise: A Cultural Guide* (Singapore: Times Academic Press, 1996), 12.

4. Mary Anne Staniszewski, *Believing Is Seeing: Creating the Culture of Art* (New York: Penguin Books, 1995), 226.

5. Jiddu Krishnamurti, quoted in David Bohm, *On Dialogue* (London: Routledge, 1996), 19.

CHAPTER 6

The Capture

The Capture

Description is explanation.

Gertrude Stein[1]

To me, description is the heart and soul; it's the test. I think if you describe correctly, you really will have said almost everything.

Peter Schjeldahl[2]

When you describe, you can watch yourself think. You are active. You step outside yourself and become aware of things as they are rather than extensions of you. Asking yourself what you see and giving words to small details in a work of art carries you inside. The art doesn't give you much if you begin with an attack. None of us can avoid the quick judgments that pop into our minds. But describing keeps you in the present and helps you withhold your verdict.

If you were training to be a mediator or studying international dispute resolution, your success would depend on your ability to ask questions of people you may meet for the first time and when they're in the midst of a conflict. Starting off with a judgment about their appearance or way of speaking would keep you from learning what you need to know.

For a number of years, students in conflict resolution classes at several Washington area universities have been practicing their skills by confronting other sorts of strangers—modern and contemporary art.

Art Talks Back

Mediators and Modern Art

I met these students for the first time in 2001, when law professor Michelle LeBaron began bringing her classes to the Hirshhorn Museum for sessions on exploring

intercultural relations through art. At that time, Michelle was teaching at George Mason University's Institute for Conflict Analysis and Resolution (ICAR), and I was interested in her approach to training international mediators from many countries and religious groups. She used storytelling, metaphor, and spirituality as paths to understanding deeper concerns and diverse perspectives among her students and ultimately their clients.

Graduates in international conflict resolution enter conversations with people from different cultures, and they face thinking and ideas that are unfamiliar and sometimes threatening. Even when they share cultural backgrounds with their clients, mediators face the uncertainty of each dispute. Like most of us, they are uncomfortable with ambiguity, but their profession requires them to be ready for it. Meetings with painting and sculpture are ways to practice looking and asking before judging.

Many students were skeptical that confronting art would add anything to their negotiation skills, and some who arrived early to walk through the museum on their own were put off by objects they found weird, silly, manipulative, or impossible to penetrate. By the time I met those particular students, they were upset because they believed they were wasting valuable class time. What possible link could there be between conflict resolution and modern art?

I understood their skepticism. The museum is a long way from their classroom, but I appealed to them to at least look and answer one opening question about each work of art: What do you see? The question encouraged them to observe closely and give words to what they saw. Observation, inquiry, and description go to the heart of mediating conflict.

Describing made them concentrate on details and revealed assumptions and prejudices. Asking questions led to listening. They saw how limited their quick interpretations might be and were often surprised by their insights into art they had judged and rejected.

Asking and Describing

In each ninety minute session at the Hirshhorn, the students looked at eight to ten works of art that related to one another through forms or ideas such as the human body, the environment, memory, personal identity, human relationships, politics, architecture, and more. By first describing what was in front of them, rather than what they thought or felt, they entered the picture. Through their questions, they gave the art a chance to tell about itself.

After describing what they saw, they speculated on *why*:

Why these colors, shapes, lines?
Why this size?

Why is the work on the floor, or on the wall,
or next to another piece of art?
What's unusual?
What's missing?
When was the work made?
Where was it made?
What else was going on at the time?
Does the artist have a message?

Only then, did they answer questions about their opinions:
Do you like the work?
Why or why not?
How does it make you feel?

FIGURE 1: Rachel Whiteread, *Untitled (Library)*, 1999. 112 1/2" × 210 5/8" × 96".

Several groups looked at Rachel Whiteread's sculpture *Untitled (Library)*. It is life-sized and consists of two bookcases, each about nine feet long and eight feet high. In the Hirshhorn, one bookcase was against a wall at a corner and the other

parallel to it. Heavy overhangs make them appear uncomfortably top-heavy. They are jagged as though damaged, and the surfaces are pitted. The color is a stark white with bits of other colors where the bindings of books might have been. The label lists dental plaster as the first material in its construction. (The other materials are polystyrene, fiberboard, and steel.)

Many students said the work seemed obvious until they stood still and really looked. In the dialogue below, it appears that the questions were neatly answered when in fact the conversation was not nearly so linear. That is difficult to reproduce here, but you will see how things evolved.

What do you see?
○ Sets of shelves with the marks of books but no books.
○ White shelves that look damaged.
○ Color where the spine of a book might have been, as though they were torn away.
○ I see the shapes of books. I thought they were there until I looked closely.
○ It's like the ghosts of books.
○ The white shelves are so white—they look ghostly too.

What are ghosts? What do they make you think about?
○ Dead people returning through their spirits.
○ The shell of something with nothing inside it.
○ Death and loss.
○ Ghostly things—weird, spooky things.
○ Things that seem to be there but aren't.

In this instance, what seems to be there but isn't?
○ Books.

Anything else?
○ Well, maybe people who read books.
○ We aren't allowed to touch, so we're like people who can't get books.

So books have disappeared, but bits of them last, and this reminds you of people who may have owned books but who can't read them now.
Can you say more about that?
○ It reminds me of book burnings—say during the Cultural Revolution or World War II.

Then what you see are shelves without books, but you see the remnants of books that used to be there. Someone said it looks like the books were taken down roughly, and covers got torn. You feel the absence of people. You used the word ghostly.

What is the white material?
○ Dental plaster.

What is dental plaster?
○ Material used to get impressions of teeth to make dentures.

Is it still used?
○ Not so much in modern dentistry.

When do you think they stopped using it?
○ Probably when dentists started using plastics—maybe fifty years ago.

Why do you think Rachel Whiteread used dental plaster to make bookcases?
○ She wanted something very white—ghostly looking, sad, dead.
○ I think it's fragile, and life is fragile.

For whom is life most fragile?
○ People who lose what is precious to them.
○ People who live through wars and revolutions.
○ People who aren't allowed to read.
○ People who lose their freedom.

Earlier you mentioned the Cultural Revolution and World War II. That brings us closer to Whiteread's purpose here. She was commissioned to do a Holocaust Memorial in Vienna, and this work came out of her thinking for that. You recognized the absence and loss she suggests. You may not have known about the Vienna commission, but you went right to an emotional truth.
Her use of dental plaster could be a reference to teeth extracted for their gold during the Holocaust, and some people say the jagged edges remind them of teeth. She is known for making casts of spaces, like the space under a child's bed, to make us pay attention to space we haven't noticed. Do we commonly look at the absence of things like the space left on a shelf when you remove a book?

What helped you learn about this piece of art?
○ We stood still and looked.

○ I didn't think much of this work until we started talking about it.
○ The work seemed to have a voice that wasn't my voice, but I listened.

Could you have asked yourself some of these same questions?
○ Some of them.
○ We could have talked with each other and discovered some of the art's secrets.

Are they truly secrets?
○ I think they are, but we can learn them. Everything is more than we see.

We asked the students how conversations with art relate to negotiation. They said they became aware of how their own beliefs alter what they hear and see and how hard it is to suspend judgment. They talked about first impressions and how they can keep you from asking good questions. But then, one student said, "You can sense things before you figure them out." Intuition is also a valuable, whole way of taking in the world. You will find more on this in Chapter 10.

Creative Inquiry and Cultural Fluency

The students confronted seemingly incomprehensible art with a form of creative inquiry. As mediators, they will listen to polarized views of the truth, rephrase what they hear, ask questions, and clarify. They will need to be quiet and receptive to new information delivered by sometimes unappealing people. What may at first appear obvious could turn out to be only a partial truth. They will have to respond effectively to surprises and experiences for which they have no precedent.

The journey to cultural fluency holds heroic elements. Heroes leave familiar places to investigate the unknown, and the road may be difficult. Framing is a way to begin. Mental frames can be any shape. You can imagine a circle around anything with you at the edge.

Framing the World

How Do Artists Pay Attention?

As the aesthetic philosophers of the early 20th century like to point out, if you put a frame around anything it becomes art. Everyday objects begin to vibrate mysteriously. The mundane acquires instant drama. You start to see poetic patterns in flat surfaces.

Ben Brantley[3]

Framing is a way of paying attention. At your breakfast table, place a mental frame around a cup. What color, shape, material, and size is it? Is it made by hand or mass-produced? Did you buy it or was it given to you? Does it make you think about someone? Do you like the cup? Would you change it? Is this the best way to drink coffee or tea? What other ways do people drink tea? When did you have your first cup of tea? Who gave it to you? Where were you?

Artists frame pieces of the world and offer them to us. Sometimes they frame a cup or an apple, a person or a river. They decide what materials best tell its story. Every quality involves a decision. Artists show us what the world has shown them, what they admire and disparage, what they question, and what they understand. They highlight a memory, a pleasure, a moment in time, a fear, an insight, a sensation, and nearly anything else you can think of.

Art historian John Caldwell wrote that artist Sigmar Polke produced paintings "that seem to look back at us by changing as we look at them."[4] Polke achieves this through complex alchemical means. But even when an artist does not use such techniques, paintings change when we look closely because our perspective changes. In other words, you can see something on its own terms only if you respect its integrity by asking yourself what you see and then describing those elements. Know that an artist made choices. Why is something big, yellow, crooked, or blurry? The work answers through your intelligence. Your questions acknowledge the separate, independent existence of something. It has its own essence apart from your opinion.

What if *you* were inside a frame. What would someone see? It's hard to see ourselves and our worlds from inside our own frames.

Unmediated and Mediated Conversations

Unmediated Conversation

The conversations between the *Garden* and the *Diner* were unmediated. They asked questions and spoke directly to one another. They focused on visual details to help them explore meanings. This was a form of *coherence*, beaming a strong light on what each could see. They did not immediately insert their own experience. This avoided *incoherence*. Then, when asked, the sixteenth century projected its values onto the twentieth and the twentieth century projected its values onto the sixteenth.

Mediated Conversation

The conversation with the bookshelves was mediated. I was a facilitator who asked questions, summarized the discussion, and gave background information. The students had already sensed an emotional truth about *Untitled (Library)*, but they more or less stopped inquiring after I told them about Whiteread's commission for a Holocaust memorial.

Information gives you a context and enlarges understanding. Because context is always important, experts can add a great deal. But whatever they add is more meaningful to learners when they have had an experience and asked a question.

Proprioception

David Bohm uses the term proprioception when he writes about dialogue. It means self-perception or noticing your own movement. In a dialogue, you are proprioceptive when you notice your own thoughts and attend to what happens when you speak. Even your presence changes the situation, as it does when you move in front of a mirror. It looks one way when it reflects you and another when you are absent. Conversation also changes with your input and your silence.

The *Garden* and the *Diner* stumble into each other's worlds and see themselves uncomfortably reflected in the oddness of the other. A lot of things make no sense, and they can't help judging what they find. We tend to reject the unfamiliar because it makes us feel off balance or even unable to function. But in their dialogue, the *Garden* and the *Diner* honored strangeness with questions.

NOTES

1. Gertrude Stein, quoted in Glenn Dixon, "Talking about Art Writing," *Washington Post*, October 29, 2008.
2. Peter Schjeldahl, quoted in "Talking about Art Writing".
3. Ben Brantley, "Where Play's a Scavenger Hunt," *New York Times*, July 10, 2003, https://www.nytimes.com/2003/07/10/theater/lincoln-center-festival-reviews-where-a-play-s-a-scavenger-hunt.html.
4. John Caldwell, *Sigmar Polke* (San Francisco: San Francisco Museum of Modern Art), 1990. Exhibition brochure.

CHAPTER 7

Question and Play

Question and Play

You can tell whether a man is clever by his answers. You can tell whether he is wise by his questions.

Naguib Mahfouz[1]

The purpose of art is to lay bare the questions, which have been hidden by the answers.

James Baldwin[2]

Art survives not because it gives pleasure, but because it goes on asking questions to which we need to know the answers.

John Russell[3]

Ask Questions

Frame a Piece of the World

Your questions create a frame.
A frame sets things apart from everything else.
A work of art frames objects, ideas, and sensations and sets them in a special place.
A proscenium in a theater is a frame around the action in a play.
Your questions make you part of the action.

Go Inside the Frame and Play

What if you were in this picture?

Appreciate Mysteries

Art hides its meanings. Not everything can be explained.
There is a difference between a mystery and a puzzle.
Educator Fred Goodman said that a puzzle is designed to test ingenuity or knowledge, and if you work hard enough you may just get it.
A mystery may stay obscure but still express a truth that is valuable to you.

Asking is a humble act that makes you powerful and is a form of giving while receiving. When you ask, you are active. All questions cannot be answered, but searching for them is an act of respect.

Questions make you attentive and receptive. They can make you smarter, open new thinking, and banish prejudice. They can reduce noise of many kinds, interrupt too much talk and lecturing, and help clear up confusion.

There are times when everyone needs quick answers. How do I get to the train station? But questions about people and art beg to be answered slowly. When answers come too quickly, they may hide complexity. The first answer may require another question.

We feel vulnerable when we're confused, and unfamiliar art bewilders us. Asking yourself what you see—what *you* see—creates an opening into your intelligence by placing you squarely in the picture. It guards against what critic Lucy Lippard says is the "temptation to fix (y)our gaze on the familiarities and the unfamiliarities, on the neutral and the exotic, rather than on the area in between—that fertile, liminal ground where new meanings germinate and where common experiences in different contexts can provoke new bonds."[4]

Liminal comes from the Latin *limin* meaning threshold. Liminal ground exists on both sides of a boundary, an issue, an idea. It is an imaginary space to enter while asking questions. It is a place from which to observe with an open mind. It is space between the talker and the listener or the message and the perceiver. It exists between you and a work of art. To enter liminal ground, you must stop your usual activity in order to look, think, and breathe. We must start with appearances—form, color, shape, size—but staying with those, on the surface, and believing all questions can be answered at that level, simplifies complexity and leads to false conclusions.

Look for Cultural Values

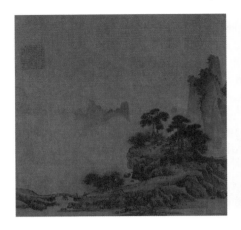 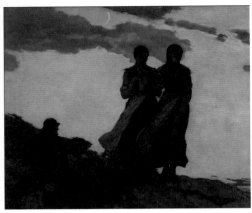

FIGURE 1: Yen Tz'u-Yu, *Hostelry in the Mountains*, late twelfth century. 33" × 38 3/4".

FIGURE 2: Winslow Homer, *Early Evening*, 1881–1907. 10 1/16" × 10 3/16".

The size of people in a landscape may offer clues to cultural notions of whether humans should control nature or attempt to live in harmony with it, and the two paintings here may raise questions about those attitudes. In Winslow Homer's *Early Evening* from 1907 we find three figures. The largest forms in his painting are two women standing high against the sky. By contrast, in the Chinese landscape from the Sung Dynasty, the people and their huts are tiny among soaring mountains and towering trees.

Both works of art appear to reveal attitudes about ways people saw themselves in nature—part of a vast whole or superimposed upon a more limited landscape, more interdependent or independent.

In revealing these attitudes or values, the paintings do not tell us everything about how people actually lived. In both nineteenth-century America and twelfth-century China, people held beliefs that were at times inconsistent with the demands of everyday life. But here, we are discussing cultural values, and art is a wonderful way to discover those even when there are gaps between ideals and real life.

In some places, you may discover cultural values by what is hidden rather than shown. For the Baule peoples of Ivory Coast, gold is like a god, and they keep a finely made pendant in the form of a man's face in a revered treasury and display it only at important funerals or at the end of a period of mourning. In other cultures, gold is a symbol of wealth with secular rather than sacred significance, and people who wear jewelry may make quite a show of it.

Art from everywhere has surface, depth, visible details, and invisible ideas. It reveals collective thinking, individual creativity, political comment, and private feeling. To complicate things, art is not static and meanings may change over time, raising even more questions.

The American illustrator Norman Rockwell painted works that told stories about American life. He may be best known for his 1930s and 1940s covers of a popular magazine, *The Saturday Evening Post,* that unambiguously depicted kindness, abundance, and graciousness. Up to the present, he is beloved by Americans who are touched by his vivid depictions of abundant food and a happy family celebrating the Thanksgiving holiday, or a pediatrician listening to the heart of a child's doll. At the same time, critics are distressed by some of these images for what they leave out: the diversity of the nation's peoples and the struggles of many Americans to live decently among prejudice. Rockwell's work gives insight into cultural values, not necessarily the ways people live them every day. (It is important to note that Rockwell was in fact concerned about human and civil rights.)

At the Summer Institute for Intercultural Communication, participants in classes are sometimes advised that big "C" Culture subsumes small "c" culture. In other words, the larger "Culture" (the interdependence of people and values within a society) includes culture with a small "c"—its art of all kinds.

No matter how individualistic modern artists may appear, they work within the collective qualities of an encompassing Culture. It is the persistent backdrop, seen or unseen, of any work of art. At the same time, as you have just seen in the two works of art above, there are distinct differences between twelfth-century China and twentieth-century America in the ways humans appear in landscapes. Underlying the reasons, and outside the scope of this book, are complex attitudes toward interdependence and individualism. In the conversation in Chapter 5, *Garden* is puzzled that *Diner* is painted by one individual. Its own image was likely painted by several artists who combined their talents and were not individually recognized by their names.

Overhear Ourself

Fred Goodman, Professor Emeritus of Education at the University of Michigan and an expert in simulation games, used the phrase, "self-overhearing" for those times when we are changed by paying profound attention to our quiet observations. This deep engagement with art, he pointed out, augments the self. We grow. Hearing yourself is part of a circuitous journey toward understanding. It begins with your observations and includes your thoughts.

Self-overhearing is a form of *communing* with yourself and others.
Communing means to speak intimately and listen in the same spirit.
Communion is a state of sharing and participating. It leads to respect.

Respect requires asking about what you don't know.
It comes from the Latin *respicere*, to look back at, to regard.
Respect asks that you look again.
It is related to research.

Research comes from the old French, *recerche*.
The addition of "re" adds force to just searching; it demands additional inquiry.
Each question is a step toward respecting what you see.
Research and respect are related to introspect.

To *introspect* means to examine one's own thoughts or feelings.
The word comes from the Latin verb *introspicere*, to keep looking into.
Looking into yourself for reactions and judgments is another form of giving respect to what stands outside you.

It leads to noticing the difference between reception and projection, not confusing what is outside you with what is within.

To *receive* is to allow something or someone to communicate to you.
Reception is a form of taking in.
To *project* is to transfer your own thoughts and feelings onto something or someone.
Projection is a form of giving out.
You see only yourself in a work of art when you immediately pass judgment without inquiry.
To have a relationship with art, you must both receive and project.

Reciprocate

A picture is not thought out and settled beforehand. While it is being done it changes as one's thought changes. And when it is finished, it still goes on changing, according to the state of mind of whoever is looking at it. A picture lives a life like a living creature, undergoing the changes imposed on us by our life from day to day. This is natural enough, as the picture lives only through the [person] who is looking at it.
Pablo Picasso[5]

Stand with the people in Winslow Homer's *Early Evening*. How does the air feel? Is this the end of a day of work? What will happen next? What would you ask them? Would you prefer to be in twelfth-century China among mountains or in a windswept landscape in America?

Reciprocity comes from *reciprocus*, a Latin term for moving backward and forward. In a reciprocal relationship with art, you move toward a picture with a question and back to your intelligence. You have a conversation. A spirit of reciprocity leads to intimacy, a relationship to art that differs from learning through its written history, a one-way transmission from expert to learner which often presents established ideas. You benefit from both approaches—an imaginative and reciprocal relationship and the learning from experts.

Gerhard Richter, a contemporary German artist, focused on another form of reciprocity by placing a mirror in an exhibition of his paintings at the Hirsh-horn Museum. When spectators appeared in front of the mirror, their reflections changed the image that had been there a moment before.

The same thing happens when you stand in front of a painting with reflective glass, and your face becomes part of the picture. But even without reflective glass, you become part of a picture when you ask the first question, "What do I see?" You enter liminal ground. You take the first step toward a culture that exists in a certain context and has meaning within a particular time and place.

Your presence changes the book you read, the art you see, and the room you enter. This is a very important point and cannot be emphasized enough. Just by entering a room, you change it. And you also bring your knowledge, desires, opinions, and prejudices. In response, the world may appear to take on some of the characteristics you attribute to it. Open-hearted conversations with art can make you more proprioceptive, more aware of where you are and more observant of your subtle engagements with many situations.

Things change as you build a connection through questions. With art, you start a relationship when you ask: why is this figure so big—what is that blob in the corner—why is that person smiling—why is this red—what does this remind me of—how do I feel when I look at this? Questions lead to unpredictable results. You may find things you didn't think you would.

Find Circles and Lines

There is something imminent in the work, but the circle is only completed by the viewer.

<div align="right">Anish Kapoor[6]</div>

A few years ago, two physicians, a husband and wife visiting Washington, DC, took an afternoon off from professional meetings to see art at the Hirshhorn Museum. They told me this was their first visit to a modern or contemporary art museum and asked for a tour of the collection.

Very little is as mystifying as abstract art if you've not looked at it before. After more than thirty years as a docent, I still find new art difficult, and I admired these two people for walking into a museum that didn't offer pretty landscapes and idealized portraits. Some of the Hirshhorn's art makes noise. Some works lie on the floor or hang crookedly on the wall. Some of it moves with hidden motors or the small breeze created by people walking by. Some art looks gooey and broken. How do you look at such things? Where are the stories?

I gave a small introduction and asked these visitors if they would be willing to do something unusual for such well-educated viewers—just look for circles and lines and talk about them with me. It seemed easy, but the conversation moved in surprising directions. We looked at Pablo Picasso's lines, Alexander Calder's circles, and Olafur Eliason's moving spheres. They related them to the human body and the stars and planets without my prompting. They looked at the objects in Joseph Cornell's boxes and talked about how circles and lines helped him tell stories. We asked one another what the painter Barnett Newman intended with a seemingly blank canvas cut through by a single line.

We broached questions none of us could answer, but our conversation made us look more attentively. For me, the hour was both stimulating and enlightening. We looked at what was in front of us. Conversation was the teacher.

Curators and museum educators train docents to organize tours in meaningful ways. They provide information on artists and artistic movements, and they talk about why certain objects are selected to be in a museum or why it is important to show them. Docents also learn through less orderly but instructive conversations among themselves when they informally look at art together to further speculate on what artists intended. They often concentrate on small details that may indicate large ideas, and they share their personal reactions. Dialogue wakes them up.

Expect the Unexpected

If we do not expect the unexpected, we will never find it.

Heraclitus[7]

the heroes were always making discoveries, by accidents and sagacity, of things they were not in quest of.

The Three Princes of Serendip[8]

Asking questions can be a form of experiment and play. When you ask instead of say, you become a perpetual beginner, opening yourself to discovery by accident. Through your questions, you may become a scientist and an artist, a person who already knows a great deal but respects coincidence and serendipity.

Your questions alert you to the difference between direct and indirect learning, the experience you live and the teaching you receive from others.

Art is often experimental and playful, and it uncovers what is not visible in other ways (ideas, values, relationships). That may be one reason why Leonardo da Vinci saw art as "the queen of sciences communicating knowledge to all the generations of the world" and why physician Leonard Shlain wrote *Art and Physics*, about links between art and science.

Because artists are ever responding to the newness of the world, we get new art. New art invites us to see what we may not have noticed and often uses an unfamiliar, unexpected vocabulary. It can be hard to read, but it means to communicate and wants to be discovered. Artists also know that when you meet their art, your opinions will become part of the picture. Your opinions are necessary and inevitable, but you need to know you have them. Where did they come from? Did a critic influence you? Did a tragedy make you sense a message you might otherwise not find? Opinions grow from many experiences and are valuable but can numb your thinking if you habitually know before you ask. You miss the vitality of the world.

A question can open a dialogue, and a dialogue can lead to discovery. Art historian Kirk Varnedoe wrote that "History has valued pictures more for the questions they raise than for the ones they resolved, more for what they opened up than for what they pinned down."[9] So you may find yourself asking questions of a picture that is raising questions of its own. And to complicate things, answers to those questions change with time and the person doing the asking. This is not a simple way to learn, but there may be no better way to discover perceptions and values in other cultures and avoid useless or irrelevant labels and categories.

Avoid Narrow Categories

Categories help us create order. Art historians group information by chronology and style. Cooks classify foods by courses on a menu. But, if you try to categorize art by cultures, you must consider carefully how far you can go with any one idea.

Yes, a Chinese landscape from the twelfth century does look—well—like a Chinese landscape. And the carefully painted cityscape you saw in Chapter 5 fits nicely into the category of American photorealism. But you will miss their eloquence if you think of these paintings as having only Chinese or American qualities.

You communicate with and across cultures when you recognize useful categories as well as their limitations. Cultures do have their individual artistic styles. No one would say that classical Egyptian sculpture looks like Chinese ancestor portraits—so ask about that. Why did Egyptians frequently depict figures in profile, and why did the Chinese pose ancestors in throne-like chairs?

Start with the image itself, not with a preset idea or a category. What exactly is in the particular work of art? And then go further. Who did the Egyptians and Chinese commemorate? What did they respect? What did they think of kings and families? Is there a connection between their art and spiritual beliefs? What strikes you as the difference between a sculpture of a pharaoh and a painting of a Chinese gentleman? Where are the works usually located? What materials did each use? Starting with a preset idea can lead to forcing a work of art into a category where it doesn't quite belong, like trying to put toothpaste back into a tube. Some may fit, but a lot will ooze out.

Art makes things up; it idealizes and parodies them. When something is made beautiful by the standards of a time and place, what does that tell us about the *ideals* of a given culture? When something is made fun of, what does that say about the *concerns* of a culture, or of a group of people, or of an individual? Both idealization (Giotto) and irony (Arneson) can tell us what cultures and individuals think is important and what people worry about.

A work of art is not a document of universal truth, another reason why forcing it into a category can lead to false conclusions. It is the tangible result of thought and contemplation. It holds ideas, values, and feelings about something or someone. When you conclude that a painting means something, ask what makes you think so. What do you actually see that makes you say what you do?

Avoid branding by asking questions—what is here? who is here? what is bold? what is hidden? Does the artist show affection or disdain for a subject? What tells you that? Is a work of art sober, melancholy, nostalgic, or preachy? How do you know? Is the work innovative or the result of a received style that has been handed down for generations? Be ready to try out an idea and then to reject it.

When art gives us perfect landscapes, people, and objects, we are tempted to misread them as depictions of the way things are rather than shining examples of something desirable. Nineteenth-century landscape painting of the American west was intentionally grand and often less than accurate. An artist might have changed the shape of a mountain or moved it because, in his picture, it looked better that way. Idealized landscapes of the American west encouraged growth at a time when the country seemed endlessly vast, and territorial expansion boundless. The notion of manifest destiny proclaimed that God willed such growth.

Ideals also appear in paintings and statues of national heroes. What convictions do they embody? What did they accomplish? What sorts of role models are they?

Are they men or women? Are they people of thought or action, philosophers or warriors, artists or scientists?

In real life, heroes are not one-dimensional, but cultures tend to idealize them as though they have no faults. At all times, ideal forms influence our thinking and our behavior. Politicians and advertisers use them regularly.

In this book, I do favor some categories that contain large ideas such as belief systems, human values, environmental concerns, migration, racism, and more. Categorizing things is helpful for learning as long as it doesn't close down thinking. The danger of categorizing people in superficial ways leads to minefields of misunderstanding. Shallow categories lead us to assume that we already know who people are and what they believe.

And a final comment about categories. I have overheard myself and others categorize things we don't like by what I call "categories of dismissal." So music I don't like is not music; soup I don't like isn't food. I cannot be reminded often enough that these are opinions, perhaps about something strange or new, if not loud and smelly, and that their right to exist and be respected does not depend on my preferred sounds and tastes.

Be an Interculturalist

One's destination is never a place but rather a new way of looking at things.
Henry Miller[10]

Through art, mysterious bonds of understanding and of knowledge are established . . .

Robert Henri[11]

Interculturalists travel consciously, knowing that living in a world of diverse human beings comprises a journey that does not exist on a straight line or have a single destination. They meet people through conversation and are ready for surprise and coincidence. They try to avoid categorizing behaviors in useless ways and to pay attention to the context in which people do things.

For hundreds of years, literature has used the journey as a literal story and a metaphor for discovery. *The Ramayana, The Odyssey, The Canterbury Tales, Don Quixote,* and *The Epic of Gilgamesh* are journeys to seek higher realms through pilgrimage and experience. Travelers become more discerning as wisdom grows. Their perspectives shift, ordinary thinking gives way to play and imagination, and the diversity of the world becomes more apparent.

We don't need to leave home to find people who please or frustrate, accents we can't understand, events that anger, remarks that hurt, jokes that offend,

and stories that touch us. Meeting the vast diversity of the world through art is often puzzling and can feel threatening. Then, going consciously into liminal ground, where you stay inside yourself but look outside, gives you a chance at finding meaning.

Meaning is not built into the marks you see. It is in you as much as in the thing out there. We find meanings in things and in other people through dialogue, verbal and nonverbal communication, exploring cultural differences, observing language in different contexts, and noticing how museums place art among objects that relate to it in some way.

Dialogue

Quantum theorist David Bohm wrote that in dialogue we open ourselves to a larger intelligence. The ancient Greeks and Native Americans are among the cultures that revere dialogue as a great teacher. A dialogue opens a larger picture. It gives us time to see into behavior we don't like or understand. It can keep us from being impulsive and doing damage.

Communication

True communication includes respecting, receiving, introspecting, and being aware of projecting. It begins with your gaze and your hearing and leads to communing, an intimate act that needs time.

Communication means making something common. Sometimes information (when you give someone directions) flows one way, from a speaker to a listener. But communication is also a conversation in which you and I talk and, through our dialogue, discover a third thing, a new idea or meaning that did not exist before we started talking. This new meaning is born from something in you and something in me.

If I want only to convince you to accept my beliefs, a new idea cannot arise. David Bohm notes how the screen of our own thoughts and the sensations of fear and pleasure alternately push us away from some things and attract us to others. To create something together, or to have true communication, we must listen freely, without prejudice.

Looking is a type of dialogue. True looking, according to writer, John Berger, "is not mechanically reacting to stimuli. We only see what we look at. To look is an act of choice. As a result of this act, what we see is brought within our reach."[12] You bring your body into connection with an object through visual contact.

It is difficult to look freely without prejudice. It requires attention to what you like or fear. Looking is quiet and slow and honest. The act of looking is reciprocal.

The painting looks back, or as Picasso said, it changes when you look at it. To look you must be still.

Cultures

Cultures embody ways of life, customs, and values. Communications expert Robert Kohls wrote that cultures include everything a group of people thinks, says, does, and makes. Culture is learned and transmitted from generation to generation, and people within cultures share a familiarity with practices that may baffle an outsider. Cultures are complex, interlocking systems that reveal themselves slowly. We persistently move within them, seldom sensing either their reaches or limitations.

Languages

Languages are part of culture. Art too has language. Its size, color, and the ways in which it puts pieces together all create meaning. Its expression is not a secret code but a language you can learn.

Museums

Museums feel like new cultures when they confront you with art that appears strange. You may think you are being closed out by a few insiders who know things you don't. You may feel uneasy or vaguely threatened by what is strange and unfamiliar and wonder if you need to unravel a secret language to read art. But the language of art is not a secret.

NOTES

1. Naguib Mahfouz, *Khufu's Wisdom*, trans. Raymond Stock (Cairo and New York: American University in Cairo Press, 2003).
2. James Baldwin quoted in Sylvia Rankin, *The Myth of a Post Racial America* (Minneapolis: Graywolf Press, 2014), 115.
3. John Russell, *The Meanings of Modern Art* (New York: Museum of Modern Art, 1974).
4. Lucy Lippard, *Mixed Blessings: Art in a Multicultural America* (New York: Pantheon Books, 1990), 2.
5. Pablo Picasso, in conversation with Christian Zervos, 1935, quoted in Sylvan Barnet, *A Short Guide to Writing about Art* (New York: Longman, 1997), 12.
6. Anish Kapoor, "In conversation with John Tusa," accessed December 14, 2018, http://anishkapoor.com/180/in-conversation-with-john-tusa-2.
7. Heraclitus of Ephesus, Greek philosopher, c.553–475 BCE.

8. *The Three Princes of Serendip* (Venice: Michele Tramezzino, 1557).

9. Kirk Varnedoe, *A Fine Disregard: What Makes Modern Art Modern* (New York: Harry N. Abrams, 1990), 213.

10. Henry Miller, *Big Sur and the Oranges of Hieronymous Bosch* (New York: New Directions, 1957), 25.

11. Robert Henri, *The Art Spirit* (Boulder: J. B. Lippincott Company, 1923), 19.

12. John Berger, *Ways of Seeing* (London: Penguin Books, 1972), 8.

CHAPTER 8

Travel

Travel

Historically art has challenged participants to transcend into another consciousness, to momentarily abandon oneself in order to enter an alien sensibility. We liberate a mute voice in ourselves. We cast our perceptual nets into other realms. We cross the boundaries of our usual ways of seeing.

David Barr[1]

Art serves to open thought rather than close it down. . . . It allows us to understand without assenting, to go over to the other side and still stay home, to be violated and yet in control. It appeals to our freedom and individualism and in the process to our investment in collectivities. It may allow us, in our timid fashion, to indulge a certain taste for the sublime.

Wendy Steiner[2]

A journey into art is visual, mental, and intuitive. Things affect you and you affect them. Artful travel is conscious, active, and attentive. You notice yourself in a new place. Each experience is exceptional.

Art Is an Interesting Travel Companion

Opens thought
Several ideas all at once.
Fast images with slow messages.
More questions than answers.
Convergences, serendipity, and coincidences.

Persuades you to understand without assenting
Respect without liking what you see.
Learn without agreeing.

Sends you over to the other side while you stay home
Confront weirdness without culture shock.

Seeks common ground without giving up what you believe
Find "liminal" space for looking, seeing, talking.

Violates you while you stay in control
Feel good or bad.
Get dizzy, calm, angry, amused, frustrated, or delighted.
Still keep your feet on the ground.

Invests in collectivities while enjoying freedom and individualism
Sense others' religious fervor.
Participate in political outrage.
Enter a cultural landscape and feel what it's like over there.
Identify with another person and still be yourself.

Culture shock implies a splintering of personal identity, but on a journey into art you can deliberately enter new worlds without that consequence. You may feel insecure, but you're safe. People suffering culture shock fear that those who live and think differently threaten their values and ways of life, and they tend to disparage what they don't understand. It makes them intolerant of diversity.

Art shields you from culture shock by offering double vision. You see others and yourself all at once with no threat to yourself. You go inside that other through your vision, your intuition, and your intelligence, and you can "understand without assenting" knowing you have control even when something is strange or disturbing. Your ideas merge with a painting to add meaning.

Works of art are common ground where we meet what we believe are artists' opinions, sentiments, loves, and hates. But none of us know precisely what an artist believes; so some intentions get lost. When the artist is no longer present, a work of art takes on a life of its own, and when we arrive we are included. We may be surprised, offended, amused, or angered. When we examine our responses, we look more deeply into ourselves.

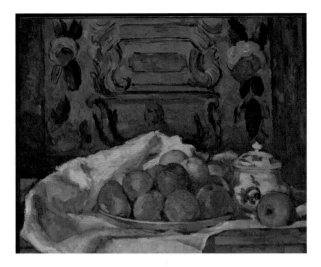

FIGURE 1: Paul Cézanne, *Dish of Apples*, c.1876–77.
18 1/8" × 21 3/4".

The artist Paul Cézanne carefully observed apples to understand how they looked because he was a "realist" who wanted "true-to-life representation, only he wanted it *more* true to life," he "wanted to touch the world of substance . . . with intuitive awareness."[3] Intuition, grasping something without reasoning, may be instant, but thought follows.

Writer D. H. Lawrence says that Cézanne was a realist in more than one way. He would not stop at surfaces and be satisfied with mere appearances. He studied an apple in order to paint it the way it looked, but he also realized there is a lot more to an apple than its shape and color. The outside suggests something complex and interesting within, and he needed both his eyes and his intuition to understand. He once referred to "the melancholy of an old apple."[4] Nearly everyone intuits character from appearances, but how much do we trust this form of knowing?

Lawrence writes that our eyes see "only fronts, and the mind on the whole is satisfied with fronts. But intuition needs all-aroundness, and instinct needs insidedness."[5] Cézanne wanted to be an insider. Appearances were an opening to something unavailable to his eye and his mind, and he needed his intuition to take him beneath the surface. He looked, he painted, and he looked again. He needed to keep his thinking open so he wouldn't close out new information. He avoided what Lawrence calls a rush to believe in clichés, the enemy of the living imagination.

A cliché is something you borrow. It isn't original, and it gets in the way of insight. You can travel everywhere in the world and not really see anything if you rely on over-used, predictable, handed-down, stereotypical ideas. Take a good look and ask yourself what you see.

Preachy Art

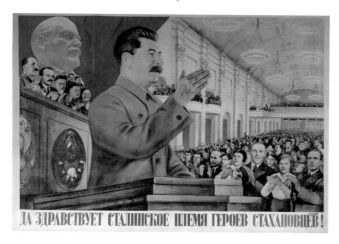

FIGURE 2: Gustav Klutsis, *Long Live Stalin's Breed of Stakhanovite Heroes*, 1934. Poster.

An alert observer refuses clichés that suggest easy answers with fixed meanings. Painting and sculpture with political messages are meant to convince you of something rather than open your thinking. So-called heroic art, like that made by Fascists or Soviets, puts forth its agendas through pictures of people saluting a Nazi flag or admiring oversized heads of Joseph Stalin. Such images were made to cure spectators of wrong thinking and lead everyone to the same conclusions. They asked for or demanded adoration rather than critical thinking, and many were large, not intimate, in order to overwhelm or intimidate.

The poster you see here, from 1934 Soviet Russia, depicts a large Joseph Stalin addressing many people who appear enthralled by what he is saying. Behind him is an iconic bust of Vladimir Lenin hovering over a group of officials who are lent power by his presumed presence. These figures are meant to convey the strength of the regime and demand deference. Robert Hughes would call this a "transfusion model of education." He wrote that no art should ask you to subscribe to this but should rather call for "debate, not reverence."[6]

Other Kinds of Reverence

Reverence may also show up when we meet art that is difficult to understand or that comes from far away. People and art from foreign places may be fascinating and worthy but not *only* because they come from an unfamiliar place. Wholesale

acceptance can lead to a kind of reverse racism that places others in an isolated situation because you cannot see complexity nor sense the life in people (or in art), when you offer wholesale reverence or dislike. When you venerate or scorn without noticing your own role in doing this, you insert distance between you and the other. Both thoughtless acceptance and rejection dismiss truth and reality and close off experience and honest dialogue. The person or the art deserves a chance to look back and answer. Be a skeptic; look before judging and look for a long time. There is usually a great deal we cannot see, but we must begin with what is visible.

Traveling from Surface to Depth

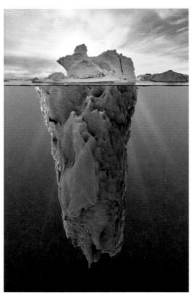

FIGURE 3: Iceberg, posteriori/ Shutterstock.com.

Only a small portion of a huge iceberg is above the surface of the water, and you can't judge its size by what you see. Even without an oceanographer's instrument to measure it, you know it's much bigger than it appears. But other things require more of you. Art and people show only small portions of what they really are, but their surfaces are important because they are entry points to their depths. Size and form, clothing, skin color and gender are surface details that lead you to judge things. To respect your judgements but also surpass them, you can look at the world as an artist.

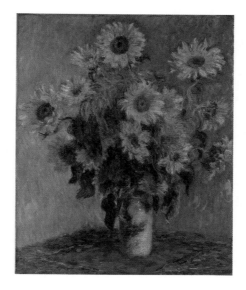

FIGURE 4: Claude Monet, *Bouquet of Sunflowers*, 1881. 39 3/4" × 32".

What do you see?
o Sunflowers.

What are sunflowers?
o Large, yellow flowers that turn toward the sun.

What is the sun?
o A star that gives warmth and light.

What else besides flowers needs warmth and light?
o People.

How does yellow make you feel?
o Joyful.
o Overwhelmed.
o Blinded.

What does it remind you of?
o Sunburn.

How did Monet paint these sunflowers?
o With choppy strokes of paint.

Why?
○ To make them look alive.

Why did he choose to paint sunflowers instead of roses?
○ Maybe they say something about him.

Asking questions is disorderly. The process moves you from one thought to another, from the painting to you and back. Your questions attach you to the art.
How do you feel about sunflowers? About yellow? About Monet? Why do you think he painted this? Is it just a painting of sunflowers?

Is This Just a Bowl?

Artists from the Islamic world often cover entire surfaces of pitchers, ceramic bowls, books, and architecture with elaborate patterns or calligraphy. These decorations make the surface attractive and desirable, but, more profoundly, the calligraphy recalls the revelations of the Holy Quran. The calligraphy then transforms ordinary objects into an homage to the divine, enhancing "the activities and settings of daily life within the Muslim world. To create practical objects with beautiful ornamentation . . . reflects the infinite manifestations of the divine." Such works of art lead "to a greater appreciation of the works of man, and in turn to contemplating the workings of God."[7] Even if you don't read Arabic, you can notice the surface.

FIGURE 5: Small Bowl, Iran, 1500–10. 1 1/4" × 4 7/16" × 4 7/16".

What do you see?
○ Swirling patterns.

What are these particular patterns?
○ Arabic calligraphy.

Why is it used to cover a bowl?

You may not be able to answer every question without help, but you are already traveling beyond appearances when you make contact with the surface and start asking. Right now, you are not looking at a bowl but at a picture of a bowl. So what's the subject of the picture? Most of us would say that the subject is the bowl. But the calligraphy is part of the picture too.

All objects, when they are pictured, become something other than their original selves. This is true of *all* objects, even ordinary ones. That concept has interested artists for a long time, and it became even more noticeable in the 1960s when several of them created what came to be known as the pop art movement. Their subjects were ostensibly the commercially made goods we buy and use.

Among the most famous of these goods was a soup can (not shown here), produced by the Campbell Company and made into a painting by the American artist, Andy Warhol. Once again, when people looked at his painting, they weren't looking at an actual soup can but at a picture of one. The can wasn't in a market or a kitchen but in a museum. It was out of its usual context, and that changed its meaning.

Where do we usually see a picture of a soup can?
○ In advertising.

Why is it in an ad?
○ To convince us to buy soup.

Then what happens when it turns up in a museum?
○ We look at it.
○ We aren't being convinced to buy soup.

A picture of a Campbell's soup can in a museum or anywhere else does not have the same purpose as the actual can in a grocery store. For one thing, it doesn't have soup in it. The artist who painted the one in a museum wants us to look and question it. Do we like its design—the tilted O, the fleur-de-lis at the bottom, the red label at the top? Why are there so many cans of soup in markets? Who buys

them? What's it like to open a can? How does the food inside look and smell? How does it feel to hold one of these?

An object like this is so common that people don't pay attention to it unless they need what's inside, and if they buy it, they probably don't look closely at the details of the label because they are thinking about eating. Or they may reject it because they would rather make their own soup and grow the tomatoes, or they don't want to buy something that adds to a garbage landfill. The pop artists often poked fun at the commercial world and at consumers. But they also paid attention to the designs and forms of things we easily overlook because we see them all the time. And sometimes they used ordinary things to devalue the serious subject matter in more traditional art, some of which you've seen in this book.

The soup can is only part of the subject. The rest of it has to do with how we look at things, what we value, what we eat, how we decide to buy things, and how advertisers flood us with images of products someone wants us to buy. The surface is a picture of a soup can. But the meaning rests in you.

Your direct experience opens you to learning as nothing else can. What you learn second-hand, what someone else tells you, may be useful but will not have the same meaning or impact. Try telling someone who has never tasted chocolate, what that is all about. Nothing I can say about Venice will give you the value of a fifty cent ride across the Grand Canal. No one looks, feels, and understands exactly as you do. What do *you* think of soup cans?

Integrity

the state of being whole
The Oxford English Dictionary[8]

The inside and the outside are two parts of the same thing. Surface and depth are one. Your intuition and your thinking are as much a part of you as the color of your eyes and the slope of your shoulders. Your beliefs and talents, your fears and desires live in one person who has height, weight, and a certain shaped nose. Everyone has a surface made of perceptible information, and everyone has depth made up of a lot more than anyone can see.

In 1999 I attended a workshop where Martin Bennett, a well-known intercultural trainer and writer, introduced a target-shaped model called "The Seven Spheres of Inclusion [SSI]."[9] The individual personality is at its center, and concentric rings around this "bull's eye" hold internal, external, organizational, and national dimensions of personality.

We can't see internal dimensions unless individuals reveal them, nor can we always read gender, age, race, and ethnicity from surface details. In childhood, we learn to attach meanings to appearances, but adults learn not to assume that those tell complete stories. Once again, we face the difference in denotation and connotation—the face denotes certain surface details, but complexity exists beyond its appearance.

Values are difficult to discern. They are deeply held ideals that grow out of cultural teachings and individual interests, and some you can detect from what people say or do. But many values are under cover, and you find them only through a sincere desire to know another human being.

Art is a micro offering of human values. It reflects both shared thinking and individual expression, exposes notions of beauty that vary across cultures, reveals spiritual beliefs, offers perceptions of nature, and shows respect for the rustic or the polished. It carries you into diverse thought, passion, sadness, celebration, awe, nostalgia, anger, and confusion—not through mushy, generalized ideas but marvelous evocations of the specific. By looking closely at particular objects, you can discover the less visible beliefs and concerns of the people who made them. You can find something of their integrity and begin to build a relationship by seeking common ground.

Navigating Cultures through Art

An Appreciation of Reciprocity and Subjectivity

to go more deeply into the experience of the other—no matter how "foreign"— is to go more deeply into our own experience as well.

Andre Dubus III[10]

Art is not international. It is bounded by the time and place in which an artist works, and the original meaning of a work of art is particular to both. When we arrive, most of us can't help injecting our own meanings. It isn't easy to cross over to that other side and allow ourselves, in Wendy Steiner's words, to be violated by different thinking that opens thought rather than closes it down. A painting can challenge us to hold several ideas at once and to become part of something out there while remaining within our own skins where we preserve an awareness of ourselves as we begin to know a stranger.

Likes and dislikes, interests and knowledge—our gaze alone—make us a mediating presence between one thing and another. The backdrop of our thinking is the complex culture in which we grew up, where shared ideas and values have a common language. Those meanings travel with us everywhere. People within the boundaries of any culture understand its many vocabularies in ways outsiders do not.

Though art takes meaning from its context, and we bring to it our own readings, we are nevertheless woven into that other time and place. It makes us know, as nothing else can, that we are part of something we often don't perceive. If we persist in seeing the world only in separate parts, we tend to treat other people and the natural environment as though we are not connected to them, and we do not sense our interdependence or the reciprocal nature of life.

Artist David Barr wrote that he takes satisfaction in vaporizing boundaries. Another way to think of that is to return to the idea of entering *liminal ground*, the place where art critic Lucy Lippard says new meanings germinate. It is a metaphorical space between us and another where we realize that meanings on one side may not transfer to the other, and if they do, something small or large may change. The journey into liminal ground or metaphorical space is deliberate and conscious, and it helps to have a playful attitude.

Navigation into the art of all cultures requires us to be conscious of what we prefer and what we assume as we move toward it. Writer Robert Hughes asked for "an informed multiculturalism" that does not accept the idea of one group's perception of history or beauty as the true one. He worried that such claims foster separatism instead of "a recognition of cultural diversity or real multiculturalism, generous and tolerant on both sides."[11]

Vaporize Boundaries

Notice details.
Give them words.
Don't be satisfied with fronts.
Confront your tastes honestly.
No one needs to know what you think and you can change your mind.
Ask precise, not general, questions.
Through questions, you navigate difference.

At their best, questions may lead you, as Robert Hughes says, to "think and act with informed grace, across ethnic, cultural and linguistic lines" and encourage you to acknowledge that "differences among races, nations, cultures and their various histories are at least as profound and durable as their similarities."[12] Conversations with art are a form of intercultural communication in its finest subjective mode.

Multiculturalism asserts that people with different roots can coexist, that they can learn to read the image-banks of others, that they can and should look across the frontiers of race, language, gender and age without prejudice or

124

illusion and learn to think against the background of a hybridized society. It proposes—modestly enough—that some of the most interesting things in history and culture happen at the interface between cultures. It wants to study border situations, not only because they are fascinating in themselves, but because understanding them may bring with it a little hope for the world.

Separatism denies the value, even the possibility, of such dialogue. It rejects exchange . . .

Robert Hughes[13]

NOTES

1. David Barr, *Nets*, 1988, film and essay produced by Macomb Community College.
2. Wendy Steiner, *The Scandal of Pleasure* (Chicago: University of Chicago Press, 1997), 211–12.
3. D. H. Lawrence, quoted in Martin Gayford and Karen Wright, *The Grove Book of Art Writing: Brilliant Writing on Art from Pliny the Elder to Damien Hirst* (New York: Grove Press, 1998), 253.
4. Imogen Sara Smith, "Still Life Photographs," *The Three Penny Review* 122 (Summer 2010).
5. Lawrence, quoted in *The Grove Book of Art Writing*, 253.
6. Robert Hughes, *Culture of Complaint* (New York: Oxford University Press, 1993), 108.
7. Marianna Shreve Simpson, *Introduction to Islamic Art* (Washington, DC: Smithsonian Institution, 1993).
8. Oxford English Dictionary, 11th ed (2009), s.v. "integrity."
9. Lee Gardenswarts, Anita Rowe, Patricia Digh, and Martin Bennett, *The Global Diversity Desk Reference: Managing an International Workforce* (New York: Pfeiffer, 2003), 92–110.
10. Andre Dubus III, *Words without Borders*, eds Alane Salierno Mason, Dedi Felman, and Samantha Schnee (New York: Anchor, 2007), quoted in Evelyn Small, "Book Notes," *Washington Post*, April 22, 2007.
11. Robert Hughes, *Nothing If Not Critical: Selected Essays on Art and Artists* (New York: Penguin Books, 1990), 96.
12. Hughes, *Nothing If Not Critical*, 96.
13. Hughes, *Nothing If Not Critical*, 83–84.

CHAPTER 9

When Art Speaks, Listen

When Art Speaks, Listen

Painting should call out to the viewer . . . and the surprised viewer should go to it as if entering a conversation.

Roger de Piles[1]

Chapter 4 begins with the opening lines of John Logan's play *Red*. Artist Mark Rothko barks them at a new assistant who has walked into his studio for the first time. What do you *see*? What do *you* see? Rothko wants him to *listen* to the painting—to start a conversation—to be active—to think for himself. Rothko, like many artists, demands a direct dialogue with his work. If you walked into an artist's studio, what would you pay attention to?

Color may be symbolic (blue for purity in some cultures). At other times, it may not stand for anything, but its brightness or darkness becomes part of the painting's message.

Subject matter seems obvious in works that tell familiar stories. At other times, what you see may stand for ideas or concepts. An empty chair may commemorate a death. A piece of cake may speak to the pleasures of eating. But what if it's green?

Placement includes ways artists put things together. Placement guides your reaction and gives you clues to meaning. What do you see first? Where does your eye go? What is the largest thing? The smallest? What is in front, and what is behind? Placement includes the actual location of the entire work. Sculptures on the floor instead of on pedestals stand closer to you and make a more direct connection. The ones on pedestals are more distant. They proclaim themselves precious objects outside your reach.

Materials tell a story. Found objects, the cast-off things artists put into their works usually have little value until they are reused creatively. Some have

"memory" built into them because they've been used. Other materials, such as bronze or gold, have intrinsic value. Artists use many things you may not normally associate with art, and their choices make meaning.

Frames are part of a painting's language. An ornate gold frame says that a painting is important, and it keeps you at a distance. Unframed works symbolically invite you to enter. Some artists place their canvases on stiff wooden stretchers; others hang their canvases loosely so that they are flexible like the fabric itself. Some paint their frames to make them part of the work. Others continue the paint around the edges of the canvas to make the work go beyond its traditional borders.

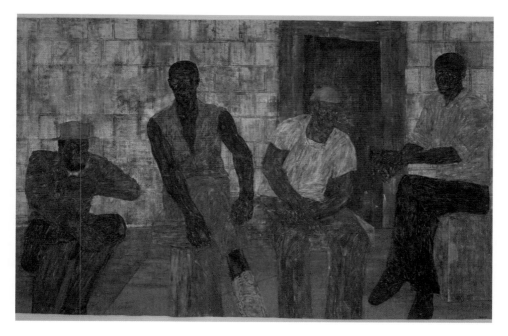

FIGURE 1: Leon Golub, *Four Black Men*, 1985. 121 3/8" × 190 1/4".

Four Black Men speaks through its subject matter, color, placement, materials, and the lack of a frame. Leon Golub places viewers on a street where they suddenly come upon four men sitting against a wall in a relaxed pose. The suddenness is unsettling. Asking *how* he makes that happen is a good opening to a conversation.

How does Golub make a viewer feel uneasy?
o He paints the men close to the edge of the canvas so that they appear to be quite near.
o He dresses them in bright colors.
o He places them against a wall that blocks their movement and the viewer's ability to see into the space behind them.
o He lets the canvas hang loosely so a frame doesn't separate the viewer from the picture.

Where is this scene?
o South Africa.

When was it painted?
o 1985.

What was going on in South Africa at this time?
o Many people were out of work during the long period of Apartheid or extreme segregation.

What does he hope the viewer will do?
o He wants viewers to look at the men as a group but then see them as individuals who are suffering under a repressive political system.
o He wants viewers to consider how they feel about the people in the painting and the conditions of their lives.

What else would help them understand this painting?

Leon Golub tells the story of a twentieth-century tragedy using an artistic device that dates back to classical Greek and Roman times when sculptors placed figures in friezes, above the heads of spectators to make them appear heroic and monumental. Golub also makes his figures large and strong, and they might be heroic if they were free to act. But they are blocked, both by the society in which they live and the wall behind them. Instead of a frieze, Golub places the four men in his painting at eye level so that viewers meet them directly.

He said that he thought of art as a comment on how things were at a particular time and place so that when we look, we find a summary of what people thought was important. In *Four Black Men* he summarizes South Africa at a certain time in its history and takes us there. Our dialogue with the painting, starting with what *we* see and feel makes the painting mean something to us. When we then look into its background, new knowledge makes our experience larger and richer.

Here Golub paints only one aspect of the lives of South African men. But by simplifying, he gives us complexity. He appeals to our emotions so that we empathize with the plight of people who suffer lethargy and depression because they cannot work or move about freely.

A painting is different from a newspaper story. The painting does not tell an entire story or report on conditions as a newspaper may. Rather, it aims for your feelings by placing you right there with these men and creating an immediate, present-tense experience.

A Brief Summary of *Four Black Men*

What are the subjects?
o Human suffering.
o Politics.

Where is the painting?
o Close to you.

What kind of space?
o Shallow.

What kinds of colors?
o Strong and bright.
o No shadows.

What size?
o Large.

What kinds of materials?
o Loose canvas.
o Paint.

Other Ways Art Speaks to You

Art Speaks through Symbols

Symbols are forms that stand for an idea you can't see. In Hindu statues, a dwarf symbolizes evil or ignorance, and the god Shiva crushes it under his foot. Other symbols, such as dragons, have different cultural meanings depending on where

you find them. The dragon symbolizes evil in the West while in East Asia it traditionally symbolizes potent and auspicious powers. We don't question the meanings of symbols in our own cultures, but strangers need to learn what they mean. We need guidance from knowledgeable instructors.

FIGURE 2: Leng Mei, *Marital Felicity*,
1741, 4th month. 46 5/8" × 25 3/4".

The title of this family painting tells you its purpose: how to have a happy marriage. The artist teaches values through figures that represent ideal people, and he paints on silk, a valuable material, to emphasize the importance of the subject. This is not a quick sketch done on cheap paper.

What do you see?
○ A man seated on a couch.
○ A woman seated on a chair.
○ Two small figures that could be children.
○ Four other women, not seated.
○ A round window in the background revealing a garden outside.

Some things are more difficult to identify
○ The garden outside the window includes rocks that have been eroded by nature.
○ The four standing women are servants.
○ One of them, behind the seated man, holds a tray of peaches and pomegranates.
○ The man on the couch is the father of the family, and he holds a scepter.

- Books and scrolls surround him.
- The two small figures are male children.
- One child touches a book; the other holds a jade chime.
- The seated woman is the mother attended by servants. She looks at one son.
- A stand made of gnarled branches holds an incense burner.

Nearly everything in this work of art means something. The people and objects are symbols or stand-ins for ideas.

Gnarled branches bring nature inside the home. We must respect nature.
Eroded rocks remind us of time passing. Everything changes.
Peaches symbolize immortality.
Pomegranates symbolize fertility.
The scepter makes wishes come true.
Books and scrolls show a respect for learning.
Male children are desirable to carry on the family name.
Chimes symbolize happiness.
You must be prosperous to afford servants.
Incense is both pleasant and cleansing.

What is this about?

This is not a portrait of actual people but an archetype of an ideal family introduced by Confucius over two thousand years before it was painted. Confucius was a philosopher, born about 551 BCE, who taught the importance of moral values both within the family and the larger society. He defined gentlemen as people of good moral character and saw them as leaders of both the family and the larger social order. As time went on, followers modified his teachings but continued to promote the moral man as the right person to lead both family and society.[2]

Art Speaks through Archetypes

Archetypes are figures or symbols that characterize thought patterns. The mythological god Apollo may represent ideas connected to archery, healing, music, poetry, prophecy, purification, and seafaring. An old woman may stand for the wisdom of the ages or the particular wisdom that comes from child bearing. Some archetypes stand for supernatural powers, and all are rich in meaning and values. Like the dragon, their significance changes depending on when and where you find them. Cultures promote certain forms that appear over and over and function as a shorthand to understanding shared ideals, values, histories, and desires. You have seen examples of this in the Confucian painting of the ideal family and

the mounted Yoruba carving of a leader endowed with respected supernatural and temporal powers.

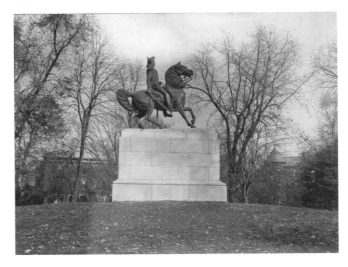

FIGURE 3: Clark Mills, *Lieutenant General George Washington*, commissioned 1853.

George Washington, the first president of the United States and known as "The Father of the Country," is an American archetypal figure. He engendered a new nation by commanding an army and also leading a convention to write a constitution. He was a man of action. A nation could rely on his leadership, and a family could feel protected by his strength. A traffic circle named for him in the city of Washington, DC is the site for a bronze statue of him riding horse, which he controls.

Washington was also a husband, farmer, businessman, legislator, county judge, and churchwarden. But his depiction in this statue is not about his biography or the nuances of his personality. The statue in Washington Circle holds the archetype, not the fully complex man.

He rides a horse, a symbol of power, as we have seen in Yoruba culture and elsewhere in the work of Marino Marini. Washington's horse is in motion, its tail and mane blowing forward to let us know the wind is behind him, the forces of nature propelling him to do what is right. The horse is strong, and so is Washington as he sits upright and in control. One might argue that the man of action or warrior is a more enduring archetype for Americans than the contemplative intellectual.

Benches surround the statue. They are for ordinary citizens who can't ride the mighty horse above their heads but can aspire to what the statue represents. In schools, children read about George Washington's honesty, courage, and strength to encourage them to carry on those qualities and to serve their country.

Art Speaks through Ideas

[Art is] an object of knowledge mediated by the artist's hand, a reality now more complex—or more simplified and irreducible than it was before.

W. S. Di Piero[3]

All art is about ideas. But when art seems more about ideas than what we actually see, it can leave us baffled, exasperated, or bored. How do we make sense of canvases with only lines, squares, blobs of color, or a jumble of discordant images? "My three-year-old could do this." But while three-year-olds randomly make forms that resemble some of those in museums, they do it without intention. When we ask children to tell us about their drawings, it is often our questions that lead them to offer meanings. "This (wonderful swirling wet goopy orange blob)—is, uh, my brother." Until you asked, a child may just have enjoyed the sensation of messing around.

What you see in art is intentional, not random. Artists leave accidental marks on a canvas because they decide to communicate through them. Their lines, circles, and scribbles have meaning within the context of the picture.

Art Speaks through Lines

if any one thing is certain in this world, it is that art is there to help us live, and for no other reason. We need it to explain the inexplicable.

John Russell[4]

FIGURE 4: Barnett Newman, *Covenant*, 1949. 47 3/4" × 59 5/8".

Here is a canvas, painted red with two lines on it.

What is a line?
○ A long narrow mark.

135

○ A wrinkle.
○ A boundary.
○ A phone line.
○ A shipping line.
○ The equator.
○ The starting line.
○ The finish line.
○ Enemy lines.
○ Class lines.
○ A line of defense.
○ Your line of work.
○ A line of words on a page.
○ A line of children in school.
○ A plumb line.
○ A property line.
○ Your neighbor's fence.

Lines are everywhere. They are necessary, expressive, passive, active, powerful, and packed with meaning. Pyramids and skyscrapers, brick houses and mud houses all use lines. Their builders start with lines in the earth before they put up walls. Babies become lines when they stand up and walk. You create a line with your posture. The highest line in a society may indicate what people think is important—trees or churches or skyscrapers.

Lines mean different things in different places and among various peoples. On the cover of Karen Armstrong's book, *A History of God: The 4,000-Year Quest of Judaism, Christianity and Islam*, you see three pictures that look like this:

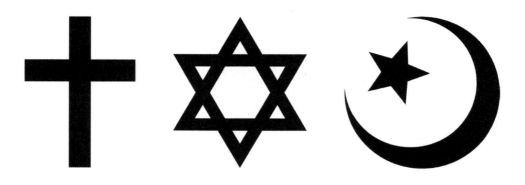

In themselves, these lines and curves have no meaning. They are merely shapes. But they are powerful to people who recognize them and know their meanings.

When an artist separates a line from everything else and uses it consciously, ask:

Where does the line go?
What does it do?

Look at the line:
What color?
What size?
Where is it?

Look at yourself:
What struck you first?
What drew you in?
What made you not want to bother?
What do you think of abstract art?
How do you feel when you look at just color and a line?

Look at the artist:
Who was s/he?
Where did s/he live and work?
When?
What was going on then?
What other art was made at the time?
What did s/he like?
Did s/he make other paintings like this?

Barnett Newman was born in New York City in 1905 and loved life there. He ran for mayor in 1933 with proposals for free art schools, a municipal opera, a clean air department, and waterfront parks. Art historian John Russell describes him as a brave and forthright citizen, son, and husband who worked to redefine America. How did such a forthright man come to paint in such an abstract way?

Russell says that in 1945, immediately after World War II, Newman was worried that America, in its position of dominance, might not live up to its responsibilities in the larger world. The country required wisdom and a new resolution, and he believed artists had to respond. He was preoccupied with measurement, essential to scientific research that can lead to better life conditions. But for Newman, measurement was part of approaching the sacred "to measure the unmeasurable," an idea that comes from Jewish mystical experience.

He responded by using simple forms to "achieve feeling through intellectual content."⁵ In his work, he contemplated the human place in the larger, unfathomable universe. How tall is a person? How much space do any of us take up? If his line is the opening in a wall, then what is that wall? Could the line represent us and suggest our looking beyond doubt, anxiety, or anything else that blocks our larger vision?

He called his lines "zips." Some have sharp, clean edges; others are smudged so that, as Russell says, they look breathed upon. What are these zips? They may "stand for the newly created Adam" or an "abstract force of division—as God separated the waters and the firmament in Genesis."⁶ This is a very grand subject, creation itself, and earlier Western artists usually depicted it through the human figure as Michelangelo did in his famous frescoes on the ceiling of the Sistine Chapel. Newman used a line.

Art Speaks through Circles

FIGURE 5: Mario Merz, *From Continent to Continent*, 1985. 66" × 135" × 135".

What do you see?
○ A dome.
○ Broken glass.
○ Wires.
○ Words in neon.
○ Clamps.

Where is it?
o On the floor.

Does it use circles or lines?
o Both.

What is a circle?
o Something round.
o A ring.
o A circle of light.
o A circle of friends.
o Circles under our eyes.
o Circle the wagons.
o Go around in circles.
o Come around full circle.
o "Circle 'round."

Like lines, circles are everywhere and can have special meanings depending on where they are. Mario Merz used the circle to construct a glass dome and placed it on the floor; named it *From Continent to Continent* and lit those words in neon; incorporated the words into the sculpture itself; made it from sharply cut pieces of glass; held it together with metal clamps; crudely draped wires around the piece.

What are domes?
What is glass?
Where do you usually see neon?
What is the meaning of the title?
Could you go inside this dome?
Would you want to?

You are looking at a kind of igloo like the ones nomadic peoples build to enclose and protect themselves. But nomads traditionally make their temporary homes of natural materials such as leather, mud, or ice, while the materials in Merz's igloo are manufactured, and its construction makes it inhospitable. You can't find a way in, and if you tried, you would be cut by the sharp edges of the glass. It's a home that makes you homeless. Instead of protecting, it injures. As a house, it fails.

Particularly in cities, homeless people often clamp together whatever they can find to construct makeshift structures that leave them exposed. They have little or no privacy, as though they lived in glass houses, and they depend on borrowed light and other handouts. Neon is public light, used in advertising on the street.

139

Refugees and immigrants face another kind of homelessness. They may live in proper houses but not feel at home after being uprooted from their own lands. They, too, feel exposed.

The circle has a rich history in art and in spiritual traditions. Buddhists symbolized their beliefs through a wheel before they used the upright stupa and human form. Sikhs wear a circular bracelet as a reminder of the infinity of creation. Taoism teaches that there is no beginning and no end to creation. The principal form in Merz's sculpture is the circle, but he also uses sharp lines of broken glass. Unlike the line in Barnett Newman's work, which is spiritual and hopeful, these lines are threatening. People are naturally drawn to circles, but this one cuts them off.

Art Speaks through Abstraction

Lines and circles are merely forms until an artist gives them meaning by using them to express large ideas. A lot of things are just forms until you put its pieces together through your perception, intelligence, feelings, and understandings. *You* give meaning to what you see. A line and circle seem simple and easily understood, but they have layers of associations.

A lot of art uses the language of abstraction. Why? There are many reasons, but here are two:

1. Everyone can recognize lines, circles, squares, triangles, and rectangles. (That may be why children are comfortable with pictures of just forms. They can enjoy them for their appearance and bring their own stories to them.)
2. Shapes, forms, colors, and sizes can express emotions and ideas in unlimited ways.

When people believed all knowledge could be placed within the covers of a single book, art easily depended on human figures, landscapes, and a limited range of symbols to tell stories. Art's only worthy subjects were history, mythology, and religion. But when the telescope, the microscope, and psychoanalysis opened visions of an expansive universe of time, space, and self-awareness, artists responded to unfathomable complexity by inventing forms to express what they could see, what they couldn't, what they questioned, and what they felt. At times they used abstraction to bring together disparate pieces of experience. They used a familiar artistic language (lines, circles), which we recognize but may find frustrating or confusing. What to do!

Reading Abstraction

We often turn away from confusing art with impatience, anger, or even fear. We recognize colors, materials, frames, symbols, archetypes, lines, and circles. But when an artist uses them in unpredictable ways, we feel left out. It's like hearing a foreign language where we recognize sounds but not their composition into words— or like hearing words we recognize but can't compose into sentences.

Shapes, colors, sizes, and forms do not have universal meanings. They affect us emotionally when they communicate something about the human condition and the mystery of existence. John Russell wrote,

> It is possible to respond to (Barnett) Newman's paintings without knowing what he intended by them, just as it is possible to enjoy the Noh plays without understanding Japanese. . . . It will somehow get through to any sympathetic observer that Newman was up to something very grand, and that the picture on the wall results from an exemplary commingling of science and hard labor and love.[7]

Among the most beautiful and complex forms in art are Korean, Chinese, and Japanese calligraphy. You may be unable to read them as words or concepts, but you can gather some meaning from their shape and appearance. Written large, they fill space and create drama. On wet paper, they spread, reminding us what we can't control. On any paper, they reveal the skill and discipline an artist must have to write them beautifully. Where the brush is lifted, a mark narrows, and where the brush is pressed, the ink widens. When you notice these subtleties, you can follow an artist's process and think of your steps in trying to form an understanding of a single experience in your own life.

Four Black Men, Lieutenant General George Washington, Marital Felicity, Covenant, and *From Continent to Continent* speak with you through a visual language. They want you to look at them. But some art asks you not to look and uses its artistic language differently. The Baule of Ivory Coast, whom you met in Chapter 7, have at least four ways of regarding their art.

A Different Kind of Looking

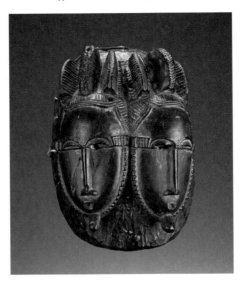

FIGURE 6: Face Mask, Baule artist, late
nineteenth to early twentieth century. 9 7/16"
× 6 5/16" × 4 7/16".

Glimpsing: The Private

Baule artists pay strict attention to subject matter and visual language, but when they finish certain objects, they hold them in concealed spaces where people have special relationships to them. Some of these private sculptures are spirit husbands and wives who watch over their human partners, and the Baule show respect by glimpsing them rather than looking with a steady gaze.

Watching: Entertainment Dances

The Baule also make masks for men to wear while performing entertainment dances. The masks represent females, males, families, and animals. A single dancer wears first one mask and then another to show that an individual embodies many personalities. The dances are public events for all to watch.

Noticing without Looking: The Sacred

An individual may become a diviner and healer after entering a trance to communicate with a wild spirit. Artists then make objects such as ancestors'

stools, gold objects, or cloths that take on great power and deserve special respect. Sacred objects should not be disturbed. They should be noticed but not looked at.

Taking a Good Look: Decorated Objects

Baule artists also openly demonstrate their skill by creating beautiful, useful objects to display, discuss, and use in daily life. Then people take a good look at them.

Baule objects speak through form, color, size, and shape as all art does, but their vocabulary includes privacy and respect. The curator of an exhibition at the Smithsonian Institution's Museum of African Art appealed to viewers to "leave with a heightened sensitivity to their own acts of looking."[8] If you want to listen to Baule art, you need to hear its language as they do.

Language and Meaning

Spoken language is at the center of all cultures, and learning other peoples' languages gives you access to them. But it is only the beginning. We may comprehend words and be able to say them, but using them appropriately and sensitively is a more refined skill. Language, in both verbal and nonverbal forms, goes to the core of who we are and what we think is important. To go beyond the frame of a culture, to cross that boundary between our own definitions and those of others, we need to respect differing perceptions of how language communicates.

Language makes sense in context. Within cultures or areas of specialization, certain words and ways of using them evolve. Those develop into modes of expression that can be inexplicable to outsiders. (Have you ever listened to two doctors discuss diseases and interventions or two lawyers discuss a legal case?) And languages within countries also evolve in their own ways. There are differences—some would say chasms—between European and Brazilian Portuguese, or British and American English. And in any language, there are subtle differences in meaning among similar words.

Within art's language, color, form, and size take meaning from their contexts and the intention of the artist. None have independent meaning. If you have heard that red means blood and blue means purity, be doubtful. The picture where they appear will answer the question. Red may mean blood, or it may mean something else, or it may mean nothing. The clothes people wear may tell you a lot about them, and sometimes they don't say much.

The language of art has history and practice behind it. But like everything else, it is fluid. Meanings shift, and you also bring meaning. Avoid "knowing"

before asking. Your questions change your experience and make you a sympathetic observer. You don't need to have been told that Barnett Newman commingled science with love to feel the charge in his painting, though the more you learn the more you will understand and grow. There are many kinds of listening.

Most of the time we feel things before we figure them out. And feelings are instructive. The next chapter proposes starting off with feelings—and then, of course, asking questions.

NOTES

1. Roger de Piles, *Cours de peinture par principes* (1676), quoted in Alberto Manguel, *Reading Pictures: What We Think about When We Look at Art* (New York: Random House, 2000), viii.

2. Anon., "*Marital Felicity*," in *China, Japan, Korea Teachers Guide* (Portland Art Museum, 1998), 32.

3. William Simon Di Piero, "Make Me a Picture," *The Three Penny Review* 103 (Fall 2005), https://www.threepennyreview.com/samples/dipiero_f05.html.

4. John Russell, *The Meanings of Modern Art: America Redefined*, vol. 10 (New York: Museum of Modern Art, 1975), 42.

5. Russell, 42.

6. Russell, 42.

7. Russell, 42.

8. Susan Mullin Vogel, *African Art Western Eyes* (Washington, DC: Smithsonian National Museum of African Art, 1999). Organized by the Yale University Art Gallery with the Museum for African Art, New York. Exhibition in The Art Institute of Chicago, 1998.

CHAPTER 10

Follow Your Senses—Sense Meaning

Follow Your Senses—Sense Meaning

First, put aside the desire to judge immediately; acquire the habit of just looking. Second do not treat the object as an object for the intellect. Third, just be ready to receive, passively, without interposing yourself. If you can void your mind of all intellectualization, like a clear mirror that simply reflects, all the better. This non-conceptualization—the Zen state of mushin ("no mind")—may seem to represent a negative attitude, but from it springs the true ability to contact things directly and positively.

Soetsu Yanagi[1]

Great art can communicate before it is understood.

T. S. Eliot[2]

The eye is a very quick instrument, much quicker than the ear. The eye gets it immediately.

Anish Kapoor[3]

Sight and Insight

I have been asking you to meet art with questions that allow it to talk before you do. But Soetsu Yanagi asks for something else, a "no mind" approach, going to your feelings first. A no mind approach draws in your body and your senses.

We are sensing beings, and sensation is the essence of experience. But it is difficult to receive purely. Your mind will send its judgments without your asking, and you can't stop this normal bombardment. But you can be aware of the jumble of thoughts and feelings that come your way. Sensing is a strong, direct experience, unmediated, and you may always remember an image or experience that hits you emotionally before you try to figure it out.

Anish Kapoor (whose art is based in science, mythology, psychology, and religion) gets to viewers first through visual pleasure. By contrasting two of his sculptures, you can see how he involves you through your senses to make you part of the art. He says, "The work itself has a complete circle of meaning and counterpoint. And without your involvement as a viewer, there is no story."[4] You provide not only your story but also a contrast to his perceptions, feelings, and ideas by supplying your own. His meaning and yours may be different, but you meet through a visual dialogue. Your vision and his art can meet intimately before you ask questions about his intentions.

Artists don't make objects. Artists make mythologies.

Anish Kapoor[5]

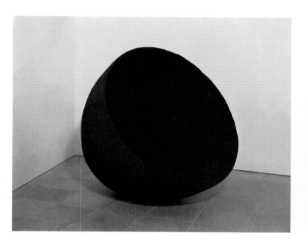

FIGURE 1: Anish Kapoor, *At the Hub of Things*, 1987. Fiberglass and pigment. 64" × 55" × 59". Photo: Sue Omerod, Coll: Hirshhorn Museum and Sculpture Garden, Washington, DC © Anish Kapoor, 2018.

FIGURE 2: Anish Kapoor, *S-Curve*, 2006. Stainless steel. 7' × 32' × 48". Photo: Joshua White, Courtesy Regen Projects, Los Angeles © Anish Kapoor, 2018.

At the Hub of Things	*S-Curve*
Soft oval.	Curved wall with sharp edges.
Dark.	Bright.
Absorbent.	Reflective.
Powdery.	Hard.
Small.	Large.
See shape.	See self, room.
Draws me in.	Keeps me out.

Going Inside Yourself

At the Hub of Things

This sculpture reminds me of a dream about falling. I can't see how far back it goes; the space seems endless. In *Destination Moon*, a 1950s film about space travel, an astronaut becomes untethered from a space station and risks floating into gravityless space forever. It's terrifying. (He does get rescued.)

My eye can't tell if this egg is solid or hollow. The piece is only lit on the sides and back, not the front. I can walk around and see the pointed end on the outside, so I know its limits, but I wonder why Kapoor made his sculpture to keep me from seeing the interior.

Going Inside

I *learn* the piece is hollow and later discover other things that help me understand how he made me feel the way I did.

He chose *blue*. It's dark and absorbs the light around it. It looks black where light can't reach it. Blue is thought to be a cosmic color. In Hindu mythology, blue is connected to Kali, the goddess of destruction. She is also known as Parvati, the goddess of motherhood.

He chose blue *pigment and firm fiberglass*. Pigment is color that often comes from plants. Pigment is powdery and fragile and can blow away in a breeze. Fiberglass is a manufactured plastic made from glass fibers embedded in resin. Fiberglass is sturdy and rigid. He used special glue so the pigment would stick to the fiberglass, but it's fragile and would fall off if you touched it or blew on it.

He is interested in *Hindu practices*. Observant Hindus draw sacred images on the ground using pigment. When the pigment blows away, it becomes part of nature.

He chose an *egg* shape. An egg is a female form, linked to fertility. It's an archetypal or symbolic form. He placed it on the *floor*. He wants it to be in your space so that you can relate to it, not look up at it in awe. He once said that he makes "mental sculpture."

He *titled* it *At the Hub of Things*. A hub is the center of a circle. A hub stabilizes a wheel so it can turn evenly. In Buddhism, the Wheel of Enlightenment symbolizes the continuous cycle of life and death. It appears on the flag of India as the Dharma Chakra or Wheel of Law.

What is at the hub of things?
○ A center.
○ The center of the earth.
○ Your center.
○ The things that make you feel stable, like family or friends.

He explores contrasts or opposites:
through color, materials, shape, placement, and lighting;
through a form that is both inviting and scary, bright and mysterious;
through joining fiberglass and pigment:
pigment is ancient and traditional;
fiberglass is modern and industrial;
through the fear of a dark cave;
through the sense of security in a womb;
through a title that suggests both stability and motion;
through Kali/Parvati embodying contrasting natures.

Contrasts remind us of life's changes: creation and destruction; birth and death.

S-Curve

I feel unsteady as I walk along this wall and need to keep looking at the floor to avoid being dizzy. My reflection gets taller or shorter as I move along. I see reflections of things behind me stretched out or upside down. I think about what it would be like to be really tall or very short, terrifically skinny or very fat.

S-Curve is long and shiny rather than round and absorbent. It reflects whatever is in front of it and seems noisy compared to the quiet egg. In *Hub* I seem to fall into darkness; in *S-Curve* I am surrounded by light. But in both, I find myself. One work sends me inside myself through suggestion and metaphor. The other reflects me like a mirror and also sends me into feelings about my body and makes me aware of where I'm standing. I stop seeing the wall and see light and other objects it reflects. *S-Curve* seems to disappear into the things it reflects.

Michael O'Sullivan wrote, in the *Washington Post*, that this wall erases itself; it's there and it isn't there at the same time. He asks, "what do you see? The mirror? Or what shows up in it?"[6] Carol Huh, a curator for the Smithsonian's Sackler Gallery said that like any mirror, it pulls you in, even as it pushes you away. Despite its shiny reflective appearance, it makes people part of it; it draws them in.

Both sculptures are places Anish Kapoor has prepared for viewers. When you're in those places, you may go beyond the limits of your past experience. This chapter

began with a list of contrasting visual elements you would see if you were there. Your mind goes further.

Pigment has been around a long time and is traditionally prepared by hand. Shiny steel, a modern material, is manufactured by machines. With his interest in Jungian psychology, Kapoor may have intended one piece to be more introverted through its absorbent pigment and the other more extroverted because of its shiny steel. Or maybe not. He wants you to complete his work. His meanings begin with his thinking but ultimately lie in your own perception and experience, what you see, feel, and think.

Who Is the Artist?

Anish Kapoor is a British artist who was born in India in 1954. His work reveals his interests in religion and psychology, particularly the work of Carl Jung who posed the concept of dualities as a way to understand human nature. Kapoor's art touches on the sacred in Hinduism, Buddhism, Judaism, Christianity, and Islam, and it brings together polarities in different cultural expressions. *At the Hub of Things* contrasts light and dark, male and female, safety and danger, comfort and discomfort, rest and agitation, traditional and modern materials, ancient symbols and individual expression.

Contrasting Artistic Ways of Working

Four Black Men **and** *At the Hub of Things*

Both Leon Golub and Anish Kapoor want you to contact their art through your senses. Golub intrudes on you through bright colors that tend to reflect light. For *Hub*, Kapoor uses dark blue pigment that absorbs light and is soft rather than bright. Golub's painting seems to move toward you. Kapoor's sculpture asks that you move toward it. *Four Black Men* gives you an immediate picture of a place and time. *At the Hub of Things* communicates mystery. Both works hold layers of meaning you discover.

Artists compose experiences for you, and you have a chance to build empathy and understanding through a dialogue that gives them a chance to talk to you. Art opens its story through its visual shell, and invariably there is more. Dialogues carry you across cultural and artistic boundaries to contact things directly and positively.

Cultures and art are similar. They are both integrated wholes made up of a complex of parts, some visible and intrusive, some invisible and mysterious. Your

eye takes in information, and as everyone does, you judge what you see. Notice how quickly your eye tells you things and how you translate that data into judgments: good, bad, pretty, ugly, friendly, scary, pitiful, delightful, like me, not like me, want it, don't want it. Our emotional responses lead us to believe certain things are true.

NOTES

1. Soetsu Yanagi, *The Unknown Craftsman: A Japanese Insight into Beauty* (Tokyo and New York: Kodansha International, 1989), 112.
2. T. S. Eliot, quoted in Leonard Shlain, *Art and Physics* (New York: Quill, William Morrow, 1991), 97.
3. Anish Kapoor, "In Conversation with John Tusa," accessed December 14, 2018, http://anishkapoor.com/180/in-conversation-with-john-tusa-2.
4. Kapoor, "In Conversation with John Tusa."
5. Kapoor, "In Conversation with John Tusa."
6. Michael O'Sullivan, "Two 'Perspectives' Explore Art and Change," *Washington Post*, December 19, 2008, http://www.washingtonpost.com/wp-dyn/content/article/2008/12/18 AR2008121801006.html.

CHAPTER 11

Make Sense of the Senseless

Make Sense of the Senseless

It is thrilling when a poet embraces the largest subjects, compress-
ing into a minute or two of human breath issues and feelings that
might dominate an opera stage or occupy a thick scholarly book.

Robert Pinsky[1]

Our largest subjects are private and public, personal and universal, familial and cultural, domestic and global, local and national, spiritual and mundane. In art they show up in small ways. Artists load meaning onto ordinary things, and we meet them as though we never knew them before.

In figures on bus seats, we feel loneliness and isolation and find struggles for justice.

In a horse and rider, we sense power or weakness and find urges toward control.

In a turtle, we feel silence and find fragility or peace.

In a bowl covered with calligraphy, we enjoy a beautiful form and sense the spiritual.

In a bronze goddess, we admire femininity and thoughts of creation and nurturing.

In a blue egg, we sense mystery and think of safety or threat.

Art is economical. It compresses the largest subjects into the smallest means—a face, an animal, a shape, a color. Into these things, artists weave traces of feeling and emotion, and each visible subject implicitly includes others. When we are permeable, empathic, and thoughtful, we expand their meanings. Artists depend on us to bring meaning to their work.

Communities respond to tragedy, human suffering, and exploitation, and artists give form to those. Their art celebrates the warmth of community, the exhilaration

of speed, nostalgia for the past, and our shared stories. They locate the largest subjects in the most ordinary things and through those things, they carry us into history, morality, values, nature, spirituality, science, music, birth, aging, death, conquest, war, poverty, racism, scarcity, abundance, and human dislocation.

At times of loss, particularly due to war and terrorism, communities and individuals often steady themselves through ritual and recollection. They build memorials, focus on shared values, and console us in unexpected ways.

War and Loss

Art gives a form to the suffering that follows loss. It may help us to grieve, to heal, and to better understand one another.

The War in Vietnam

FIGURE 1: Maya Lin, The Vietnam Veterans Memorial, 1982. Two sections, each 246' 9". Orhan Cam/Shutterstock.com.

In the face of a national tragedy, countries look for ways to recognize loss and provide places for public mourning. What they build and how people interact with their memorials vary widely across cultures. Grief may be a universal emotion, but its expression takes many forms.

The time of the war in Vietnam, in the 1960s and 1970s, was an anguishing period for Americans and others, some believing the conflict necessary, others that it was not. It brought suffering, anger, and a mistrust of political leaders, and when a memorial was commissioned, it was difficult to imagine what could commemorate that sorrowful period.

The Vietnam Memorial created by architect Maya Lin is a simple V-shaped wall etched with the names of more than 58,000 people who died. It is not a picture of the war and does not attempt to tell anyone what to think, nor does it preach a point of view on the controversy. As art, it is an abstract form. The emotions of visitors give it meaning.

The wall sits lower than other nearby memorials on the National Mall in Washington, DC, and from above, it appears that grass grows on top of it. The V-shape encloses viewers, offering a sense of privacy though it's near a busy street. The granite, a stone traditionally used for gravestones, is shiny enough to reflect the faces of visitors as they look at or touch the etched names. The unlikely happens; a public structure feels like intimate space.

Earlier you read about the Baule peoples' commemorations composed of small, intimate objects placed in private spaces. Their descendants honor their ancestors by glimpsing these items rather than staring at them. They are modest forms contrasted to a shiny granite wall. But visitors to the Vietnam Memorial feel intimately connected to a name, and some leave notes, flowers, or personal items linked to the person they lost. The setting in which they leave them is public rather than private, and people look directly rather than glimpse, but the memorial evokes many of the same feelings of loss or respect. Both memorials evoke senses of continuation through family and friends who remember.

Terrorist Attacks of September 11, 2001

A public memorial was recently built to mark the terrorist attacks on the World Trade Center in New York City. But before that, artists responded in smaller, intimate ways.

"How can you make art at a time like this! How can you not?" is a headline across the top of a page in a catalog called *True Colors: Meditations on the American Spirit* published by the Meridian International Center in Washington, DC in 2002. The catalog accompanied an exhibition of work by sixty-eight artists who responded to the attacks through new art or whose earlier work took on new meaning when placed into the context of the exhibition. Many works reflected public and private values: what Americans think is important, what they lost, and what makes healing possible.

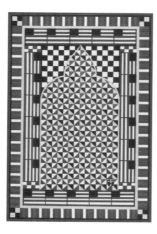

FIGURE 2: Helen Zughaib,
Prayer Rug for America, 2001.
19 1/2" × 13 1/4".

Several of the works at the Meridian Center were by immigrants and refugees to the United States who used traditional artistic forms that were familiar to them from the countries they knew as children. Lebanese-born artist Helen Zughaib painted a prayer rug in red, white, and blue. The center's intricate, geometric design is a mosque-like form that also suggests the shape of a human being. Two tiny socks or slippers, stand-ins for feet, appear on one side near the bottom, and around the edges are American flags.

Prayer Rug looks like a composition of mosaic tiles though it is made of ink and gouache, a type of opaque watercolor. The squares, triangles, rectangles, and lines are orderly and geometric, softened by the curves of the center form and the small socks. The *Oxford English Dictionary* defines the word "mosaic" as "a combination of diverse elements forming a more or less coherent whole." The word also evokes Moses, the receiver of the Judeo-Christian Ten Commandments and a figure respected in Islamic culture. The Prophet Muhammad was also a receiver when the Angel Gabriel dictated the words of the Holy Quran. Some people have said the composition resembles an American quilt, reminding them that quilting in American culture was traditionally a communal activity in which many hands worked separately to create one whole object. Helen Zughaib wrote, "I hope through my work to encourage dialogue and bring understanding and acceptance between the people of the Arab world and the United States."[2]

While not a religious symbol in itself, a prayer rug is associated with Muslims who use it as a portable, clean place for their daily prayers. She uses its form to join potent cultural symbols from the Arab world and the United States.

Prayer Rug for America, in a single image, gives us what requires paragraphs to discuss. In one compact painting we find religious and patriotic values, aspirations for healing, and remembrance of a tragic event. The artist composed the painting, wrote a statement, and then stepped back to allow you to think and to talk.

Four years after the Meridian Center's exhibition, the Whitney Museum's 2006 Biennial in New York City showed a work called *RWBs* by Liz Larner (not pictured here), now in the collection of the San Francisco Museum of Modern Art. Larner's sculpture is a tangle of aluminum tubes, each covered with a bunting of red, white, or blue. Bunting, in those three "national" colors, is an established decoration for American holidays that celebrate patriotism. But here, the tangle suggests confusion, things gone awry, torn up. It sits on the floor where it thrusts upward and out, its spiky pieces making human touch both undesirable and risky.

Both works of art ask viewers to bring their own meanings. *RWBs* is a stark contrast to *Prayer Rug for America* that, if it were an actual prayer rug, would sit neatly on the floor and invite human contact. Its geometry means to offer meaning and order, rather than confusion and disorder. A prayer rug suggests spiritual wholeness, and a tangle suggests disruption. But both artists spoke a certain truth to me at a time of national tragedy. Americans, in their multicultural nation, live among a tangle of voices, opinions, and ideas. They face noisy and unruly politics even as they seek peaceful outcomes.

Hamburgers, Cowboys, Skywriting, and Garden Parties

What do these four things have in common? In *True Colors: Meditations on the American Spirit* artists use them not just to "meditate on the American spirit" but also to comment on cultural values.

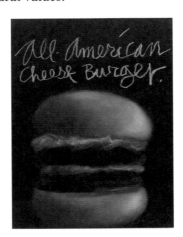

FIGURE 3: Carol Anthony, *All American Cheeseburger Dream*, 2001. 7 1/2" × 8".

Americans sometimes refer, with savor but a touch of humor and self-mockery, to their favorite meal as the all American hamburger. Carol Anthony, who painted *All American Cheeseburger Dream*, identified the hamburger as a "totem that comforts and heals. It is American and coming home."[3]

After September 11, 2001, Americans needed to come home spiritually and certainly to be comforted. Here with gentle irony, Anthony draws a cheeseburger in fuzzy colors, a slash of red for a tomato or ketchup, oozing yellow for cheese or mustard, and nonfood-like shadings of purple and blue. This is a bruised burger, beaten up and blurry against a dark background. The whole concoction floats in some ambiguous space rather than being offered on a plate. It's hard to grab, but who would want to eat food that looks like this even if they could get their hands on it?

FIGURE 4: Kendall Nelson, *To Be a Cowboy, Long X Ranch, Kent, Texas*, 1996. 16" × 20".

Kendall Nelson comments that the American cowboy symbolizes freedom, hard work, and heartland values despite the difficult life he lives. Nelson photographs her cowboy from behind. A hat and chaps (leather covers worn over his pants as leg protectors) mark him as the hardworking figure he is, but in this picture we see him resting on one leg, a hand on his hip as he confronts a line of cattle. This is not a moment of action but a time when he may think of something other than his gritty work.

Art often revises stereotypical thinking. In 2005, nearly ten years after Nelson's photograph, the film *Brokeback Mountain* opened, adding further complexity to the image of the strong man as an American icon. The two principal characters in the film have a long homosexual relationship that ends tragically, and the story

about love and intolerance raises questions surrounding stereotypes in any culture. The two cowboys, though they embody values of physical strength and hard work, do not fit the American cultural ideal of heterosexuality.

FIGURE 5: William Dunlap, *Roadside Skywriting*, 1989. 72" × 31".

William Dunlap's *Roadside Skywriting* seems to be more about a winter scene and a large bare tree in the foreground than skywriting. When it was done in 1989, the pastel colors with "white lines in the sky trailing high altitude aircraft"[4] were optimistic symbols. In the artist's words, "Once a hallmark of our peripatetic times and gravity-defying technology, a glimpse of silver fuselage and following vapor trail will never again look so benign."[5]

Faith Ringgold made *Faith's Garden Party #1* before the September 11 attacks. Placed into the context of *True Colors: Meditations on the American Spirit*, it's a gathering that celebrates American diversity. Here, thirty-nine people of different ages, skin colors, and backgrounds come together. Ringgold poses them against a grassy green backdrop with a pond, waterfall, bird feeder, and big lantern in the sort of attractive backyard where Americans like to gather friends and neighbors. Her painting resembles folk art, a style that looks simple but requires careful observation. Why did she select this style?

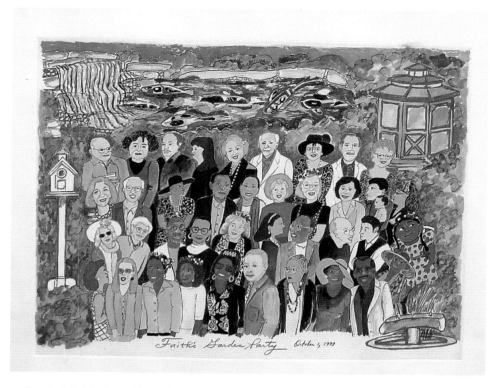

FIGURE 6: Faith Ringgold, *Faith's Garden Party #1*, 2001. 22" × 30".

A Few Thoughts on Folk Art

Folk art, according to critic Lucy Lippard, pictures familiar, everyday surroundings telling a story of life as the artist experiences it. Folk art is known as a pleasure for the eye, not meant to teach or indoctrinate the viewer into a way of thinking. Its straightforward ways of showing things don't change with fashion, and its themes (birth, work, celebration, death) cut across cultural boundaries. It brings together all aspects of life, combining everyday activity with myth, history, religion, and politics and is usually about communal rather than individual activity.

Folk art has a long tradition in the United States. It appeals to an American appreciation of literal, straightforward depictions and storytelling. Ringgold's choice to use it may have been one reason why the organizers of *True Colors: Meditations on the American Spirit* selected *Garden Party*. Both the subject and the style say something about things Americans feel are important, and, in the

context of this exhibition, refer to American values. But this work specifically marks a gathering that took place in June, 2000, and Ringgold had other reasons for making it.

How a Style Tells a Story

Folk art is a lesson in what the have-nots have. . . . Folk art, indigenous and strange, is not concerned with issues in art—rather its concerns are with the human condition. . . . In fact, it is the folk artists who are the most tuned into popular culture, translating and expanding it.

Susan Hankla[6]

Ringgold writes that the people at the gathering are family, friends, art dealers, writers, collectors, and curators who were invited to celebrate her new studio and garden in New Jersey. She had planned to make this painting so she asked everyone to wear bright clothes and flamboyant hats to add a lighthearted note of fun and celebration. Traditional folk art depicts people more as types than individuals, but here Ringgold skillfully paints individual portraits to reveal personalities.

It turns out that *Garden Party #1* also celebrated the Anyone Can Fly Foundation whose membership brought together artists of the African diaspora, many of whom were excluded from acceptance in the mainstream art world. They were artists who, like Ringgold, were struggling against racism and sexism to achieve acceptance and recognition. Folk art is sometimes called outsider art, and she may have had this in mind as one layer in telling the story of her garden party.

Lucy Lippard prefers the word "vernacular" to "folk" or "outsider art." "The term 'Outsider art' . . . is determinedly exclusive . . . used loosely to span art by all untrained artists, usually of the working class, and more tightly to describe visionaries inspired by religion or by mental illness—in short art by anyone who is not 'like us.'"[7]

The term "vernacular," by contrast, implies something made at home. Vernacular comes from the Latin for domestic native, specifically from *verna*, meaning home-born slave. This could lead us into another line of questioning about Ringgold's reason for choosing the style that she did.

Though Faith Ringgold is not a vernacular artist, she uses their ways of making things, particularly quilts in which she combines portraits and stories. She has been influenced by Tibetan and Nepali tankas or religious paintings,

and her appreciation of fabric may have come from her mother who was a clothing designer in Harlem. As a full professor at the University of California at San Diego, Ringgold is not an outsider to the mainstream art world. But her respect for the folk tradition is in her art and in the work she does to help other artists gain recognition. In *Garden Party*, a group of diverse individuals come together for celebration and much more. Its inherent message of peace and healing was poignant when the painting appeared in an exhibition following the horror of a terrorist attack. The context in which things appear affects their meanings.

Hamburgers, cowboys, skywriting, and informal parties embody a range of American desires, accomplishments, and ideals: simple food, comfort, work, strong men, community, mastery of the environment, and achievement. In the Meridian exhibition, artists highlighted some of the things Americans turn to for comfort in the face of threat. Unpretentious food speaks to informality and amiable social gatherings. The cowboy is an archetypal figure who controls destiny through hard work and self-reliance. Skywriting is a reminder of invention and accomplishment. And at the garden party, a diverse community celebrates shared values.

The Vietnam Memorial is a form of remembrance, made for a particular time and place. It is formal and stationary contrasted with a floating cheeseburger, wispy skywriting, a relaxing cowboy, or a garden party. But all these works bring us close to the particular culture that inspired artists to make them and give rise to emotions and values people share in the face of a tragedy. A catastrophe can make us focus on what we cherish and, at times, on values gone astray.

Shelter and Exposure

Home and Comfort

Home . . . finds us . . . settled in our expectations. We feel assured that we have discovered everything interesting about our neighbourhood, primarily by virtue of our having lived there a long time. . . . We have become habituated and therefore blind to it.

Alain de Botton[8]

Home suggests shelter, comfort, and safety – and people tend to believe fervently that their own sorts of houses are correct. Cultural practices, family ideals,

prosperity, climate, and aesthetics come together to create powerful beliefs in the rightness of certain dwellings: stone, brick, wood, paper, mud, grass—house on a hill, near the sea, in a city, on a farm—close to the earth, up on stilts—one door, two doors, no doors.

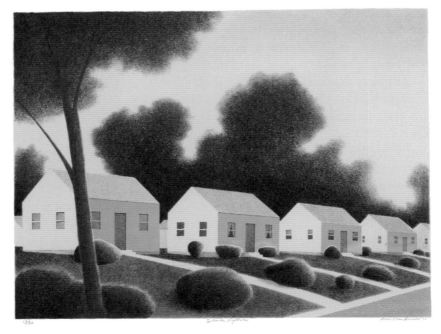

FIGURE 7: Kevin MacDonald, *Suburban Apotheosis*, 2000. 13" × 17".

After World War II, American developers started building the types of houses that appear in MacDonald's silkscreen painting. New forms of mass production had lowered costs, and such houses appealed to Americans who were grateful to afford new homes.

In MacDonald's picture, the houses are recognizable but odd. They're tinged with an unlikely light, the doors have no handles, and the windows are mostly blank. We see no people.

An apotheosis is the highest point in the development of an idea. It comes from the Greek *apotheoun*: *apo* "from" and *theos* "god," and means to make a god of something. In the second half of the twentieth century, many Americans' high idea of the comforts of home rested in the sort of houses shown in *Suburban Apotheosis*. They were in newly created communities that represented stability and safety. Set apart from urban centers, they appealed to people who wanted to live in orderly environments and enjoy the steady life that did not exist during the turmoil of World War II.

But in MacDonald's simple landscape there are undertones of intolerance, fear, racism, and ignorance. Many families moved into suburban communities such as these not only to find order and predictability but also to flee the growing diversity of their neighborhoods. The houses are cold and isolated rather than warm and inclusive, and their ghostly pallor seems a comment on the deadening sameness of these isolated populations. A door without a handle keeps people in or out and makes us wonder who can come and go. Are people imprisoned in these isolated communities? The picture doesn't overtly ask questions, and the artist does not preach. He offers images of home, and we bring the rest.

Kevin MacDonald made *Suburban Apotheosis* at least one year before the terrorist attacks of 2001. At any time, we may think of longings for the safety of known communities, but in the context of an exhibition held after a terrorist attack, the picture raises questions about the consequences of fear and the dangers of isolation.

FIGURE 8: Mario Merz, *From Continent to Continent*, 1985. 66" × 135" × 135".

Earlier, you saw this odd house, and now you see it again in another context. MacDonald's houses are just as inaccessible as Merz's igloo. But MacDonald's invisible people choose life in suburbia while Merz's people, also invisible, do not choose to live as they must. The houses in *Suburban Apotheosis* reflect American culture during a particular period, but *From Continent to Continent* is about all cultures at all times where homeless people are vulnerable. Merz uses the circle, a welcoming shape favored by certain nomadic people when they build their tents

or igloos. But his circular house reminds us of people who are forced into poor or dangerous situations.

There are no door handles in *Suburban Apotheosis*, and this dome has no doors. You can't get into any of these dwellings. The things these artists leave out are as eloquent as what they include. Absence is often part of the language of art.

From Continent to Continent looks as though it were put together hastily, like the structures of boxes and blankets made by the homeless. Street people are exposed. They have no privacy; yet people walking by don't really see them, a condition of poverty that moves from continent to continent.

To take objects out of their royal silence one must use either stratagem or crime.

Zibigniew Herbert[9]

FIGURE 9: Robert Polidori, *1401 Pressburg Street, New Orleans*, 2006. 39 3/4" × 53 15/16".

On August 29, 2005, thousands of people suddenly became homeless in the city of New Orleans, Louisiana when a devastating hurricane swept through, destroying some 160,000 homes. Robert Polidori photographed the remains, and through his work we see beyond the headlines of the disaster. Unlike MacDonald's and Merz's composed works, he photographed real houses, lived in mostly by African Americans who lost their homes when entire communities were damaged or wiped out. The devastation in this particular room may have come directly from the storm or from further destruction by police and military units looking for the dead or injured.

Like a stage set, *1401 Pressburg Street* walks us into a room separated from the rest of the house. The walls come out at right and left angles, one of them looking scraped; two others are bright blue and marked by the water and wind of the storm. Our eyes go to the three cylinders of a lamp in primary colors and then to a landscape painting, an electric lounge chair knocked backward, a sofa jutting out at a diagonal from the lower left of the picture, a towel or blanket, a table littered with objects, the back of a television set, and baskets. We notice fiberglass, metal, plastic, and wood—materials that almost seem to have a life of their own.

We would normally enter this house only if we were invited, but the picture takes us into private space meant to exist behind walls that no longer exist. We enter the home of people we've never met, and we may tend to judge them by the things they own and assume we know something about them. But the context is gone. The room is subtracted from its former milieu: a house, a street, and a community, and more to the point, the people are gone. What was the rest of this house like? Did a family live here? How many people? What ages?

The picture looks like a constructed work of art. The red of the lamp on the left sends our eyes to a piece of furniture on the right. The diagonal of the sofa leads to the underside of an upended chair, the blades of the ceiling fan point right and left, and one of them echoes the color of a wooden door. But the picture takes us beyond the things themselves. Why did the occupants have an Arctic landscape on the wall? How ironic that this pretty framed picture of an inhospitable place on the earth now survives a hurricane that may have killed the people who owned it. There is further irony in the text on the wall that is titled, "Don't Quit."

The room is a messy memorial to people we don't know, and the photograph freezes it and preserves it. We are allowed to enter exposed private space. We observe things we are not meant to see this way and are left with sadness and empathy for strangers who lost their homes. We relive something of the terror from the storm and understand that all of us are vulnerable to sudden hits. The room tells us about fear, desertion and loss, mourning and enduring grief.

1401 Pressburg Street is a photograph of an actual room that tells a story of loss and devastation. Another artist tells a similar story but through the careful use of found objects.

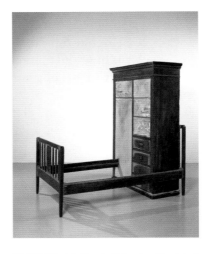

FIGURE 10: Doris Salcedo, *Untitled*, 1995. 77 1/8" × 74 7/8" × 49 5/8".

Appearances

What do you see?
○ A bed.
○ An armoire.

Where is the armoire?
○ Standing in the bed.

What is missing?
○ The mattress.

In the photograph here, it may be difficult to see the fine details in this work. The bed is shorter than most. The armoire has bits of lace adhered to it, its door and drawers are glued shut, and it is filled with industrial cement. No one can sleep in this bed or put clothes away in the armoire. Everything is scratched and pitted with delicate but scarring marks.

Questioning What You See

If you came upon this work without any information, you could ask:
What is a bed?
How is it often used?
What's missing here?

What's odd?
What are the materials?
What is their condition?
Why does the work sit on the floor instead of a platform or pedestal?
Is this a silent or noisy piece of art?
What makes it seem that way?

Seeking Information

Who is the artist?
Where was she born?
When did she make this piece?
What was going on in her country at the time she made this piece?
What would the bed and the armoire say if they could speak?

Our beds are forms of shelter. They may be cots or hammocks, small or large, have canopies over them or mosquito nets around them, sit on the floor or on a frame. In our beds, we sleep, make love, give birth, play, weep, dream, read, think, are ill, recover, and are comforted. We "go to bed." The bed is a potent symbol and a necessary possession. In this bed, there is a hole where the mattress was, and the armoire, heavy and scarred, stands like a looming figure or a grave marker huddling into the bed. The whole sculpture stands on the floor the way real furniture does. Its composition may remind you of a gravestone.

Columbian artist Doris Salcedo has witnessed the brutal results of persecution by political factions and drug lords. She uses furniture she's rescued from houses where people lost their possessions, their homes, and in many cases, their lives. In her sculptures, scarred furniture stands as a metaphor for the suffering of victims, many of whom were women who cared for land that was illegally seized from them. The gouges and scratches are stand-ins for wounds, and the lace stuck to the armoire is a kind of bandage or perhaps a hope for healing. The artist says that she shows life lifelessly.

What represents comfort in your home?
How would you show the opposite of comfort?
○ Some people sleep better on mattresses and others on cots.
○ Desires for comfort may be universal, but what is "good" and "right" differ.
○ We believe our familiar ways of living are the right ways.

Our judgments get in the way of reading other peoples' perceptions and desires. We recognize houses, igloos, rooms, and furniture, but, in works of art, artists

change their contexts, subtract or add details, and select features to highlight ideas. Houses may then tell stories about wanting to live well, an igloo may suggest homelessness and insecurity, a disheveled room can confront us through its destruction, and a bed and armoire can recall violence. As works of art, they bring life to human experience. They are modest forms, but they have grand aspirations.

Kevin MacDonald and Mario Merz examined the details of houses and shelters that reveal ways people live, but they did not make them look like real homes. Polidori's photograph is revealing in a different way because it is a straight-on depiction; the real details were there before the artist arrived. And Salcedo uses real furniture to compose a sculpture that is both an abstraction and a powerful reminder of actual suffering. Where you don't see people, objects may represent them.

Art compresses ideas. And those ideas enlarge when you find and question them. You can enter the lives of people who would otherwise remain unknown.

NOTES

1. Robert Pinsky, "It Is Thrilling When a Poet . . .," *Washington Post*, November 6, 2005, https://www.washingtonpost.com/archive/entertainment/books/2005/11/06/it-is-thrilling-when-a-poet-e/b2dcd0f1-e7d9-4c11-9e00-1f7e7da03f5b/?utm_term=.c301abdec6cf.

2. Helen Zughaib, *True Colors: Meditations on the American Spirit*, February 20–April 14, Meridian International Center, Washington, DC, 2002.

3. Carol Anthony, *True Colors: Meditations on the American Spirit*, February 20–April 14, Meridian International Center, Washington, DC, 2002.

4. William Dunlap, *True Colors: Meditations on the American Spirit*, February 20–April 14, Meridian International Center, Washington, DC, 2002.

5. Dunlap, *True Colors*.

6. Susan Hankla, *Retrieval—Art in the South* (1983), quoted in Lucy Lippard, *Mixed Blessings: Art in a Multicultural America* (New York: Pantheon Books, 1990), 79.

7. Lucy Lippard, *Mixed Blessings: Art in a Multicultural America* (New York: Pantheon Books, 1990), 78.

8. Alain de Botton, *The Art of Travel* (New York: Vintage Books, 2002), 242.

9. Zibigniew Herbert, "To Take Objects Out", *Selected Poems by Zbigniew Herbert*, trans. John and Bogdana Carpenter (Oxford: Oxford University Press), 41.

CHAPTER 12

In Other Worlds

In Other Worlds

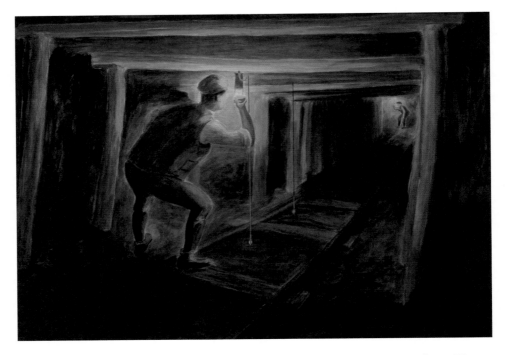

FIGURE 1: Oliver Kilbourn, *Marker There (Mark It There)*, from the series *My Life as a Pitman*, c.1975. 21 1/4" × 29 3/4".

On August 5, 2010, thirty-three Chilean miners were 700 meters underground in the San José mine when their exit shaft collapsed. For sixty-nine days, rescuers from Chile and at least a dozen other countries worked to bring the miners back, all the while ingeniously lowering supplies and communicating support. Around the world, more than a billion people followed news accounts and cheered when the men were rescued. Daily news stories told us what was happening, and we could try to imagine what it might be like for one of *us* to be trapped underground. But how could we know what it was like to be one of *them*? Before the Chilean disaster, the Pitman Painters had helped us know.

The Pitman Painters, known in the 1930s as the Ashington Group, were miners in England who created works of art that carried viewers inside their tough lives. They drew with thick lines to show men's muscled backs and shoulders or the soles and heels of their shoes as they squeezed into tight spaces. Sometimes, with just a few details, the pictures hit you with the feeling of working in a mine. In the painting here, we see a tall miner in a narrow tunnel, his back and knees bent as he moves under wooden beams set into a low ceiling.

These works of art accomplish what Leon Golub does in *Four Black Men* when he confronts you with the sensation of being backed against a wall. These pictures make you an insider. The artists pack their own meaning into their art, but it's your attention that makes them mean something to you.

The Insider Artist

Artists go inside their subjects. Cézanne went inside a mountain and an apple. Marini went inside a horse and rider. When Helen Zughaib made her painting of a prayer rug, she deeply understood what a potent symbol it was. When artists drip paint, they are saying something about paint and also about the drip, the color, and the canvas. They go inside those materials. The Pitman Painters were insiders to their way of life, and they chose particular means to tell their stories.

You the Insider

We have no pure understanding independent of all our contexts.

Kirk Varnedoe[1]

All experience is personal.

Adrian Brown, psychiatrist[2]

None of us were born knowing what we know. We learned to see the world from the perspective of our many contexts: our genders, sexual orientations, races, ethnicities, families, religions, politics, and nationalities. From these complex circumstances, which coalesce within us, we design our life stories. And those stories are populated by numbers of other people who are shaped by the layers of their own contexts.

The artist makes us notice these contexts and guides us toward empathy and insight. Art makes us more proprioceptive, more aware of where we are in respect to others. A sixteenth-century Iranian garden and a twentieth-century American

city were as odd to one another as a giraffe may be to a poodle. When the *Diner* asked the *Garden* what it thought about the city, the *Garden* said it wouldn't want to live there. It knew exactly why, and at the end of the conversation, didn't end up thinking cities were better than gardens. It would never share the *Diner*'s point of view on truth. Sixteenth-century Iranians and twentieth-century Americans did not make sense of life in the same ways, but they did not deny one another the right to live as each preferred.

What Is Beautiful?

Cultures teach us about beauty. One of our many contexts is an aesthetic system, a collection of ideals that compose the perfect body and the beautiful face. Our culture's aesthetic system convinces us that some things not only look good but *are* good. Ideals of beauty make us want some things and not others, and they lie beneath many prejudices. Their lessons are so familiar we don't question them until we confront other concepts of beauty.

Author, Wallace Stegner wrote that aesthetics are the gauze through which we see. We scarcely notice how our own cultural ideals of beauty weave into politics and religion because they feel natural, while other people's ideals may seem unattractive or weird. Everyone does not enjoy the same kind of beauty. The same woman does not look beautiful to everyone. What did people of the time think of the Venus of Willendorf? What do you think?

Aesthetics are so deeply embedded into cultural values that nations will fight to defend them. Those values live in didactic art—in the American George Washington, the Roman Marcus Aurelius, and the Angolan mask. They tell you what people treasure and consider beautiful. Some art depicts people who don't exist but should. And some uses irony to hit us with our unquestioned ideals. Robert Arneson humorously contrasted the real with the ideal when he gave us Elvis Presley as a Roman general. He parodied perfection and questioned our exalted notions of heroes.

Portraits are invitations to search for cultural ideals. Who does the person in a historical portrait (think Napoleon) believe he is? Who do *we* think he is? To what does he aspire? How is he dressed? How would you describe him to someone else? How would someone from another time and place describe him?

Art answers some questions but poses others. It sheds light on many truths but can also be hard to read. And its eloquence gets it into trouble. Why? We get bogged down in the question of what art is when maybe a better question is what it does and doesn't do.

What Does Art Do?

Art answers cultural, intercultural, personal, and historical questions, and it tells its stories with power and authority.

Art creates a drama that opens the possibility for facts. It is a fiction that leads you to discover the details of life and reality. The fiction is made of pieces the artist maneuvers and arranges in particular ways. When you meet a work of art, you sense a story even if you don't know what motivated the artist. To compose *Untitled (Library)*, Rachel Whiteread arranged blank shelves of a certain size, color, and texture, plotting them out so that you might supply a story.

Whiteread memorialized the Holocaust of World War II, a real event that inspired her to make a fictional bookcase. When you ask what you see, you begin to instill it with meaning. The more you stay with it, and the more you ask and listen, the more you discover about bookcases and yourself. Neither the bookcase nor Marita Dingus' figures tell the whole story about the Holocaust or oppression or poverty because nothing can. But Whiteread and Dingus creatively embrace their enormous subjects and bring them closer to us. Art is not about a distant other but about our mutual participation in each other's stories.

A drawing can make us feel the weight of a stone and the fragility of a leaf. It gives us a physical sense of the bodies of miners in England and the height of mountains in China. Claude Monet makes us feel the intensity of yellow sunflowers, and *Untitled (Library)* hits us with loss and emptiness.

Art also messes things up. It's filled with mismatches and revisions, and it often plays around with context to make you see a new way. Artist Marcel Duchamp put an everyday sort of mustache on a picture of Leonardo da Vinci's hallowed *Mona Lisa*. We're not surprised by mustaches or by famous paintings of women, but when they show up together, we need to ask what's going on. Duchamp was part of the Dada Movement in art that meant to convey the terrors of World War I by confronting the dark side of civilization. You might say that Dada artists used art as a weapon against horror, not by showing it but by reaching for its traits and letting us supply its meaning.

In our Art as Intercultural Communication class, Sandra Fowler and I introduced the concept of "meaning making" through a type of domino game in which participants each received a packet of postcards with pictures of paintings or sculptures. We asked them to place their cards, one at a time, next to other cards that related to their own in some way. Anyone could put down a card when they saw a reason to do so. The objective of the game was not to win anything but to consider how one work of art related to another through ideas, shape, color, and more.

The participants played silently until they'd finished placing their cards. Then we asked why they made the decisions they did. One person had placed an African mask next to a Chinese landscape because she felt that both expressed an awe of nature; another had seen a relationship between a thrusting steel sculpture and a frightened figure because both seemed off balance; a third person had connected a landscape to a theater because they both emphasized the color green. The decisions were personal, and a few people said that during the silent play, they didn't understand why certain class members placed their cards as they did. The activity led to conversations about artistic and personal choices and inspired tolerance for varying perceptions. Art asks for that respect. It comes out of a long effort and asks that you then put your own effort into looking and asking.

Art responds to questions that focus on vision, sensation, and meaning rather than information and fact. When people boycott art they find offensive, they don't realize that art is not a picture of reality in which everyone finds a similar meaning. It helps to recognize that there are appropriate questions for science, others for religion, and still others for art. The purpose of one discipline or belief system is not to answer for or to confirm the expression of the others, even when they overlap as they frequently do.

Art raises more questions than answers. Its meanings are not constant because it is part of a living process in which artists present what they see or think. Then they wait for us to answer. Art flickers as it moves from itself to you. It is filled with paradox. It estranges you, pushes you away, and then drags you back. It speaks a language made of details, and you recognize its language according to your own facility, which grows with practice. Artists don't make beauty. It's something *you* discover and create by collaborating with an artist through your questions and long consideration.

What Art Does Not Do

Art does not tell a factual story. It is not literal and does not claim to be a true rendering of what we call reality. *An Old Woman and Sages in a Garden* and *Diner* do not give you pictures of truth and reality but rather inquire into them. The dialogue between the two paintings opens a path toward knowing other selves.

Art does not provide an orderly progression from one thing to another like arithmetic getting you ready for algebra. It proposes a *whole* idea of something that comes about through an act of imagination, and it asks you to approach it through your own imagination.

Art does not try to sell anything. It is not a form of advertising. If you were hungry, would you want to eat Carol Anthony's *All American Cheeseburger*

Dream? She doesn't give you a literal sandwich. She had other reasons for making the picture.

Art will not cure you of anything. It is neither therapeutic nor a recipe for living. It wakes you up and opens conversations. It is not dogma and doesn't coerce you. You have a choice to go into it or turn away.

What Do Artists Do?

When I pick up a stone, it's a stone. When Miro picks up a stone, it's a Miro.

Joan Prats[3]

The artistic gesture edits life.

Douglas Gordon, artist[4]

People sometimes say their children make paintings that look like the art they find in museums, and sometimes they do. But children make things for themselves while artists compose, or distort, things to show how life feels. Artist Robert Gober makes domestic items such as chairs or sinks that you easily recognize, but with close looking, you see that a chair is too low to the ground, and a sink is missing its faucet. The chair looks comfortable but isn't quite. The sink should allow you to use water for cleaning or drinking, but you can't because something essential is missing. What is Gober saying by tweaking these ordinary objects? Who is he? What is he saying about himself as well as the rest of us? Learning about Robert Gober will enlighten you.

Artists use the freedom of abstraction to say what they could not through realistic images.

They break things up.
They create consciously but respect accidents.
They give us more details than we can process at a glance.
They frame and reframe the world.
They resist ideology.

They make art about what they sense, not necessarily what they see.
They find the eternal in the everyday.
They find the inner mystery of outer things.
They connect images to feelings.
They play without knowing what the results will be.
They grasp implications of new knowledge.

They make you recognize things you overlook.
They help you find something of yourself in others.
They invite you to take a walk.

Commence with experience . . . investigate the reason.

Leonardo da Vinci

Art shock and culture shock are similar.
Newcomers feel alienated.

Think Like an Artist

Look first.
Simplify by describing.
Find complexities by questioning.
Create a relationship.
Inhabit another's story. Be conscious of your own.
Try to let things be themselves, not an extension of you.
But remember, you are always part of the drama.
Fight clichés.
Watch for false categories.
Hear yourself say, this is like . . .
Really? Is it?

What Do You See?

Ideology knows the answer before the question has been asked. Principles are something different: a set of values that have to be adapted to circumstances but not compromised away.

George Packer[5]

Ideologies are numerous and everywhere. They're in your culture's standards of beauty, your religion's rights and wrongs, your workplace's hierarchy of authority, your political stand on how people should govern, your family's sense of loyalty. Ideologies provide structure and meaning, but we need to know their limitations. Sociologist Daniel Bell wrote, "Ideology makes it unnecessary for people to confront individual issues on their individual merits. One simply turns on the ideological vending machine, and out comes the prepared formulae."[6]

Artists resist ideologies, but they have principles. It's difficult to be an artist, to look freshly, ask what's there, and then make something honest and perhaps self-revealing—something that has integrity. One of the reasons people get worked up about art is because they look at it from the point of view of their ideologies and think it offends their principles.

But no one needs to sacrifice a principle to say, "I will respect you enough to have an openhearted conversation though I may disagree with you. I will approach you as an individual and find out about you. This action reflects my values, my principles."

Art is lively, not static. Something is always unfolding. The best part is that it addresses us personally. It doesn't lecture to masses of people. It begs for conversation, careful learning against a lot of competing forces, primarily our urges to Google questions, get immediate compressed answers, and search for statements that fit our opinions. To enter the lives of people we would otherwise not know, we must look slowly and ask many questions.

Art is not an ideology. It is the special thing right in front of you, right now. It is an image of an artist's truth. When you ask yourself what you see and "overhear" your own answer, you collaborate with the artist to create meaning and meet a stranger without prejudice.

Take a good look.
What is in sight?
What is insight?

NOTES

1. Kirk Varnedoe, *A Fine Disregard: What Makes Modern Art Modern* (New York: Harry N. Abrams, 1990), 213.

2. Adrian Brown, personal communication.

3. Joan Prats, personal communication.

4. Douglas Gordon, personal communication, Hirshhorn Museum, 2001.

5. George Packer, "Deepest Cuts," *The New Yorker*, April 25, 2011.

6. Daniel Bell, *The End of Ideology: On the Exhaustion of Political Ideas in the Fifties, with "The Resumption of History in the New Century"* (Harvard University Press, 1962), 405.

Works of Art

CHAPTER 1

1. Rock Painting
Tassili-en-ajjer region of Algeria, c.8000 BCE.
Dmitry Pichugin/Shutterstock.com

2. Venus of Willendorf
Original unearthed at Paleolithic Archeo-
logical Sites at Willendorf in Austria,
30,000–25,000 BCE.
Oolitic limestone, 4 3/8".
Naturhistorisches Museum, Vienna,
Austria.
Lefteris Tsouris/Shutterstock.com

3. The Great Sphinx of Giza
Giza Plateau, c.2588–2532 BCE.
Limestone, 66' × 62' × 240'.
Anton Belo/Shutterstock.com

4. Winged Victory: The Nike of Samothrace
Pythokritos of Lindos, Greek, c.190 BCE.
Parian marble, 96".
The Louvre, Paris, France.
muratart/Shutterstock.com

5. Bust of Marcus Aurelius
Roman, c.100s CE.
26 1/4".
Kamira/Shutterstock.com

6. Mosaic of Justinian and Retinue
Church of San Vitale, Ravenna, Italy,
c.546 CE.
Metropolitan Museum of Art (Met).
Fletcher Fund, 1925. For more information
visit the Metropolitan Museum of Art at
https://www.metmuseum.org

7. *Presentation at the Temple*
Alvaro Pirez, c.1430.
Tempera and gold on wood,
13 3/8" × 15 7/8".
Metropolitan Museum of Art (Met).
The Jack and Belle Linsky Collection, 1982.
For more information visit the Metropoli-
tan Museum of Art at
https://www.metmuseum.org

8. *Khusraw at the Castle of Shirin*
From a manuscript of the *Khusraw and
Shirin*, Nizami.
Iran, Timurid period, early fifteenth century.
Ink, opaque watercolor and gold on paper,
10 1/8" × 7 1/4".
Freer Gallery of Art and Arther M.
Sackler Gallery, Smithsonian Institution,
Washington, DC: Purchase—Charles Lang
Freer Endowment, F1931.36.

9. Face Mask (*pwo*)
Chokwe artist, Democratic Republic of the
Congo, Angola, early twentieth century.
Wood, plant fiber, pigment, copper alloy,
15 3/8" × 8 3/8" × 9 1/4".
Museum Purchase.
85-15-20.
Photograph by Franko Khoury.
National Museum of African Art,
Smithsonian Institution.

10. *Elvis*
Robert Arneson, 1978.
Glazed ceramic, 47 1/2" × 31" × 18 7/8".
Gift of the Sydney and Frances Lewis Foun-
dation, 1985.
Photography by Lee Stalsworth.
Hirshhorn Museum and Sculpture Garden,
Smithsonian Institution Accession Number:
85.16.
© 2018 Estate of Robert Arneson / Licensed
by VAGA at Artists Rights Society (ARS), NY.

11. *New Figuration*
Tony Cragg, 1985.
Plastic objects and fragments, with metal,
mounted with Velcro strips, dimensions
variable: 110" × 169 1/8" × 2 3/4".
Museum Purchase, 1987.
Hirshhorn Museum and Sculpture Garden,
Smithsonian Institution Accession Number:
87.16.
Photography provided by Artist / Gallery.
Courtesy Hirshhorn Museum and Sculpture
Garden and Tony Cragg.

12. *Woman as Creator*
Marita Dingus, 2002.
Mixed media, 18' × 5' × 5".
Francine Seders Gallery.
Photograph courtesy Francine Seders.
Courtesy Marita Dingus.

CHAPTER 2

1. *A Pastoral Visit*
Richard Norris Brooke, 1881.
Oil on canvas, 47" × 65 13/16".
Corcoran Collection
(Museum Purchase, Gallery Fund).
Courtesy National Gallery of Art, Washington.

2. *Untitled*
John Chamberlain, 1961.
Enameled metal, 23" × 23 3/4" × 22 1/4".
Gift of Joseph H. Hirshhorn, 1972.
Photography by Lee Stalsworth.
Hirshhorn Museum and Sculpture
Garden, Smithsonian Institution Accession
Number: 72.63.
© 2018 Fairweather & Fairweather LTD /
Artists Rights Society (ARS), New York.

3. *Levits*
Franz West, 2001–06.
Epoxy resin and metal, each 34 1/2" × 18"
× 22".
Joseph H. Hirshhorn Purchase Fund and
Museum Purchase, 2007.
Photography by Lee Stalsworth.
Hirshhorn Museum and Sculpture
Garden, Smithsonian Institution Accession
Number: 07.3.
© Archiv Franz West. Used with permis-
sion of Hirshhorn Museum and Sculpture
Garden and Archiv Franz West.

4. *Dwelling*
Hiraki Sawa, 2003.
DVD and digital C-type prints on paper,
09:20 minutes, each print 19 7/8" × 24".
Joseph H. Hirshhorn Purchase Fund, 2006.
Hirshhorn Museum and Sculpture Garden,
Smithsonian Institution Accession Number:
06.2.
Photography provided by Artist / Gallery.
© Hiraki Sawa. Courtesy Hirshhorn
Museum and Sculpture Garden and James
Cohan, New York.

5. *Carp and Turtles*
Maruyama Ōkyo, 1770/1795.
Two-panel screen; ink, light color, and gold
wash on silk, 30" × 76".
Portland Art Museum, Portland, OR.
Museum Purchase: Margery Hoffman Smith
Fund and Asian Art Acquisition Fund, with
additional funds provided by friends of the
Museum, 1997.1.

6. *Bus Riders*
George Segal, 1962.
Plaster, cotton, gauze, leather, vinyl, steel,
and wood, 70" × 42 3/8" × 90 3/4".
Gift of Joseph H. Hirshhorn, 1966.
Photography by Lee Stalsworth.
Hirshhorn Museum and Sculpture Garden,
Smithsonian Institution Accession Number:
66.4506.
© 2018 The George and Helen Segal Foun-
dation / Licensed by VAGA at Artists Rights
Society (ARS), NY.

7. *Enlighten*
Christoph Girardet, 2000.
Single-channel video installation with sound
loop, 05:10 minutes.

Joseph H. Hirshhorn Purchase Fund, 2006.
Photography by Lee Stalsworth.
Hirshhorn Museum and Sculpture Garden,
Smithsonian Institution Accession Number:
06.25.
Courtesy Christoph Girardet.

8. Queen Sembiyan Mahadevi as the
Goddess Parvati
Chola Dynasty, tenth century.
Bronze, 42 1/4" × 13 1/8" × 10 1/8".
Freer Gallery of Art and Arthur M. Sackler
Gallery, Smithsonian Institution, Wash-
ington, DC: Purchase—Charles Lang Freer
Endowment, F1929.84.

9. Horse and Rider
Yoruba Peoples, early twentieth century.
Carved wood, 17 3/4" × 7" × 15 1/8".
Toledo Museum of Art, Toledo, Ohio.
Purchased with funds from the Libbey
Endowment, Gift of Edward Drummond
Libbey, 1973.11.

10. *Horse and Rider*
Marino Marini, 1952–53.
Bronze, 81 1/2" × 47 × 77 3/4".
Gift of Joseph H. Hirshhorn, 1966.
Photography by Cathy Carver.
Hirshhorn Museum and Sculpture Garden,
Smithsonian Institution Accession Number:
66.3345.
© 2018 Artists Rights Society (ARS), New
York / SIAE, Rome.

11. Scenes from the Life of Saint Francis:
Liberation of the Heretic Pietro
Giotto di Bondone (1266–1336).
Fresco, detail.

Saint Francis cycle in the Upper Church of San Francesco at Assisi, Italy.
Scala / Art Resource, NY.

12. *Writing the Written*
Shahzia Sikander, 2000.
Vegetable color, dry pigment, watercolor, and tea on hand-prepared wasli paper, 8" × 5 1/2".
© Shahzia Sikander, courtesy Shahzia Sikander Studio.

CHAPTER 3

1. A Horse
Prehistoric cave painting, Las Monedas, Spain, c.15,000 BC.
Scala / Art Resource, NY.

2. *The Secret Life of Plants (La Vie secrète des plantes)*
Anselm Kiefer, 2002.
Lead, oil, chalk, pigment, 76 3/4" × 118 1/8", 700 kg.
National Gallery of Australia, Canberra.
© Anselm Kiefer.

3. Japanese Water Jar for Tea Ceremony
Momoyama period, 1568–1614.
Mino-Karatsu-ware, stoneware with iron pigment under ash glaze, 7 1/2" × 9 1/4" × 9 1/4".
Freer Gallery of Art and Arthur M. Sackler Gallery, Smithsonian Institution, Washington, DC: Purchase—Charles Lang Freer Endowment, F1967.17a-b.

4. *Untitled (No. 49)*
Leonardo Drew, 1995.
Wood, rust, fabric, and mixed media, 137 1/2" × 287 1/2" × 8".

Gift in loving memory of Paul W. Hoffmann, 1996.
Photography by Lee Stalsworth.
Hirshhorn Museum and Sculpture Garden, Smithsonian Institution Accession Number: 96.13.
Artwork © Leonardo Drew, courtesy of Sikkema Jenkins & Co., New York.

CHAPTER 4

1. *don't be afraid*
Jim Hodges, 2004–05.
Ink on vinyl, dimensions variable, 35' × 75' as installed at HMSG 2005–06.
Gift of the artist, 2005.
Photography by Lee Stalsworth.
Hirshhorn Museum and Sculpture Garden, Smithsonian Institution Accession Number: 05.11.
Used with permission from Jim Hodges Studio.

2. *Holy Mountain III*
Horace Pippin, 1945.
Oil on canvas, 25 1/4" × 30 1/4".
Gift of Joseph H. Hirshhorn, 1966.
Photography by Cathy Carver.
Hirshhorn Museum and Sculpture Garden, Smithsonian Institution Accession Number: 66.4069.

3. *A Day on the Grand Canal with the Emperor of China, or Surface Is Illusion but So Is Depth*
David Hockney, directed by Philip Haas, 1989.
DVD cover.
Courtesy of Milestone Film & Video. Used with permission.

4. Kangxi Emperor's Southern Inspection
Tour, Scroll Three: Ji'nan to Mount Tai
Wang Hui, c.1698.
Handscroll, ink and color on silk,
26 3/4" × 45' 8 3/4".
China, Qing dynasty.
Image copyright © The Metropolitan Museum
of Art. Image Source: Art Resource, NY.

5. *Piazza San Marco*
Canaletto (Giovanni Antonio Canal),
late 1720s.
Oil on canvas, 27" × 44 1/4".
Purchase, Mrs. Charles Wrightsman Gift,
1988. For more information visit the
Metropolitan Museum of Art at
https://www.metmuseum.org

6. *Ohio Theater, Ohio*
Hiroshi Sugimoto, 1980.
Gelatin silver print on paper, 19 15/16" × 23
7/8" (sheet), 16 5/8" × 21 7/16" (image).
Holenia Purchase Fund, in memory of
Joseph H. Hirshhorn, 2003.
Photography by Lee Stalsworth.
Hirshhorn Museum and Sculpture Garden,
Smithsonian Institution Accession Number:
03.18.
© Hiroshi Sugimoto, courtesy Fraenkel
Gallery, San Francisco.

7. *My Wife and Mother-in-Law*
William Ely Hill, 1915.
Puck 78, no. 2018 (November 6, 1915), 11.
As found at http://www.loc.gov/pictures/
item/2010652001/

8. *Head of a Woman (Fernande Olivier)*
Pablo Picasso, 1909 (cast 1960).
Bronze, 16 3/8" × 9 3/4" × 10 1/2", 11.3 kg.

Gift of Joseph H. Hirshhorn, 1966.
Photography by Lee Stalsworth.
Hirshhorn Museum and Sculpture Garden,
Smithsonian Institution Accession Number:
66.4050.
© 2018 Estate of Pablo Picasso / Artists
Rights Society (ARS), New York.

CHAPTER 5
1. *An Old Woman and Sages in a Garden*
Iran, c.1520–40.
Miniature.
Freer Gallery of Art and Arthur M. Sack-
ler Gallery, Smithsonian Institution,
Washington, DC: Purchase—Smithsonian
Unrestricted Trust Funds, Smithsonian
Collections Acquisition Program, and Dr.
Arthur M. Sackler, S1986.216.

2. *Diner*
Richard Estes, 1971.
Oil on canvas, 40 1/8" × 50".
Museum Purchase, 1977.
Photography by Lee Stalsworth.
Hirshhorn Museum and Sculpture
Garden, Smithsonian Institution Accession
Number: 77.75.
© Richard Estes, courtesy Marlborough
Gallery, New York.

CHAPTER 6
1. *Untitled (Library)*
Rachel Whiteread, 1999.
Dental plaster, polystyrene, fiberboard, and
steel, 112 1/2" × 210 5/8" × 96".
Joseph H. Hirshhorn Purchase Fund,
2000.
Photography by Lee Stalsworth.
Hirshhorn Museum and Sculpture

Garden, Smithsonian Institution Accession
Number: 00.4.
Courtesy Gagosian Gallery on behalf of
Rachel Whiteread.

CHAPTER 7

1. *Hostelry in the Mountains*
Yen Tz'u-Yu, late twelfth century.
Ink and color on silk, 33" × 38 3/4".
Freer Gallery of Art and Arthur M. Sackler
Gallery, Smithsonian Institution, Washington,
DC: Purchase—Charles Lang Freer
Endowment, F1935.10.

2. *Early Evening*
Winslow Homer, 1881–1907.
Oil on canvas, 10 1/16" × 10 3/16".
Freer Gallery of Art and Arthur M. Sackler
Gallery, Smithsonian Institution, Washington,
DC: Gift of Charles Lang Freer, F1908.14a.

CHAPTER 8

1. *Dish of Apples*
Paul Cézanne, c.1876–77.
Oil on canvas, 18 1/8" × 21 3/4".
The Walter H. and Leonore Annenberg
Collection, Gift of Walter H. and Leonore
Annenberg, 1997, Bequest of Walter H.
Annenberg, 2002. For more information
visit the Metropolitan Museum of Art at
https://www.metmuseum.org

2. *Long Live Stalin's Breed of Stakhanovite
Heroes*
Gustav Klutsis, 1934.
Poster.
Presented to the Tate Gallery by David King
2016 / © Tate, London / Art Resource, NY.

3. Iceberg
posteriori/Shutterstock.com

4. *Bouquet of Sunflowers*
Claude Monet, 1881.
Oil on canvas, 39 3/4" × 32".
H. O. Havemeyer Collection, Bequest
of Mrs. H. O. Havemeyer, 1929.
For more information visit the
Metropolitan Museum of Art at
https://www.metmuseum.org

5. Small Bowl
Iran, 1500–10, Safavid period.
Silver inlaid with gold and niello,
1 1/4" × 4 7/16" × 4 7/16".
Freer Gallery of Art and Arthur M. Sackler
Gallery, Smithsonian Institution, Wash-
ington, DC: Purchase—Charles Lang Freer
Endowment, F1954.115.

CHAPTER 9

1. *Four Black Men*
Leon Golub, 1985.
Oil on linen, 121 3/8" × 190 1/4".
Thomas M. Evans, Jerome L. Greene, Joseph
H. Hirshhorn, and Sydney and Frances
Lewis Purchase Fund, 1985.
Photography by Lee Stalsworth.
Hirshhorn Museum and Sculpture
Garden, Smithsonian Institution Accession
Number: 85.8.
© 2018 The Nancy Spero and Leon Golub
Foundation for the Arts / Licensed by
VAGA at Artists Rights Society (ARS), NY.

2. *Marital Felicity*
Leng Mei, 1741, 4th month.
Hanging scroll, ink and color on silk,
46 5/8" × 25 3/4".

Portland Art Museum, Portland, Oregon.
Bequest of Margery Hoffman Smith,
83.38.356.

3. Lieutenant General George Washington
Clark Mills, commissioned 1853.
Life-sized.
American Sculpture Photograph Study
Collection, Smithsonian American Art
Museum S0001805.

4. Covenant
Barnett Newman, 1949.
Oil on canvas, 47 3/4" × 59 5/8".
Gift of Joseph H. Hirshhorn, 1972.
Photography by Lee Stalsworth.
Hirshhorn Museum and Sculpture
Garden, Smithsonian Institution Accession
Number: 72.213
© 2018 The Barnett Newman Foundation,
New York / Artists Rights Society (ARS),
New York.

5. From Continent to Continent
Mario Merz, 1985.
Steel, glass, neon, clay, metal cables,
electrical wire, and transformer,
66" × 135" × 135".
Joseph H. Hirshhorn Purchase Fund, 1990.
Photography by Cathy Carver.
Hirshhorn Museum and Sculpture
Garden, Smithsonian Institution Accession
Number: 90.6.
© 2018 Artists Rights Society (ARS), New
York / SIAE, Rome.

6. Face Mask
Baule artist, Côte d'Ivoir, late nineteenth to
early twentieth century.
Wood, cloth, string,

9 7/16" × 6 5/16" × 4 7/16".
Gift of Walt Disney World Co., a subsidiary
of The Walt Disney Company.
2005-6-61.
Photograph by Franko Khoury.
National Museum of African Art
Smithsonian Institution.

CHAPTER 10
1. At the Hub of Things
Anish Kapoor, 1987.
Fiberglass and pigment, 64" × 55" × 59".
Photo: Sue Omerod, Coll: Hirshhorn
Museum and Sculpture Garden, Washing-
ton DC.
© Anish Kapoor, 2018.
Gift of the Marion L. Ring Estate, by
Exchange, 1989.
Hirshhorn Museum and Sculpture Garden,
Smithsonian Institution.
Photography provided by Artist.
Accession Number: 89.12.
© Anish Kapoor. All Rights Reserved,
DACS, London / ARS, NY 2018.

2. S-Curve
Anish Kapoor, 2006.
Stainless steel, 85 1/4" × 384" × 48".
Photo: Joshua White, Courtesy Regen
Projects, Los Angeles.
© Anish Kapoor 2018. All Rights Reserved,
DACS, London / ARS, NY 2018.

CHAPTER 11
1. The Vietnam Veterans Memorial
Maya Lin, 1982.
Black granite, 246' 9" × 10' 1", tapering to 8".
Washington, DC.
Orhan Cam/Shutterstock.com

2. *Prayer Rug for America*
Helen Zughaib, 2001
Gouache, 19 1/2" × 13 1/4"
Library of Congress, Prints and Photographs
Division. LC-DIG-ppmsca-01724. Used
with permission of the artist.

3. *All American Cheeseburger Dream*
Carol Anthony, 2001.
Oil, crayon, and paper, 7 1/2" × 8".
Courtesy McLarry Fine Art and Carol
Anthony.

4. *To Be a Cowboy, Long X Ranch,
Kent, Texas*
Kendall Nelson, 1996.
Gelatin silver print, 16" × 20".
© Kendall Nelson. Used with permission.

5. *Roadside Skywriting*
William Dunlap, 1989.
Oil paint and dry pigment on rag paper,
72" × 31".
Copyright © 1989 William Dunlap. All
Rights Reserved. Photo credit Hubert Worley.

6. *Faith's Garden Party #1*
Faith Ringgold, 2001.
Color serigraph, 22" × 30".
© 2018 Faith Ringgold, member Artists
Rights Society (ARS), New York. Courtesy
Faith Ringgold and ARS.

7. *Suburban Apotheosis*
Kevin MacDonald, 2000.
Silkscreen, 13" × 17".
© Estate of Kevin MacDonald. Used with
permission.

8. *From Continent to Continent*
Mario Merz, 1985.
Steel, glass, neon, clay, metal cables, electrical
wire, and transformer, 66" × 135" × 135".
Joseph H. Hirshhorn Purchase Fund, 1990.
Photography by Cathy Carver.
Hirshhorn Museum and Sculpture
Garden, Smithsonian Institution Accession
Number: 90.6.
© 2018 Artists Rights Society (ARS), New
York / SIAE, Rome.

9. *1401 Pressburg Street, New Orleans*
Robert Polidori, 2006.
Fujicolor crystal archive print,
39 3/4" × 53 15/16".
© Robert Polidori. Used with permission.

10. *Untitled*
Doris Salcedo, 1995.
Wood, cement, cloth, and steel,
77 1/8" × 74 7/8" × 49 5/8".
Joseph H. Hirshhorn Purchase Fund,
1995.
Photography by Lee Stalsworth.
Hirshhorn Museum and Sculpture Garden,
Smithsonian Institution Accession Number:
95.26.
© the artist Courtesy White Cube.

CHAPTER 12

1. *Marker There (Mark it There)*
Oliver Kilbourn, c.1975.
Acrylic on paper, 21 1/4" × 29 3/4".
From the series *My Life as a Pitman*.
© Ashington Group Trustees. Photo credit:
Woodhorn Museum & Northumberland
Archives.

Index

Illustrations are denoted by the use of *italics*.